2 $ 1 4 9 5 G 7

D1210168

Penguin Classics of World Art

The Complete Paintings of Vermeer

Jan Johannes Vermeer was born in Delft in 1632. His father, a silk merchant and tavern keeper, was also an art dealer and it was this last concern which Vermeer was to take over. In 1653, Vermeer married Catherina Bolnes who came from a rich family in Gouda and the same year he was elected to the Painter's Guild at Delft. Two years later, on the death of his father, he became an art dealer, making little more than a modest living from the trade. It seems that he was frequently having to borrow money to support his eleven children and the only existing evidence that he sold any of his paintings shows that he did so in order to pay off a debt.

Very few of Vermeer's paintings now remain and there is very little factual information concerning his life and work, much of modern scholarship on the subject being largely speculative. It is thought that a fire in Delft may have destroyed much of his early work, as his first known paiting is *The Procuress*, dated 1656. It is true, however, that no other artist enjoys such a high reputation based on such a small body of work, and although his art went largely unrecognized in his own day, Vermeer was twice elected to the Guild, in 1653 as a Master.

Vermeer's work reveals the possible influence of Rembrandt and Caravaggio and his knowledge of the Utrecht school points to the possibility that he visited Terbruggen. Evidence suggests only that he left Delft to visit The Hague to settle a dispute over an Italian painting. Today, Vermeer is revered for his timeless, monumental style. His use of techniques such as camera obscura and the mirror elevates his domestic interiors to the level of classic art and this is perhaps best demonstrated in *The Love Letter*.

Vermeer died in poverty in 1675 at the age of forty-three. His work received no critical attention until the appreciation of the Impressionist movement at the end of the nineteenth century, when he rose from obscurity to renown, eliciting praise from critics and artists alike. He is now considered amongst the great masters.

Table of contents

The Complete Paintings of

Vermeer

Introduction by **John Jacob**

Notes and catalogue by **Piero Bianconi**

Penguin Books

Penguin Books Ltd, Harmondsworth, Middlesex, England
Viking Penguin Inc., 40 West 23rd Street, New York, New York 10010, U.S.A.
Penguin Books Australia Ltd, Ringwood, Victoria, Australia
Penguin Books Canada Ltd, 2801 John Street, Markham, Ontario, Canada L3R 1B4
Penguin Books (N.Z.) Ltd, 182–190 Wairau Road, Auckland 10, New Zealand

First published by Rizzoli Editore 1967
This translation first published in Great Britain by Weidenfeld & Nicolson 1970
Published in Penguin Books 1987
Text adapted and updated by Sebastian Wormell

Copyright © Rizzoli Editore 1967
Translation and introduction copyright © by George Weidenfeld & Nicolson, 1970
All rights reserved

Printed in Italy

Except in the United States of America, this book is sold subject
to the condition that it shall not, by way of trade or otherwise, be lent,
re-sold, hired out, or otherwise circulated without the
publisher's prior consent in any form of binding or cover other than
that in which it is published and without a similar condition
including this condition being imposed on the subsequent purchaser

Photographic sources

Color plates: Blauel, Munich; Brenwasser, New York;
Buckingham Palace, London (reproduced by gracious
permission of Her Majesty the Queen); Frick Collection,
New York; Herzog Anton Ulrich-Museum, Brunswick;
Iveagh Bequest, Kenwood, London; Librairie Flammarion,
Paris; Mandel, Milan; Mauritshuis, The Hague; Meyer,
Vienna; National Gallery of Art, Washington; Rijks-
museum, Amsterdam; Scott, Edinburgh; Staatliche
Museen, Berlin-Dahlem; Stewart Gardner Museum,
Boston, Mass.; Witty, Sunbury-on-Thames, England.
Black and white illustrations: National Gallery, London;
Rizzoli Archives, Milan.

Introduction

Vermeer is a problem: his paintings are known and loved by thousands, but of the artist we know practically nothing. The paintings themselves under the closest critical scrutiny, far from illuminating the personality of the artist—and they are almost all we have to go on—reveal instead psychological and stylistic problems of the most baffling kind. Add to this that his reputation is barely over a hundred years old, and that it has already attracted the most celebrated forgery case of modern times, and we have a singularly enigmatic figure posthumously crowning the achievement of seventeenth-century Dutch *genre* painting.

It is sometimes difficult to divorce Vermeer from his nineteenth-century reputation, from Théophile Thoré, whose articles in the *Gazette des Beaux Arts* in 1866 may be said to have discovered him, and not to smile indulgently at scholars like Burkhardt who, lecturing in 1874, deprecated the contemporary adulation for the "over-rated single figures of the Delft painter, Meer: women reading and writing letters and such things"; or Fromentin, who *ought* to have devoted a section to Vermeer in his *Maîtres d'autrefois,* published in 1876, but contented himself with the observation that "this peculiarity" of Dutch painting "has some points of view which are rather strange, even in his own country." No one respects the art critic who fails to recognize a great master in the making, but Burkhardt and Fromentin were not imperceptive, and Fromentin had at least noted the influence of Vermeer on the younger French painters; between them they had indicated the difficulty over Vermeer: the restrictive ordinariness of his subject matter, and the oddity of his treatment of it. Their remarks too, help to illumine the reasons for the not incomprehensible two-hundred-year neglect. Perhaps it was inevitable that the age of photography should "discover" the master painter of light and optical effects—provided that his paintings were of sufficient quality not to have been destroyed.

But first it is necessary to place Vermeer in the seventeenth century, and to realize that this uncommon painter of the commonplace was one of the youngest of the third generation of the great Dutch painters of the seventeenth century. He comes at the end of a magnificent epoch, inhibited by the outworn tradition as well as the achievements of the schools of Haarlem, Utrecht and Amsterdam. We know that he was left a tavern in Delft, with the not unusual business of picture-dealing on the side; that he possessed paintings by Theodor van Baburen, Cesar van Everdingen, and possibly Wynants, for he included them in his own pictures; and that when he died he left three paintings by Carel Fabritius, two portraits by Hoogstraeten, a *Crucifixion* by Jordaens, as well as a number of un-attributed landscapes and still-lifes. He does not appear to have been well-to-do (the affluence of his interiors contrasts markedly with the insolvency in which he left his litigious widow and eleven children) and he is never recorded as having sold a picture, except to cover a debt. And yet he was twice elected to the committee of the painters' guild in Delft, and in 1653 was Master. In 1671 he was also called to The Hague as one of the experts to inspect the Elector of Brandenburg's disputed purchase of Italian pictures. It would seem that this artist's artist, who was only mentioned three times in printed books in his life time, on one occasion as having nothing by his own hand to sell, made a modest livelihood by his picture-dealing which enabled him to concentrate the purity of his art unaffected by commercial values.

It is significant that De Monconys, to whom we owe the comment that Vermeer had nothing of his own for sale, nevertheless did see one picture by him in Delft in 1663 which he describes disparagingly, as Burkhardt was to do later, as "containing a single figure." With the possible exception of his early pictures, *Christ in the House of Martha and Mary,* and

The Toilet of Diana, which are figure compositions in the Utrecht and Venetian manner respectively, Vermeer's paintings were not designed for the trade. And yet for an artist's work to have a chance of survival, a good enough local reputation such as Vermeer seems to have had is not enough: his pictures must be commissioned, collected by princes and prized by early connoisseurs, even under the wrong attributions, if later generations are to have a chance of appreciating the body of his work as a whole. It is not surprising when one considers the history of taste in picture collecting that Vermeer's "single figures" have had few adherents. There was a flourishing trade in Dutch pictures to England, France and the German states in the late seventeenth century. But the taste of collectors was often for painters of the second rank—the Dutch Romanists, and artists such as Bloemart, Jan de Bray and Wouvermans. Even the great vogue for Dutch painting in the mid-eighteenth century centered on the landscape painters—Van der Heyden, Hobbema, Van de Neer, the Ruisdaels and especially Van Goyen—who were highly esteemed in England and Germany. But when the painter Richard Wilson was asked to name the best landscape masters, he mentioned "two painters, whose merit the world does not yet know who will not fail hereafter to be highly valued, Cuyp and Mompers." If Cuyp's golden landscapes had to wait in the company of Mompers' what chance had Vermeer's subtleties in an obvious world of Metzus, Ostades and Steens?

The first European artist to mention Vermeer with approval was Sir Joshua Reynolds. In his *Journey to Flanders and Holland,* 1781, he singled out Vermeer's *Milkmaid* for praise. Two paintings by Vermeer entered English collections in the eighteenth century: one, *Lady and Gentleman at the Virginals* in the Royal collection was bought as a Frans van Mieris; but it is tempting to suppose that the purchase of the other, the little *Guitar Player* at Kenwood, was prompted in part by Reynolds' advice. It appears in the Travelling Account Book for 1794 of Henry, 2nd Viscount Palmerston, who often dined with Reynolds, and may have heard Vermeer's name mentioned at his own table. The full provenance is of recent discovery, and does not appear in the standard works on Vermeer. The entry reads as follows: "Bought at the Hague from Monsr. Nyman. . . . A Woman Playing on a lute—Vandermeer of Delft 16 (Louis d'Or)." But Dutch cabinet pictures of high quality—De Hoogh and Terborch—had become popular by the late eighteenth

century. The taste continued into the nineteenth century, carrying Vermeer with it, and his pictures, although often misattributed, came to be prized by a few collectors. There were two in the Lebrun Collection in Paris by 1792, while others appeared in the Lapeyrière sales in Paris in 1817 and 1825, while in 1822 the Dutch Government bought the *View of Delft.* Of the thirty-six possible autograph works, thirteen were to be found in English collections or on the London art market in the nineteenth century, some of which were sold to America, while others appeared in German collections and in picture sales in Paris and Holland. It was this growing appreciation of isolated individual pictures that enabled Thoré to draw attention to the *œuvre* as a whole.

There was however another reason. Reynolds had been quick to spot the peculiar quality of *The Milkmaid,* which had appeared fairly regularly in Dutch auctions throughout the eighteenth century. Writing to Edmund Burke, in August 1781, he observed that "Dutch pictures are a representation of nature, just as seen in a camera obscura" (Reynolds himself owned a camera obscura, now in the Science Museum, London). Vermeer's executor was Anthony van Leeuwenhoek, a pioneer of optical studies and an "indefatigable maker and user of lenses" and the internal evidence of Vermeer's pictures clearly indicates the use of the camera obscura, as Reynolds observed. In fact, the X-rays of the *Head of a Girl* in the Mauritshuis at The Hague make one wonder whether Vermeer did not, as suggested by early writers on the subject, lay his preliminary colors directly on the flat, projected image (see L. Gowing, *Vermeer,* 1952, p. 137–8, Fig. 31). There is no denying Vermeer's insistence on the *optical* effect (look for instance at the hand of the painter in *The Artist's Studio*), rather than the *conceptual* image. In this he was at one with the natural philosophers of the seventeenth century, from Kepler onwards, who used the camera obscura for almost every kind of optical experiment.

A similar interest in optics was alive in the mid-nineteenth century. The invention of the camera, which could fix the image chemically, led to developments in the history of painting which are well known. The Impressionists' direct reflection of their subject matter, and their truth of tone were echoed in the work of Vermeer. Not only the connoisseurs of Dutch seventeenth-century cabinet pictures, but the French painters of the second half of the nineteenth-century

opened our eyes to the particular truths perfected in Vermeer's "single figures."

Perhaps we are nearer now to an understanding of the central difficulty over Vermeer: his curious psychological detachment. The female figures of his late pictures, dressed in sparkling satins, and almost invariably lit from the left, exist in an almost airless domestic vacuum, divorced from the spectator by the barriers of carpet-covered tables or the perspective of marbled floors the artist places in front of us. Their faces are strangely de-personalized, seen as still life objects, "displacing the light with measured purpose." The effect can partly be explained by the distancing use of the camera obscura—an effect similar to the intensified colors and unaccustomed richness of the reduced image of a familiar room seen in a mirror, which we have probably all noticed at some time.

But what was the "measured purpose" of this ambiguous reticence? Are we to see in Vermeer an artist of complete optical objectivity, or the Lautrec syndrome—a maimed painter, who because of his personal problem withdrew behind his camera cabinet to observe the ladies of his household? What is the box that appears behind the easel in the mirror above the head of the lady at the virginals in *The Music Lesson*? And yet, as Gowing (*op. cit.* p. 124, Fig. 29 and Plate 27) has pointed out, the picture on the wall, a *Roman*

Charity similar to the picture at York by Baburen, which partly appears to the right in this painting, gives a probable clue to Vermeer's meaning. Other instances can be cited, but it is not clear whether Vermeer is merely combining the vulgarity of the earlier Dutch *genre* paintings of tavern scenes as an overtone to the gallantry of Terborch, or whether he is implying an allegory on man's dependence on women, which in the later pictures becomes an allegory on womankind itself. The meaning is there, but it is ambiguous, and the personal problem remains.

If Rembrandt is "the magician with no tricks up his sleeve," Vermeer is the antithesis. An almost secret painter, inverting the Baroque tradition by the substitution of passivity and withdrawal in place of exuberance and flourish. He had, as Van Gogh observed, an "infallible sense of composition" which he elevated to the status of mathematics. His vision, his subject matter, was restricted to the beauty of colored surfaces, to the domestic interior and the occasional view from a window. But above all he is the painter of light. He does not draw what he knows to be there, but paints instead the tones of light and shade, of color and texture where they fall optically. It is light alone which breathes life into his figures, conjuring up ghosts of light rather than darkness.

JOHN JACOB

An outline of the artist's critical history

Three years after his death, Vermeer's name did not even appear in the voluminous treatise by S. van Hoogstraeten on the painters of the "old school" (*Inleidinght tot de hooge Schoole der Schilderkunst*, 1678); the Dutch art historian A. van Houbraken (*De groote Schouburgh der nederlandsche Kunstschilders en Schilderessen*, 1718–21) confines himself to a mere mention, taken from the description of the city of Delft (*Beschrijvinge der Stadt Delft*, 1667–68) by D. van Bleyswycks. The latter's scanty biographical notes, in a volume of more than a thousand pages, are the only known contribution to the subject in contemporary historical accounts; the *Gulden Cabinet* by De Bie (1662), Sandrart's *Teutsche Academie* (1675–9) and the *Abrégé de la vie des peintres*, written by De Piles (1692–7) in the Netherlands, omit all mention of Vermeer, as does the *Cabinet der Statuen* by De Geest (1702), Rembrandt's brother-in-law. Van Bleyswycks does quote some verses of A. Bon which at least reveal some interest among poets. And having counted the far from kindly comment by B. de Monconys (see Outline Biography, 1663), we have exhausted contemporary references to the artist outside the sphere of the strictly archival.

Vermeer was soon forgotten, and as bitter evidence of this G. de Lairesse (*Grand livre des peintres*, 1707) refers to him only as a diligent painter of views in the manner of Frans van Mieris. One might also add that other eighteenth-century biographers of artists, such as Weyerman and Van Grool, do not even mention his name; another case in point is that of Boitet who, in a description of Delft (1729), deals at great length with the painters of the second half of the seventeenth century and mentions Carel Fabritius. For the remainder of the century Vermeer's name merely appears in passing in some rare references, and these are by artists and connoisseurs rather than by historians and critics. Praise then is due to the English painter Sir Joshua Reynolds (1781) for his comments upon *The Milkmaid* (9); to J. B. P. Lebrun, husband of the artist Elisabeth Vigée-Lebrun, for lamenting (*Galerie des peintres . . .*, 1792) the lack of Vermeer's works in Paris; and to the Dutch engraver Christian Josi for the admiration he expresses in memory of the master in an article written in 1795 (S. Sulzberger, *Kunsthistorisches Mededelingen*, 1948).

In the first half of the nineteenth century the situation deteriorated. R. van Eynden and A. van der Willingen (*Geschiedenis der vaderlandsche Schilderkunst*, 1816), in spite of their enthusiasm for Vermeer, whom they baptized the "Titian of Dutch painting," could do no more than quote the meager information in Van Bleyswycks; Pérignon, who drew up the catalog of the first Lapeyrière sale (1817), comments favorably on the master but the passage bears no close examination; as for Gault de Saint-Germain (*Guide des amateurs*, 1818, and again in the catalog of the Louvre, 1850), he refers to Van Bleyswycks several times as an example of ignorance about Vermeer. At last with Du Camp (1857) and Gautier (1858) the first steps were taken towards the illuminating comments of writers such as Proust, Gillet and Claudel; while in Blanc (1860), Viardot (1860), the brothers Goncourt (1861) and Waagen (1864) appear evident signs of the critical change instigated by Thoré-Bürger.

Etienne-Joseph-Théophile Thoré (1807–69) was a lawyer, journalist, critic and socialist, and a friend of Leroux, Proudhon, etc., right up to the 1848 revolution, in which he played a leading part. The following year he was exiled, spending his time in Belgium, Holland and England, and devoted himself to art criticism under the pseudonym William Bürger (Bürger = citizen). As early as 1842 he had admired the *View of Delft* (8), and his chief pre-occupation during his exile was to restore the fame of Vermeer. What drove him above all to make such an attempt was his desire to challenge the fashion for Italian art which existed in France under the Second Empire. He identified the Middle Ages with mysticism; the Renaissance with allegory and the aristocratic spirit; the Dutch School attracted him by its naturalistic spontaneity. Bearing in mind his political sympathies, we may reasonably suspect Thoré-Bürger of venturing into fields outside the limits of aesthetics: but neither this, nor his over-readiness of attribution should lead us to undervalue his contribution to our knowledge of Vermeer. Between 1858 and 1860 he published his first writings on his beloved painters of the Netherlands, and these formed the basis for his decision, in 1866, to take his passion, Vermeer, as his sole subject. Three articles appeared in the *Gazette des Beaux Arts*, fifty-eight pages in all, but so passionately, shrewdly and cogently written that they utterly changed current ideas about the master.

In fact very few people can have read them. As late as 1874, in three conferences dedicated to the "Dutch genre painters," Burkhardt deprecated Houbraken's neglect of Hobbema and De Hooch, but did not comment upon his silence on Vermeer, whose figures of women writing or reading letters the distinguished critic in any case thought "overrated." And in 1877 even Fromentin could only discover a certain "curious" gift of observation in the artist.

Vermeer's rediscovery went hand in hand with the belated appreciation of Impressionism. In both could be perceived the

same unprejudiced attitude to subject matter, while a similar interest in the play of color and light transformed these effects into the real subject of their painting. So it is not surprising that the highest praise for Vermeer after Thoré-Bürger is to be found in Van Gogh; and that enormous sums were beginning to be paid for Vermeer's works, at the very time when the poet Verhaeren was singing the first praises of the Impressionists, and Durand-Ruel was enjoying great success with an exhibition of their work in New York.

This was at the end of the nineteenth century. In the twentieth, Vermeer is ever more minutely studied and highly praised. The various enthusiastic and intuitive comments of novelists and poets, touched on above, illuminate the researches of art historians and scholars, who gradually disclose more and more of the master's extraordinary qualities. They have begun to adore him, to enthuse about him as they do about Piero della Francesca; and in the same way, in an attempt to discover his disciples among the greatest modern artists, they have come to the point of discovering abstract proportions in his works of the kind which, even if they could hesitantly be attributed to Piero, could hardly be admitted in a seventeenth-century painter. We will quote just one illustration, the following passage formulated under the influence of current neo-Platonic theories (the "Golden Number," etc.): we learn that in composing one of his pictures Vermer employed "an axial triedric section displaced slightly to the right, its apex composed by the line of flight from the horizon."

Such assertions should be lumped together with those which report the discovery of symbolic and allegorical values in Vermeer's paintings, assertions which start from unverified premises and end by discovering that the picture's outstanding merit lies in some recondite meaning of this kind.

Vermeer's artistic message may well not yet be entirely clear; but it seems more reasonable, for the moment, to concentrate our enquiry upon his highly refined sensitivity to light and color and on his sure touch in the arrangement of volumes.

So perished this phoenix (Carel Fabritius), to our loss. He departed this life at the peak of his fame; but by great good fortune there rose from his ashes Vermeer, who continued along his way like a true master.

A. Bon, quoted in D. van Bleyswycks, *Beschrijvinge der Stadt Delft*, 1667–8

This Van der Meer, whom historians have not mentioned at all, merits particular attention. He is a very great painter, in the manner of Metsu. His works are rare, and are better known and esteemed in Holland than anywhere else. . . .

J.-B.-P. Lebrun, *Galerie des peintres flamands*, 1792

Apart from the sky, which is soft and like cotton-wool (in *The Street*), the work is painted with a vigor, a solidity, a sureness of impasto very rare among Dutch painters. This Jan van der Meer, of whom I knew nothing but a name, is a vigorous painter who uses flat colors applied over wide areas in superimposed layers. He must have visited Italy. He is an exaggerated Canaletto.

Maxime du Camp in *Revue de Paris*, 1857

Vermeer paints *all prima* with unbelievable force, precision and intimacy of tone. He achieves the magic quality of a diorama, without artifice.

Théophile Gautier, in *Le Moniteur*, 1858

A confoundedly original artist, Vermeer. One might say that he represents the ideal sought by Chardin: the same milky paint, the same touch with little dabs of broken color, the same buttery texture, the same wrinkled impasto on the accessories, the same "stippling" of blues, of bold reds in the complexions, the same pearl-grey in the background. . . . And, a most surprising thing, this man, Chardin's master, yet certainly unknown to our artist, appears in a painting of a quite different style, a street in Delft with brick houses, to be the precursor of Decamps.

Edmond and Jules de Goncourt, *Journal*, 1861

In Vermeer the light is not at all artificial; it is exact and natural, as in nature, precisely as a meticulous physicist might wish it to be. The ray that enters from one side of the picture crosses the space to the other side. The light seems to come from the paint itself and naïve spectators could easily imagine that the light actually slips in between the canvas and the frame. Someone who came into the house of M. Double, where *The Soldier and Smiling Girl* was exhibited on an easel, went behind the painting to see where the marvellous ray of light came from before reaching the open window. This is why black frames are particularly suitable for Vermeer's canvases.

In Rembrandt there is gold in the flesh and brown in the shadows. In Vermeer there is silver in the light, and pearl in the shadows.

In Vermeer there is no black. No blurring, no evasions. Every detail is clear, the back of a chair, a table or a harpsichord, as if near a window. Yet each object has its own slight shadow and its own reflexion is mingled with the pervading light. This accurate depiction of light also accounts for the harmony of Vermeer's color. In his work, as in nature, non-complementary colors such as yellow and blue, of which he is especially fond, are not discordant. He makes quite different tones match, moving from the gentlest and most subdued to the most powerful and exalted. Brightness, energy, finesse, variety, the unforeseen, the strange, something rare and enchanting, he has all the gifts of the boldest colorists for whom light is an inexhaustible magic.

William Bürger (Etienne-Joseph-Théophile Thoré), *Van der Meer de Delft*, 1866

Do you know a painter named Jan van der Meer? He painted a pregnant Dutch woman, beautiful and very distinguished. This strange artist's palette includes blue, lemon-yellow, pearl-grey, black and white. It is true that the whole range of colors can be found in some of his paintings; but the juxtaposition of lemon-yellow, faint azure and light gray is as typical of him, as are Velazquez's harmonies of black, white, grey and pink. The Dutch had no imagination, but they had unusual taste and an infallible sense of composition.

Vincent van Gogh, letter to Emile Bernard, 1877

Van der Meer has appeared in hardly any publication in France, but since he has certain gifts of observation, which are rather unusual even in his own country, the journey [to Holland] would be worthwhile for anyone who wanted to learn about this particular aspect of Dutch art.

E. FROMENTIN, *Les maîtres d'autrefois*, 1877

Many of his figures give the effect of being little more than pleasing shapes. They are pleasant notes in a delightful concert of fine, delicate, mingled and veiled tones. They do not control the surroundings, and nothing is subordinated to the figure: instead each local shade has its own strength and right accent. If they ever play an important part in the harmonious symphony, it is thanks to their form, not to any idea they express.

H. HAVARD, *Van der Meer de Delft*, 1888

Ever since I saw a *View of Delft* at the museum in The Hague, I knew that I had seen the most beautiful picture in the world.

MARCEL PROUST, letter to J.-L. Vaudoyer, 2 May, 1921

You told me that you had seen some of Vermeer's pictures, you must have realized that they're fragments of an identical world, that it's always, however great the genius with which they have been recreated, the same table, the same carpet, the same woman, the same novel and unique beauty, an enigma at that period in which nothing resembles or explains it, if one doesn't try to relate it all through subject matter but to isolate the distinctive impression produced by the color.

MARCEL PROUST, *La Prisonnière*, 1923

In the case of Hals, it is possible to get away with using the term "realism"; but its inexactitude strikes us again when we pass from Hals to Vermeer of Delft. Apart from one "Allegory" which shows his meager gift for rendering successfully a totally imaginary scene, and one mythological painting which lacks any sense of mythology whatsoever, Vermeer apparently painted only the outward aspect of daily life. He paints only the exterior: the objects appear to have been rendered just as they are in reality, both in paintings of people or in the *View of Delft* and in *The Street*. However, looking at them more closely, these scenes with figures, almost all of young women in an interior, appear by no means spontaneous, and show themselves to have been arranged with delicate precision. And to tell the truth these women appear to belong to an unknown, mysterious demi-monde which is only hinted at Vermeer has created a half-imaginary world of his own, a tiny ideal world full of *joie de vivre* and luxury, and has transfigured this world by the clarity and amazing harmony of his colors, and by the inoffensive simplicity of his ingenuous soul. In everything that Vermeer paints there float at one and the same time an atmosphere of memories of childhood, a dreamy calm, an utter stillness and elegiac clarity, which is too fine to be called melancholy. Realism? Vermeer lead us far from the grossness and nakedness of everyday reality.

But what remains most important is this: Vermeer has no thesis, no idea, not even, in the true sense of the word, any style.

J. HUIZINGA, *Holländische Kultur des seibzehnten Jahrhunderts*, 1932

Look at the complex still-life (in *Gentleman and a Girl drinking*),

formed by the chair (with its luminous rungs, its cushion and guitar), the paper on the table and lastly by the bench which carries the shapes towards the background. Look closely at the design, the movement of color and light, and then compare it with the still-life in Caravaggio's *Love*: you will find the same spirit, but a different intention.

G. ISARLO, "Vermeer at the Rotterdam Exhibition," in *La renaissance de l'art*, 1935

. . . (in *Christ in the House of Mary and Martha*) not a doubt, not a ruffle, not a shadow, not a trace of indecision; impossible to find elsewhere, in one so young, such freshness and, at the same time, such certainty. How far we are from the agitated, searching *impasto* of Rembrandt! The grandeur which the latter achieved only at the end of his life is a gift that Vermeer was born with.

. . . A complete masterpiece (*At the Procuress's*), one of the finest paintings in the world, of a beauty almost superior to the art of the West, the beauty of a heraldic design or a Japanese print.

L. GILLET, *Les tapis enchantés*, 1936

. . . (in *The Music Lesson*) the lions' heads, the jug, the window, are treated by a master-hand; but we do not experience quite the same reaction when we look at the figures. Vermeer excels when he treats his model as a still-life. But when he wishes to paint a living model, one feels that he loses patience.

PH. L. HALE, *Vermeer*, 1937

Among these masters whose work we remember with such pleasure, Gérard Dou, Mieris, Terborch, Metsu . . ., there is one whom I would not call the greatest, since it is not a question of greatness, but the most perfect, the rarest and most exquisite; and if other adjectives were required they should be those of another language, "eery, uncanny." You have been waiting a long time to have his name: Vermeer of Delft.

PAUL CLAUDEL, *L'œil écoute*, 1946

Vermeer's place in the history of art has given rise to a number of theses, some of which have diminished his role, seeing in him a mere "genre" painter, or a potter who employed the colors of faïence for his figures as well as his objects. But such theories overlook the true nature of this extraordinary artist.

When he deals with familiar subjects, portraits, landscapes or even, as in his early work, mythological and religious themes, he introduces a completely new element which did not appear until the seventeenth century: the revelation of the Platonic idea of painting. He began from the premise that light molds living beings and objects, helps to fix features common to them and mingles with color to create form.

This concept of painting, which nobody had formulated until then, was to have important consequences in the nineteenth and twentieth centuries.

A. BLUM, *Vermeer et Thoré-Bürger*, 1946

Vermeer did not attain the profound humanity of Rembrandt. His field of vision is limited, but within the confines of pictorial perfection he brought Dutch art to its highest achievement.

. . . we insist on repeating that Vermeer was not, in the true sense of the word, an innovator. In our opinion there is no logical need to say that he was the first to introduce this or that new

element in composition or certain chromatic harmony – for example, the lemon-yellow –, before Jan Steen and others. It is true that he frequently used yellow and blue, but the Utrecht group of painters had an equal predilection for this harmony of contrast. Indeed it is not essentially a question of combinations, but of the tonal value that Vermeer succeeded in giving to his colors. It is very possible that he had derived inspiration from others for his use of color. By no means inventive, he was nevertheless more sensitive and refined than most of his contemporaries.

He simplified and clarified genre painting, stripping his subject of every accessory, and reproduced something that, without him, would never have been seen from this aspect.

A.B. DE VRIES, *Jan Vermeer de Delft*, 1948

But if he continues to play on contrast, Vermeer also reverses its proportion: instead of enclosing light areas in deep shade, he cuts off shadows in a spread of light. His painting is no longer the confused grotto whose background loses itself in infinite dusk: it is neatly enclosed by a wall, a sudden reflecting surface which, on the contrary, attains to one of the highest values. There are no more isolated islands of light, submerged in the chiaroscuro, but condensations of shade bordering the light which they enclose. By reversing the problem, Vermeer can range upwards through the whole gamut instead of descending it. It is here that the development takes place after Terborch, who was an innovator in so many ways but remained faithful to the penumbra. Before Vermeer, color coincided with the most brightly illuminated area, then, like form, was increasingly lost in the shade. Vermeer, on the other hand, first colors the shadowy areas, then raises the intensity of tone until it reaches its peak in medium light on which the whole chromatic vibration rests; and when he arrives at the most brilliant point of light, the point where formerly the real clarity of his color began, he dissolves it. But we should note that he dissolves it in light and not in shadow; he does not extinguish it with black, but with white, where it vanishes like a sound at its highest pitch. Then, like a supreme rejection, pure white points of light scintillate. By this reversal his register reaches the highest octave of light.

RENÉ HUYGHE, *La poétique de Vermeer*, 1948

. . . in one instance the rendering of atmosphere reached a point of perfection that for sheer accuracy has never been surpassed: Vermeer's *View of Delft*. This unique work is certainly the nearest that painting has ever come to a colored photograph. Not only has Vermeer an uncannily true sense of tone but he has used it with an almost inhuman detachment. He has not allowed any one point in the scene to engage his interest, but has set down everything with a complete evenness of focus. Such, at least, is our first impression of the picture, and the basis of its popularity with those who do not normally care for paintings. But the more we study the *View of Delft* the more artful it becomes, the more carefully calculated its design, the more consistent all its components. No doubt truth of tone adds to our delight, but this would not sustain us for long without other qualities and perhaps could not, by itself, have reached such a point of perfection, for the mood of heightened receptivity, necessary to achieve it,

cannot be isolated from that tension of spirit which goes to the creation of any great work of art.

SIR KENNETH CLARK, *Landscape into Art*, 1949

Like the finest frescoes in Pompeii, like *The Parade* by Seurat, *The Love-Letter* is minutely ruled on the golden section. The objects and figures are shown in height and in depth in an interrelationship which remains constant and become identified with the surrounding architecture without losing any of their character. And therein lies the miracle – though abstract painters may deny it. The figures in Pompeii and the last figures painted by Seurat are no more than symbols; those of Vermeer, although accepting the rigid formula in which they are prisoners, although more inclined to adhere to architectural divisions than to live out the derisory role imposed by the customs of their times, yet preserve something of a feeling that has its own strength even if it is thrown in as an "extra." To reject what is offered to us as an "extra" would be the sin of Jansenism; the essential point is that the human interest comes last, and that the hierarchy of pictorial values, which begins with order and finishes with a smile, is respected.

A. LOTHE, *Traite de la figure*, 1950

Vermeer is a Dutch intimist, but as a sociologist rather than as painter. At thirty years of age he became bored with anecdote, and anecdote in Dutch painting is not incidental. The sincere sentimentality of his "rivals" is foreign to him; the only atmosphere he knows is a poetic one and this is due, above all, to the refinement of his art. His technique differs from that of Pieter de Hooch with whom he was at one time confused . . . from that of Terborch or of the better Fabritius paintings. . . .

The confusion lies in his having chosen his subjects from their school; the painters Chardin and Corot, like-minded artists, later showed the same indifference in choice of subject. Not without keeping his distance; his anecdotes are not really anecdotes, his atmospheres are not really atmospheres, his sentiment is not sentimental, his scenes are hardly scenes, twenty of his pictures (forty of which are known to us) are of only one person, but for all that they are not portraits. He seems to depersonalize his models all the time, as though to merge the whole universe: to obtain not types but an extremely sensitive abstraction which makes one think of certain Greek "Kores."

ANDRÉ MALRAUX, *Les voix du silence*, 1951

Nothing is more characteristic of Vermeer's course than the transformation that the theme of *The Procuress* undergoes in his hands. At the outset it is the single and conspicuous subject of a great masterpiece. In succeeding pictures it is progressively refined into subtler and more elusive forms. Finally it is seen, as if in a marginal note, only as a picture hanging on his wall: it is a *Procuress*, a work painted early in the century by the Utrecht artist Baburen, that appears as a decoration, a collector's piece, behind *The Concert* and the *Lady seated at the Virginals*. These last oblique references to the theme are certainly no more intended to escape us than was the Cupid in the conversation-piece. Yet it is not easy to accord to such devices their full value. Whenever an artist represents as part of his subject a work in which we can construe another, an image within the image, we may expect that the

conjunction will prove significant: the use of the artifice will be well enough known. . . .

The meaning that Vermeer gathers from the pictures on the wall is his own. He does not often seek for his subjects any generalized philosophical enforcement, of the kind that Velazquez extracts from the decorations of his great genre-like works, painted in Vermeer's time. Vermeer's meaning is specific though by no means direct: he contrives almost secretly, his own mythology.

L. GOWING, *Vermeer*, 1952

The great Vermeer . . . we must certainly mention because his profound inclination towards the limitation of sentiment can be fully seen in the gleaming studs on his chairs, in his jugs encrusted with light, and even in the scintillating tiles which give the celebrated *View of Delft* the look of a "city still-life."

R. LONGHI, "Natura morta all'Orangerie," in *Paragone*, 1952

If Vermeer, like other great painters, climbed the ladder of his career one rung at a time, he did not, however, do it step by step. The development of his art seems to follow the curve of a solenoide; he comes back towards his early work "from above."

ANDRÉ MALRAUX, *Vermeer de Delft*, 1952

Vermeer's paintings can be defined without doubt as the most perfect still-lifes in European art, still-life in the original sense of the words, that is to say *vie silencieuse*, *Stilleben*, the dream of a perfect reality where the calm that envelops objects and beings almost becomes a tangible substance in which objects and characters (treated as objects) reveal a secret interrelationship. In them time seems to be suspended, and daily life appears under the aspect of eternity.

Vermeer's realism, derived from the Dutch Caravaggists, is distinct from their often earthy realism and strikes us by its poetic quality. The composition of his pictures is extremely simple: horizontal, vertical and diagonal lines give a sort of framework within which the objects are placed on planes (there are generally three) which sharply differentiate their dimensions.

CHARLES DE TOLNAY, "L'Atelier de Vermeer," in *Gazette des Beaux-Arts*, 1953

Vermeer confounds all fixed and traditional ideas about the presence in Dutch painting of different "categories": in his "genre" pictures, nothing is happening (one never knows what title to give to a Vermeer) while his city views are wholly conceived as still-lifes. That is why it is pointless to compare his motionless world with that of other Dutch "genre" painters among his contemporaries. . . .

It is useless struggling with this enigmatic artist's essential secret: he will always remain a "nightingale amongst daws" (Friedländer). Perhaps Vermeer's art will be better understood if it is conceived not as an exception, in contrast with its surroundings, but as the fulfilment and synthesis of the Dutch way of life, of the Dutch taste for anything smooth, clear-cut, bare, luminous, immaculate: like the sublimation of the "epidermises" of things, of their calm, silent life, of peaceful existence.

In short, Vermeer was aiming above all to transfer the "here and now" into a realm of enchanted silence, into that other world which Rembrandt attempted to render universally comprehensible and present.

VITALE BLOCH, *Tutta la pittura di Vermeer di Delft*, 1954

Vermeer has been called a painter of still-lifes – but in Dutch still-lifes all the objects are continuously and separately modeled, whereas Vermeer, just like a landscape-painter, paints across the forms and constructs his interiors out of near distance, middle distance and far distance. In the foreground there is a barricade without any details, far too close up; bread, fruit and chinaware sparkling with color as if they were in the open air; the rest is too far away. Van Eyck and the other early Netherlandish artists painted everything too close, for the sake of clarity. Vermeer painted everything in the middle distance too far away, whereby the objects lose their identity, their familiar forms.

Even when he brings objects right up into the foreground, he paints them with the blueness of distance. He arranges colors and forms as if he was creating a flower-piece, a decorative colored composition; but then he modulates without regard for the individual forms, in the same way in which light flows. The pattern of his picture evolves like the melody on an Aoelian harp; in Vermeer's works everything appears to have been carefully calculated, but is nevertheless determined by the casual vision which he saw in his camera. From the camera Vermeer also derived the vagueness of the nearest portions and the mellow focus of the middle distance rich in detail: with him the light dissolves the phenomena to the point of making tangible things unrecognizable and obliterating the boundaries between objects.

Vermeer's art is an art of vision, not of invention; an art of painting, not of composition. In his works, as in those of the old dramatists, the derivation of the motives is of no importance. To quote one example (to the exclusion of others) he derived from Jan Steen the motive of a thinking or dozing man with his arm supporting his head. For Jan Steen too, this figure represents an indifferent, isolated spectator of a scene, calculated to excite the interest of those who see the picture. But what does Vermeer make out of this figure? Even the napkin underneath the jug has more expression and more 'painterly' grandeur than the most successful heads of Steen. (Only Cézanne, two hundred years later, understood how to endow such white, folded cloths with so much monumentality and significance.) Amidst the grey realism of Dutch painting, the colored, tranquil art of Vermeer is like a rainbow which stands in a cloudy sky and alters the appearance of everything.

LUDWIG GOLDSCHEIDER, *Jan Vermeer*, 1958

The ideal center of the picture (*Lady and Gentleman at the Virginals* in Buckingham Palace), the leaning mirror above the instrument, is not only an expedient for remeasuring the space in the luminous, cold room, but embodies its greatest truth, since through it alone the elegant little woman standing in front of the keyboard acquires a human face and becomes one of the most evocative of the painter's portraits. But the mirror in which Vermeer was painting was surely a magic mirror, such as to reflect only an immaculate reality, immune to the ravages of time, protected from any violent passion or action. It becomes so thanks to the brilliance of the white walls, the mysterious, absorbed calm of his figures, the refined orchestration of brilliant

and deep colors, and above all the absolutely limpid light, which so intensely particularizes each each everyday object, making of it something precious, an ideal image.

A. BOVERO, "Pittura come in uno specchio," in *Civiltà nell'arte*, 1960

With Vermeer this whole myth of "action" and imagination (as in Baroque painting, in Rubens), this concept of reality as the instrument of "action" falls down: for the first time in the history of western art the subject of the picture becomes the object of vision, without compromise of any kind. And this revolution, which is substantial, even if it is so little apparent, is Vermeer's.

A. MARTINI, *Vermeer*, 1964

If I dared to say how I imagine Vermeer, it would be with the features of an alchemist who also paints, preferring the privacy of his studio to everything else, of an introvert who searches, experiments with intuitive sensibility but who – and it is in this that he differs from a true alchemist – was able was able to reach the goal at which he was aiming. . . .

I can distinguish two opposing poles in Vermeer's work: a strongly rational character and a no less profound poetic sensibility. He possesses an innate sense of form, and not a single Dutch master of the seventeenth century is his equal in this field. Moreover, he explores and extends this gift by interesting himself in the problems of space and optics.

A.B. DE VRIES, in *Dans la lumière de Vermeer*, 1966

. . . Vermeer's work seems to unveil the secret of its message by giving to its expression the delicate firmness of its architecture, the musical sweetness of its color, the juicy richness of its paint. Is Vermeer's "light" not in fact born of the irradiation of this paint surface arranged in smooth, convex layers and sometimes in thick blobs which reflect the light, of the gentle flow of color, of the density of his forms in the air? And is it not thus that one arrives at the delight that Poussin required of painting? . . .

In Vermeer's light, as incorruptible as it is sweet, the testimony of true quality is the only thing that matters. So that here art is stripped of every artifice, is led back to its *raison d'être*. For in the last analysis it is only a man's attempt to master the world and himself by means of the image he can give of it, with the goal of reaching the highest level that he can conceive.

RENÉ HUYGHE, in *Dans la lumière de Vermeer*, 1966

Each of his paintings is a complex mechanism. Every square centimeter of the canvas, every brush stroke seems to have been carefully considered. Because of this care the personality of his models gradually fades. The faces tend to be archetypal and lose all character when the painter refuses to portray their imperfections. If there was laughter in Vermeer's works it gradually paled

into smiles, and sleep served only to abstract the models even further. Portraits? Rather, a portrait of light on the skin, of the reflection of a map on a wall and, even more, the exploration of all that can be obtained from a subject attempted again and again. We recognize in Vermeer the restraint the Cubists sought when limiting their range to a guitar, a dish, a packet of tobacco and a newspaper. But in him this choice is exercised with discretion and without the ostentation of the demands made by painting alone. . . .

P. DESCARGUES, *Vermeer*, 1966

. . . Vermeer's world evades too concrete an interpretation because his genre paintings lack all those anecdotes and picturesque details which make the art of his contemporaries so homely, so ordinarily human, so easily comprehensible and amusing. Perhaps this substantial difference is connected with the fact that Vermeer was never (or never willingly) a slave of the relationship between patron and artist. If his art lacks a familiar or realistic character, as a pure expression of Dutch classicism it soars far above that of his contemporaries. His manner of seeing through color and light, and his technical perfection are less bound to time and circumstance than are those of any other Dutch artist.

E. GERSON "Johannes Vermeer," in *Encyclopedia of Universal Art* XIV, 1966

. . . he was not so much concerned with describing reality as with fixing it in its pictorial essence. The rumours of the Baroque with its triumphant displays, and first disquieting temptations had not reached the Delft painter's ear. He seems to live in a religious atmosphere which is still chastely medieval, and yet over this absorbed stillness hovers a mystery: the silent mystery of death.

Vermeer's art is nothing but this fixing of the moment, this way of making everything, even the most healthily concrete and alive banality, and every precarious, changeable daily sight – whether a trembling fleeting glance, a furtive gesture, the gleam of a pearl or the brightest ray of the sun through the clouds – into something fixed, eternal. The light, the changing light of the high windy skies in Holland, is exactly like this pictorial means, only fixed metaphysically. And it is thanks to this light that Vermeer unites space and time, stifles the anecdotal, and fixes for ever the most ephemeral, fragile look. Vermeer, therefore, is not a classic; he is, rather, one of the most modern of seventeenth-century artists, precisely because of his mystery, because of his slight doubts about reality, concealed beneath an absolute absence of emphasis, an obsessive exactness in detail – an obsession which derives from his scientific interest in the discovery of a little microscope made in those same years by his fellow citizen and friend Anthony van Leeuwenhoek.

L. TRUCCHI, "Vermeer e l'arbitrio del colore," in *La fiera letteraria*, 1966

The paintings in color

List of plates

In the captions underneath the color plates the width (in centimeters) of the ensemble of of the detail from it is given

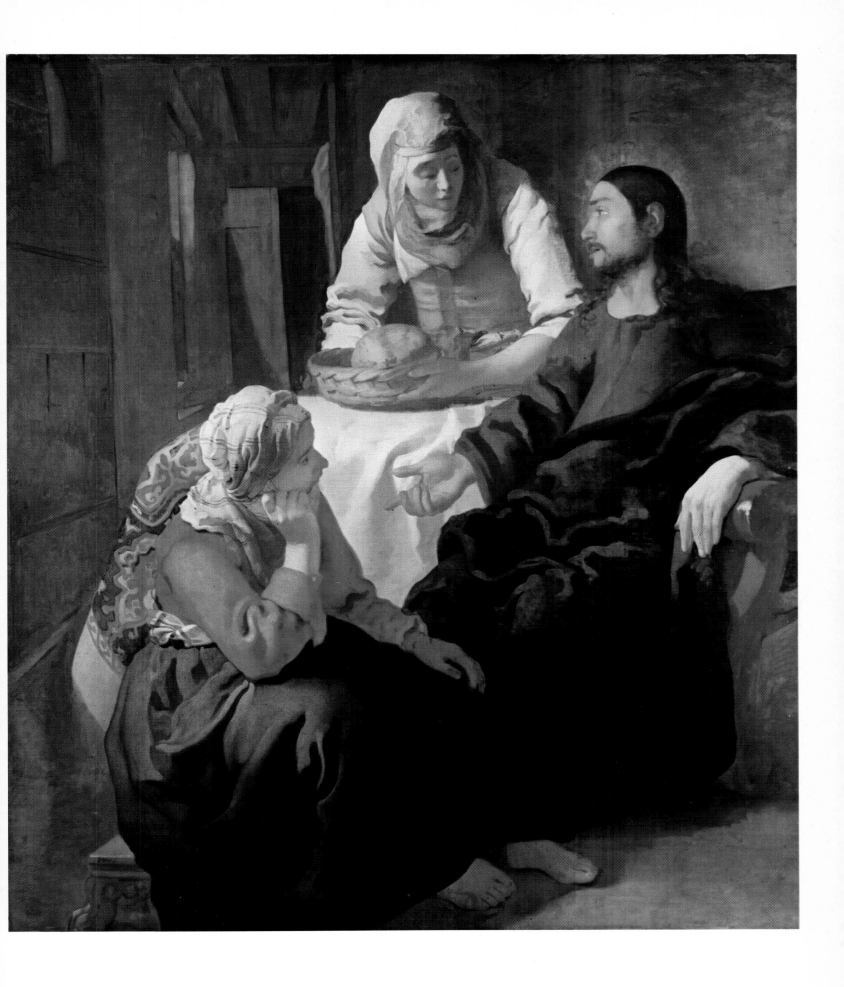

PLATE I CHRIST IN THE HOUSE OF MARTHA AND MARY Edinburgh, National Gallery of Scotland
Whole (141 cm.)

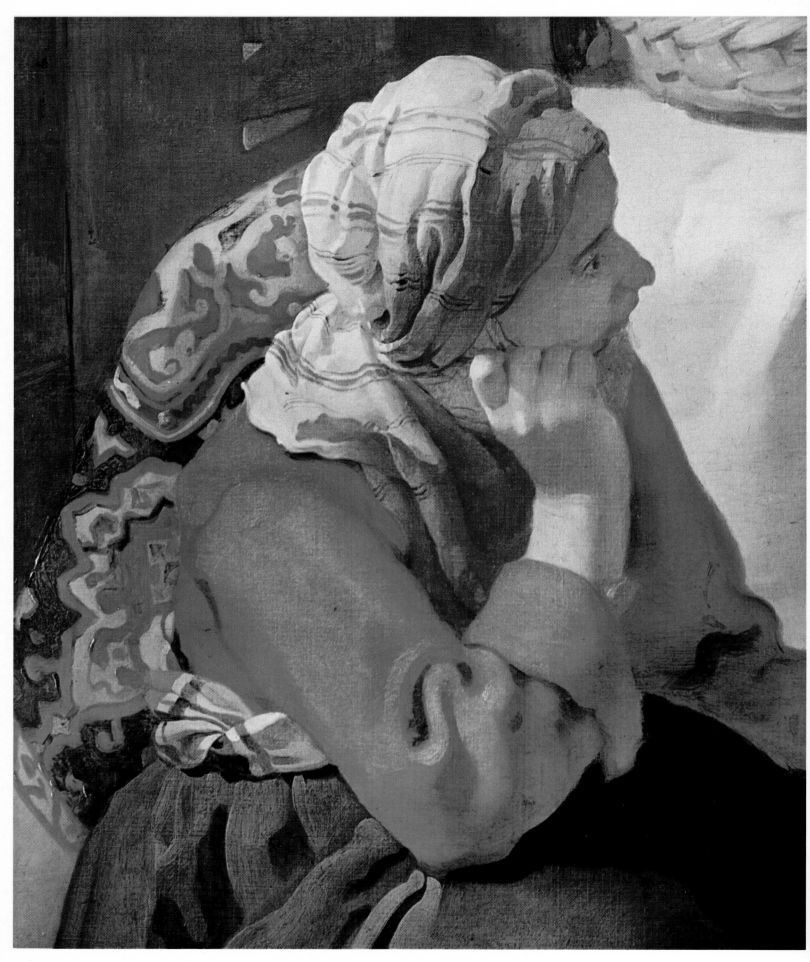

PLATE II CHRIST IN THE HOUSE OF MARTHA AND MARY Edinburgh, National Gallery of Scotland
Detail (51 cm.)

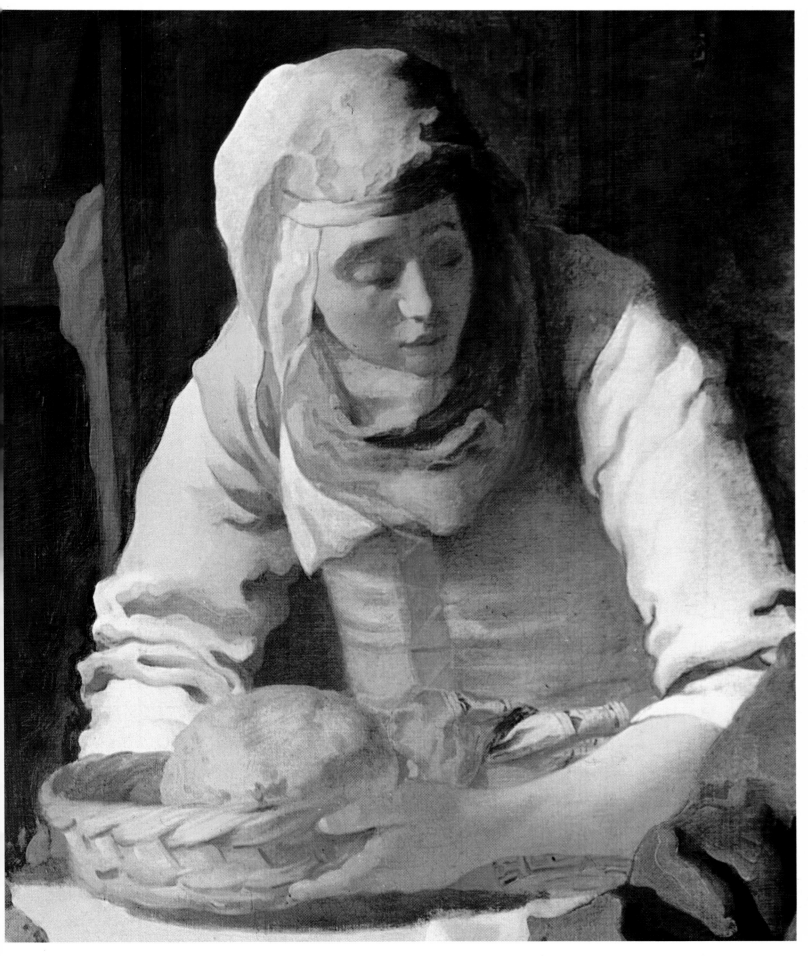

PLATE III CHRIST IN THE HOUSE OF MARTHA AND MARY Edinburgh, National Gallery of Scotland
Detail (51 cm.)

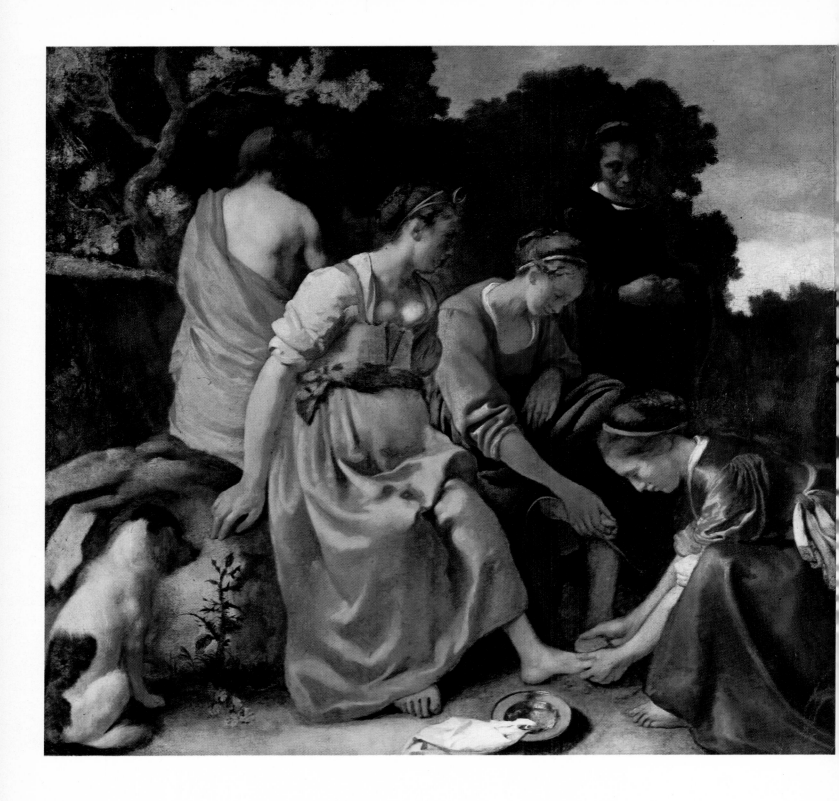

PLATE IV THE TOILET OF DIANA The Hague, Mauritshuis
Whole (105 cm.)

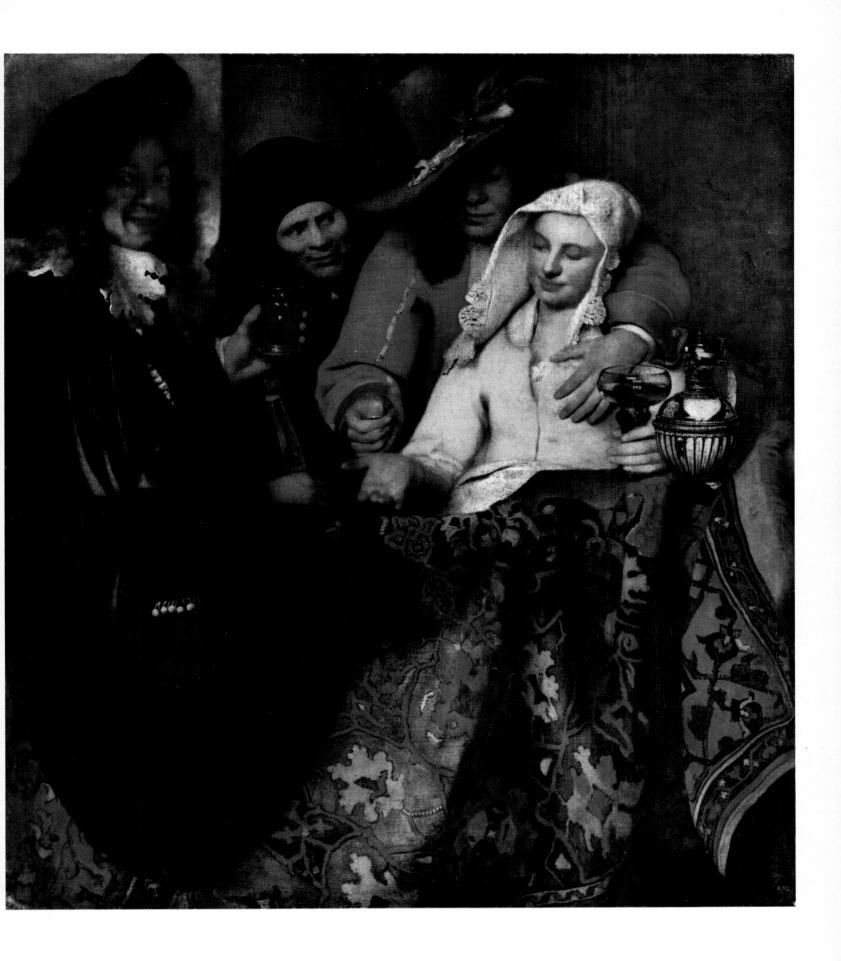

PLATE V AT THE PROCURESS'S Dresden, Gemäldegalerie
Whole (130 cm.)

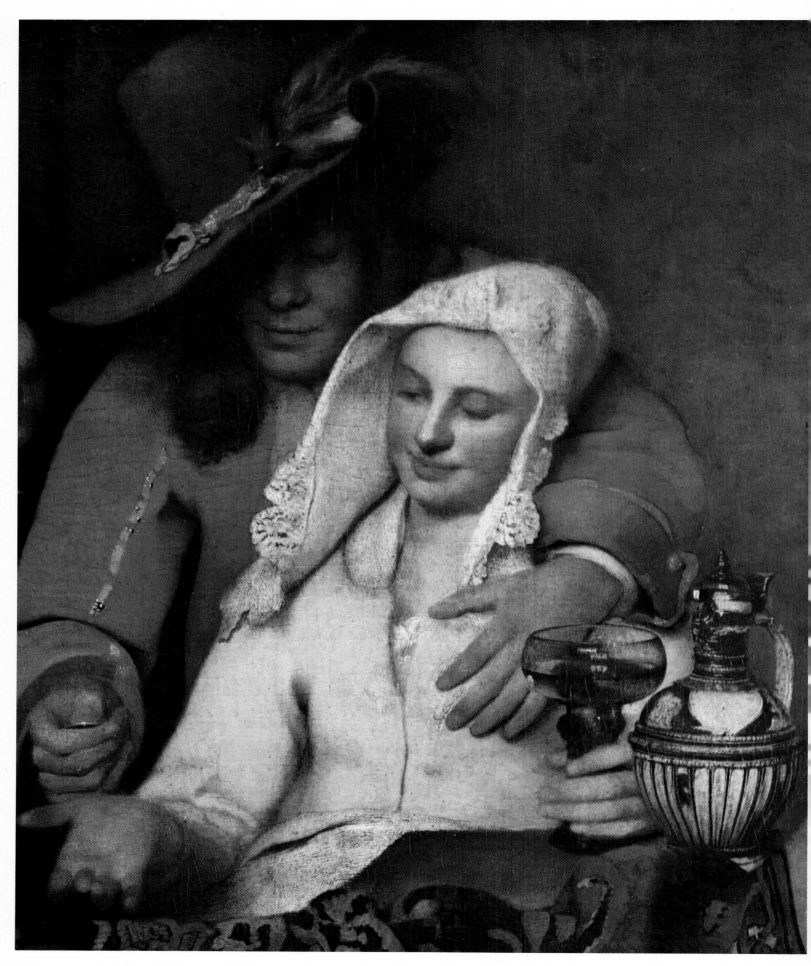

PLATE VI AT THE PROCURESS'S Dresden, Gemäldegalerie
Detail (66 cm.)

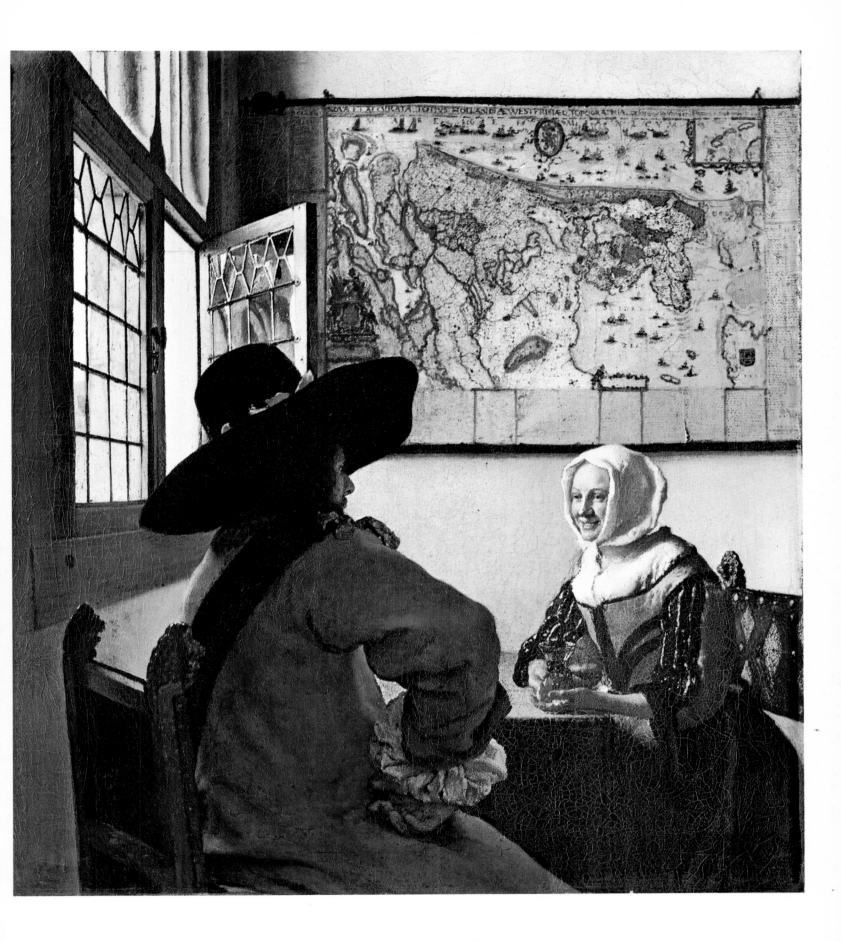

PLATE VII SOLDIER AND YOUNG GIRL SMILING New York, Frick Collection
Whole (43 cm.)

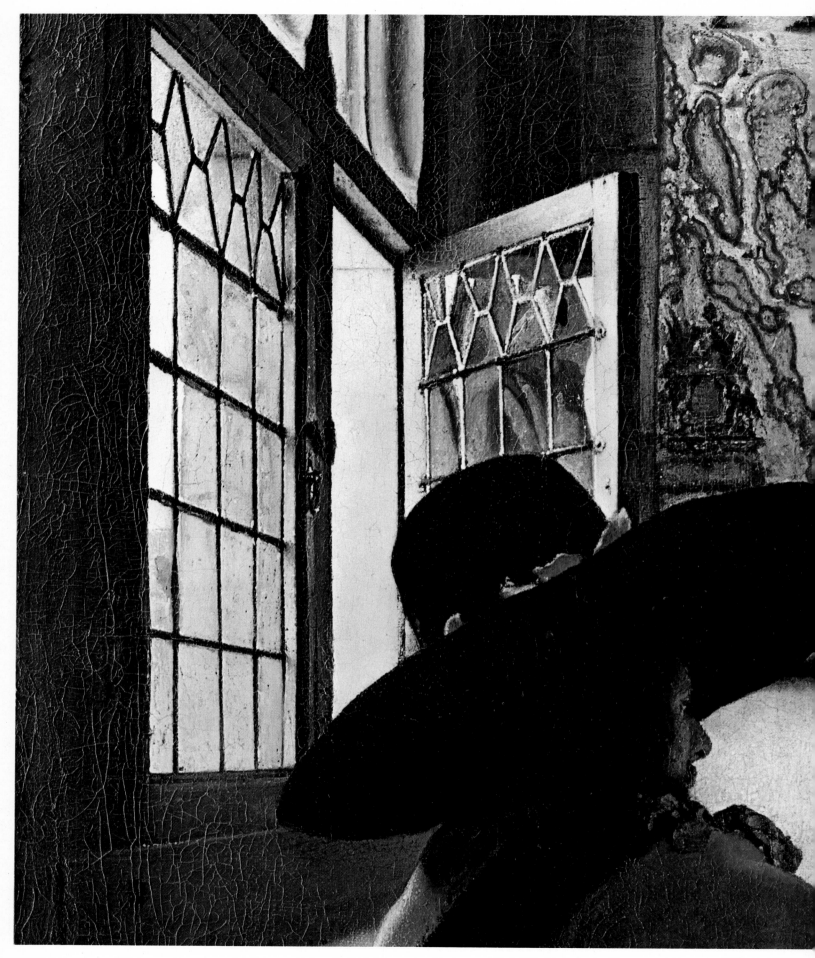

PLATES VIII-IX SOLDiER AND YOUNG GIRL SMILING New York, Frick Collection
Detail (life size)

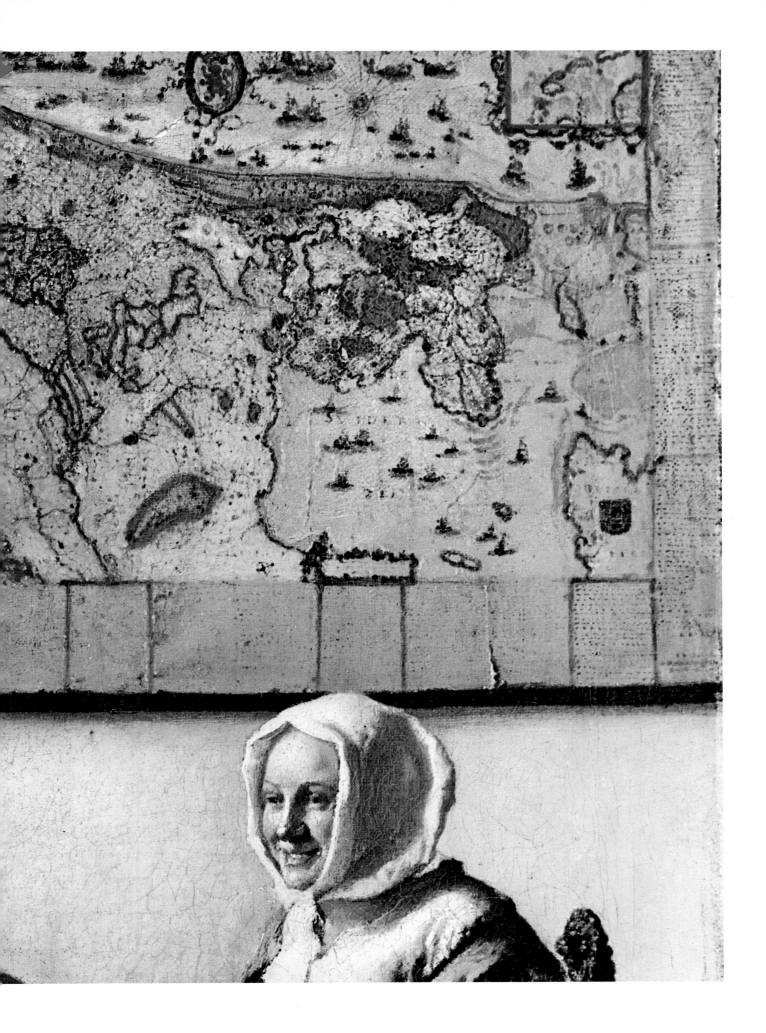

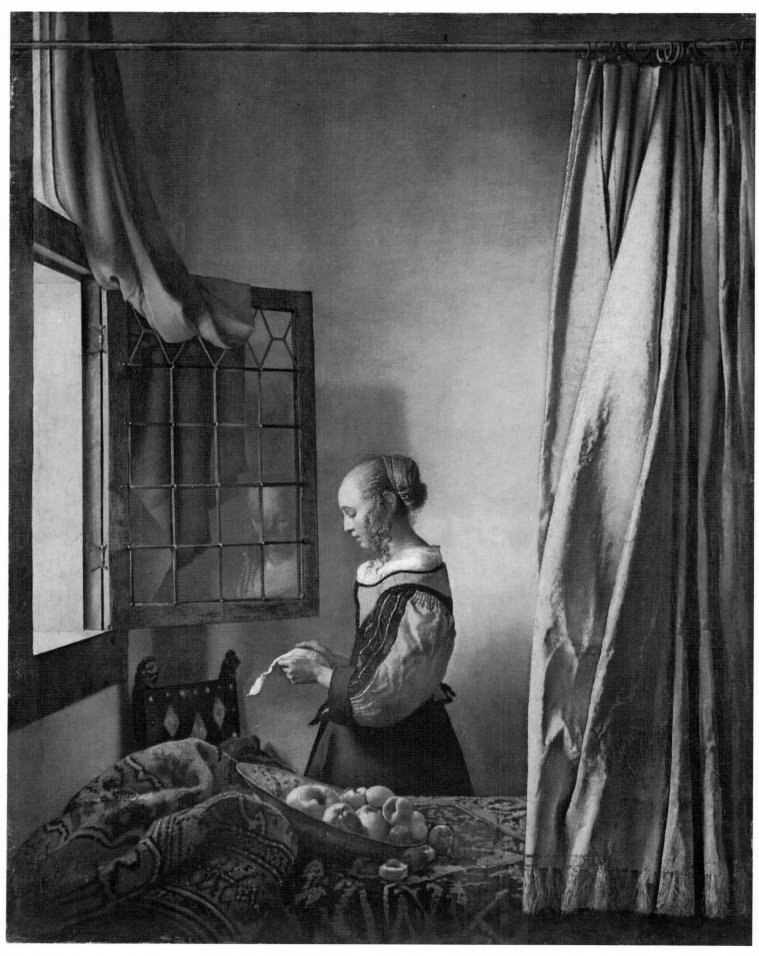

PLATE X GIRL READING A LETTER NEAR THE WINDOW Dresden, Gemäldegalerie
Whole (64.5 cm.)

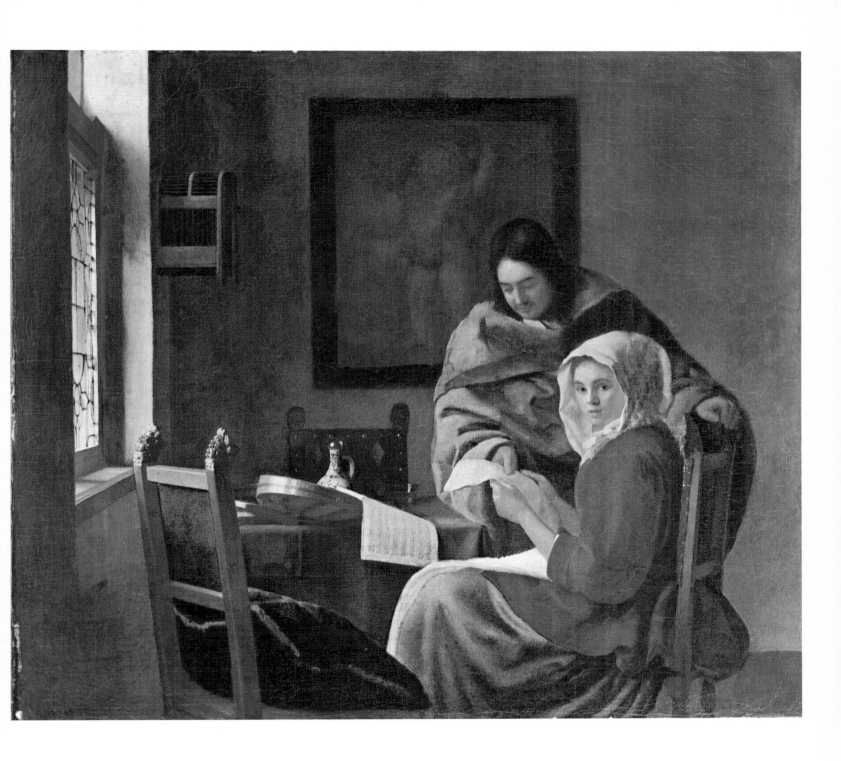

PLATE XI GENTLEMAN AND GIRL WITH MUSIC New York, Frick Collection
Whole (44.5 cm.)

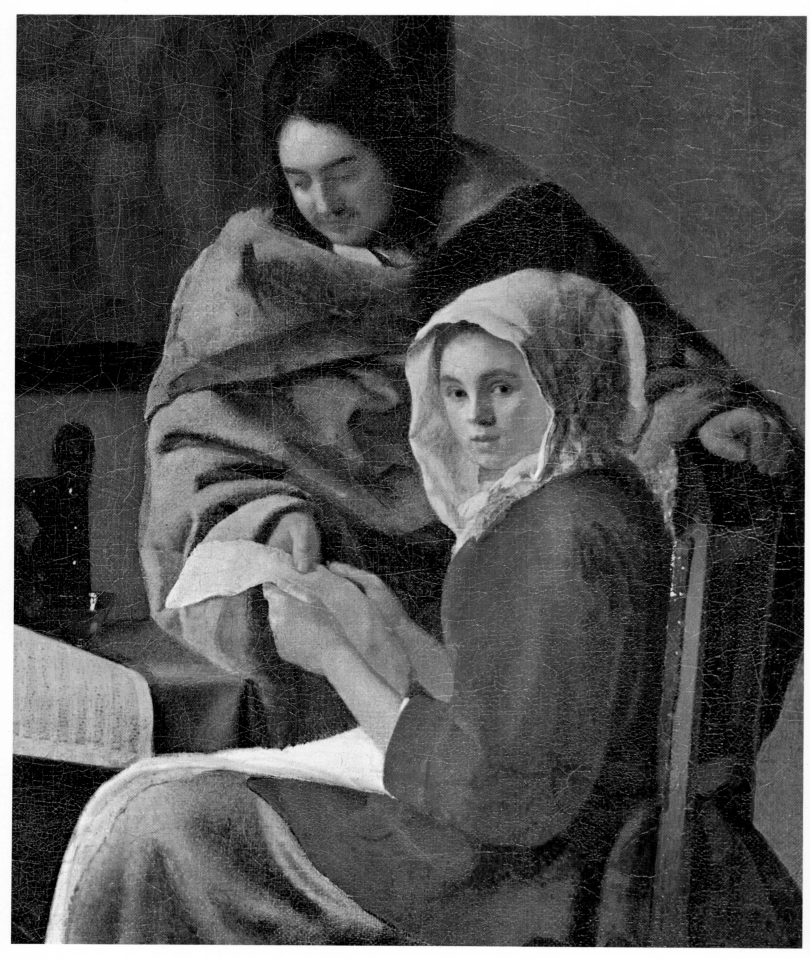

PLATE XII GENTLEMAN AND GIRL WITH MUSIC New York, Frick Collection
Detail (life size)

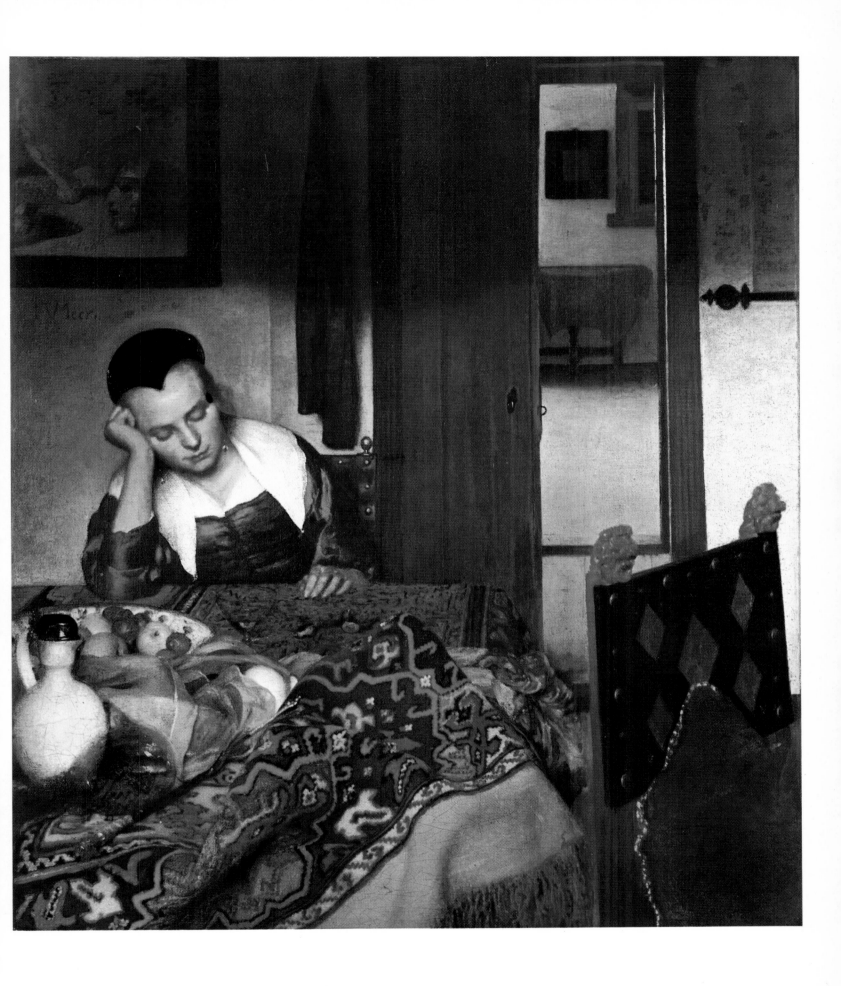

PLATE XIII GIRL ASLEEP New York, Metropolitan Museum
Whole (76.5 cm.)

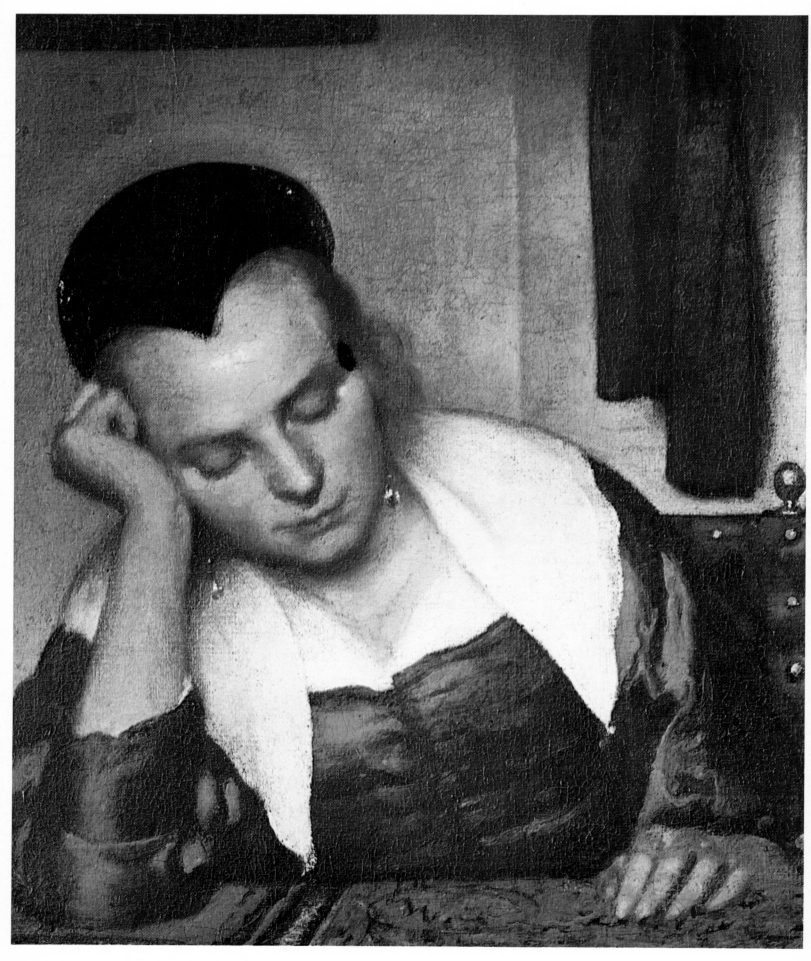

PLATE XIV GIRL ASLEEP New York, Metropolitan Museum
Detail (27 cm.)

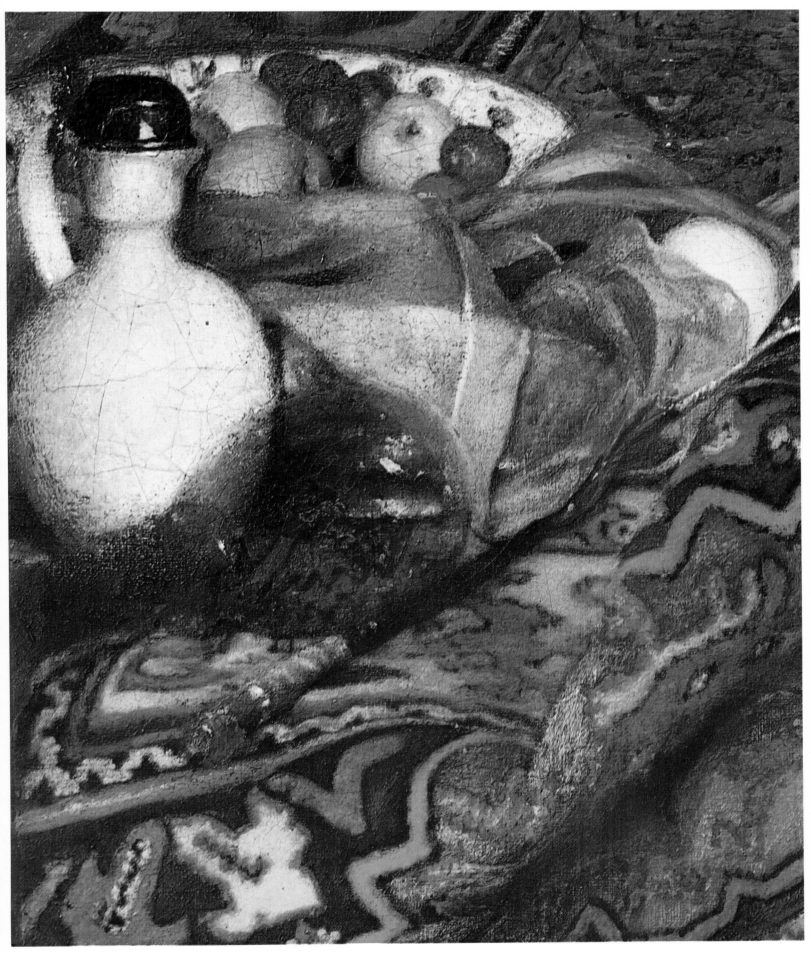

PLATE XV GIRL ASLEEP New York, Metropolitan Museum
Detail (27 cm.)

PLATE XVI GIRL ASLEEP New York, Metropolitan Museum
Detail (42.5 cm.)

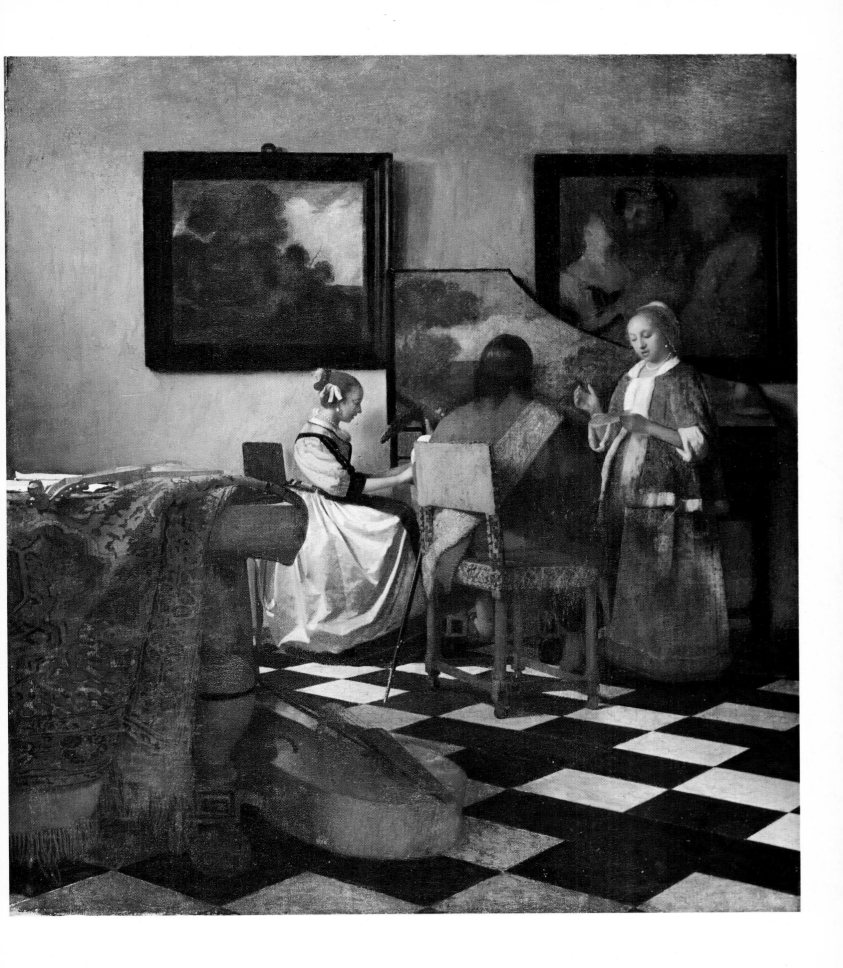

PLATE XVII CONCERT TRIO Boston, Isabella Stewart Gardner Museum
Whole (62.8 cm.)

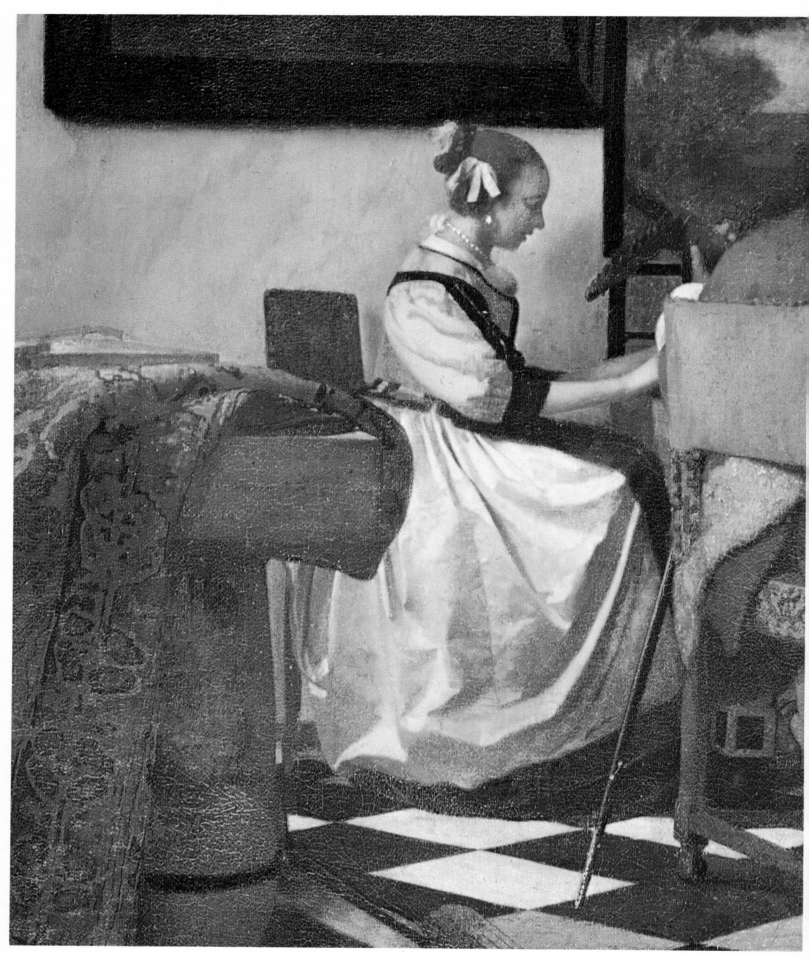

PLATE XVIII CONCERT TRIO Boston, Isabella Stewart Gardner Museum
Detail (27 cm.)

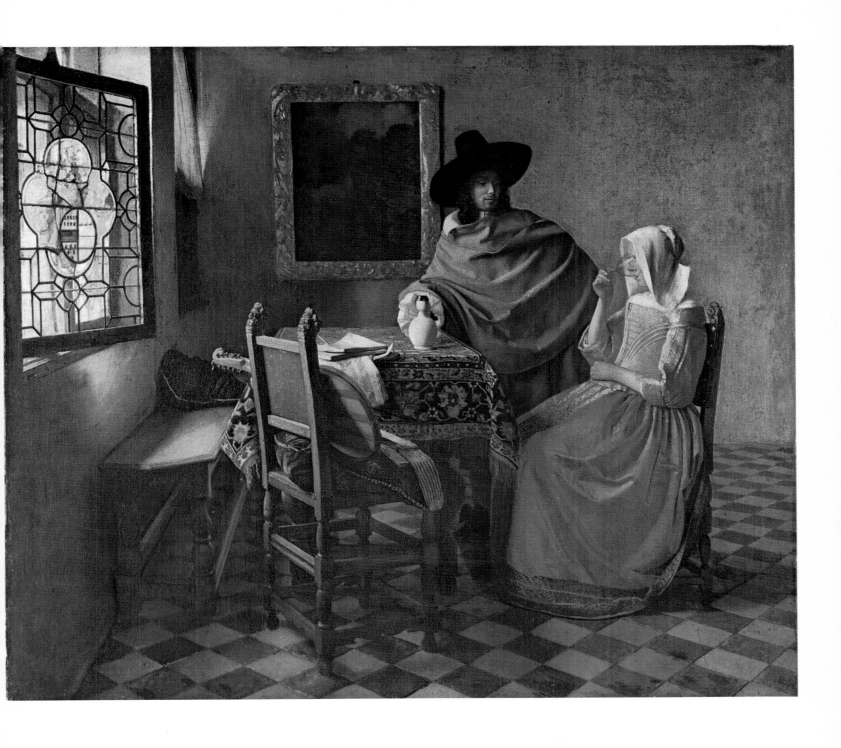

PLATE XIX GENTLEMAN AND WOMAN DRINKING Berlin, Staatliche Museen
Whole (76.5 cm.)

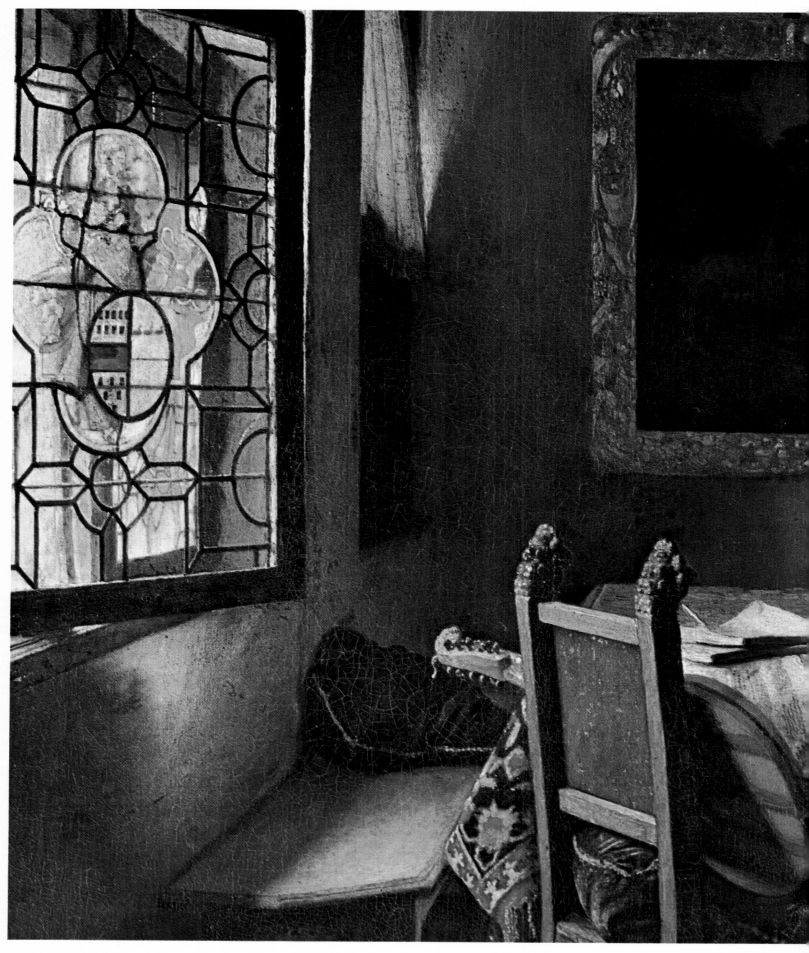

PLATES XX-XXI GENTLEMAN AND WOMAN DRINKING Berlin, Staatliche Museen
Detail (69 cm.)

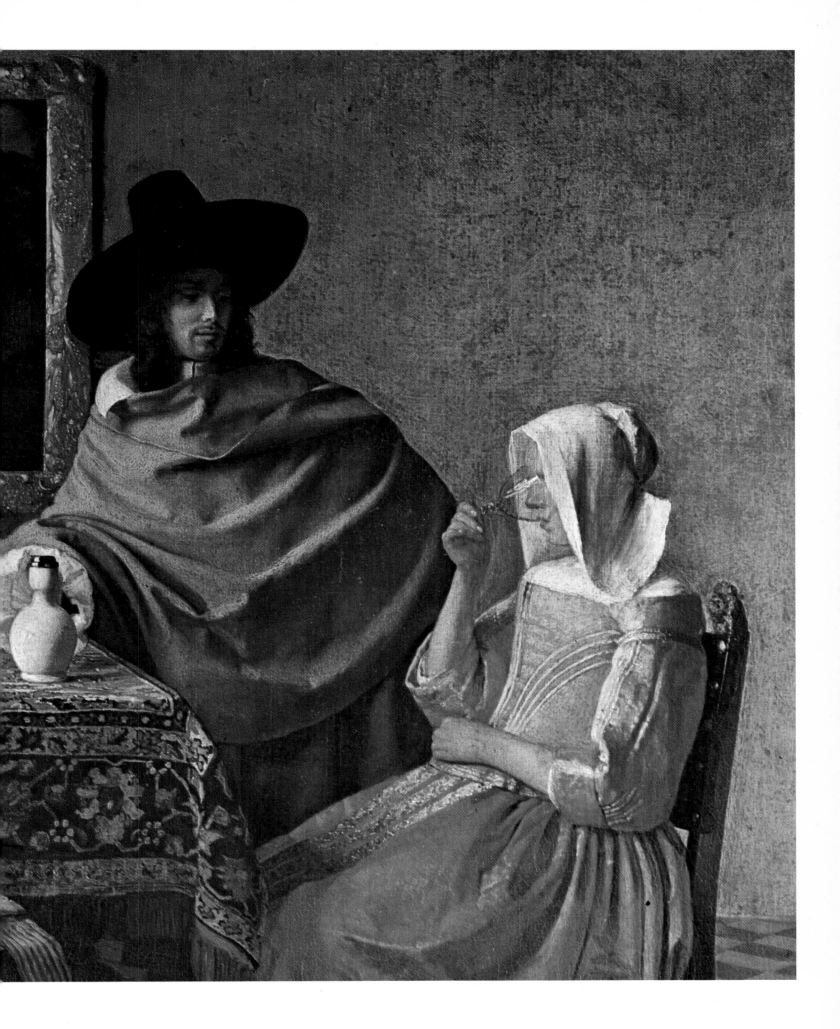

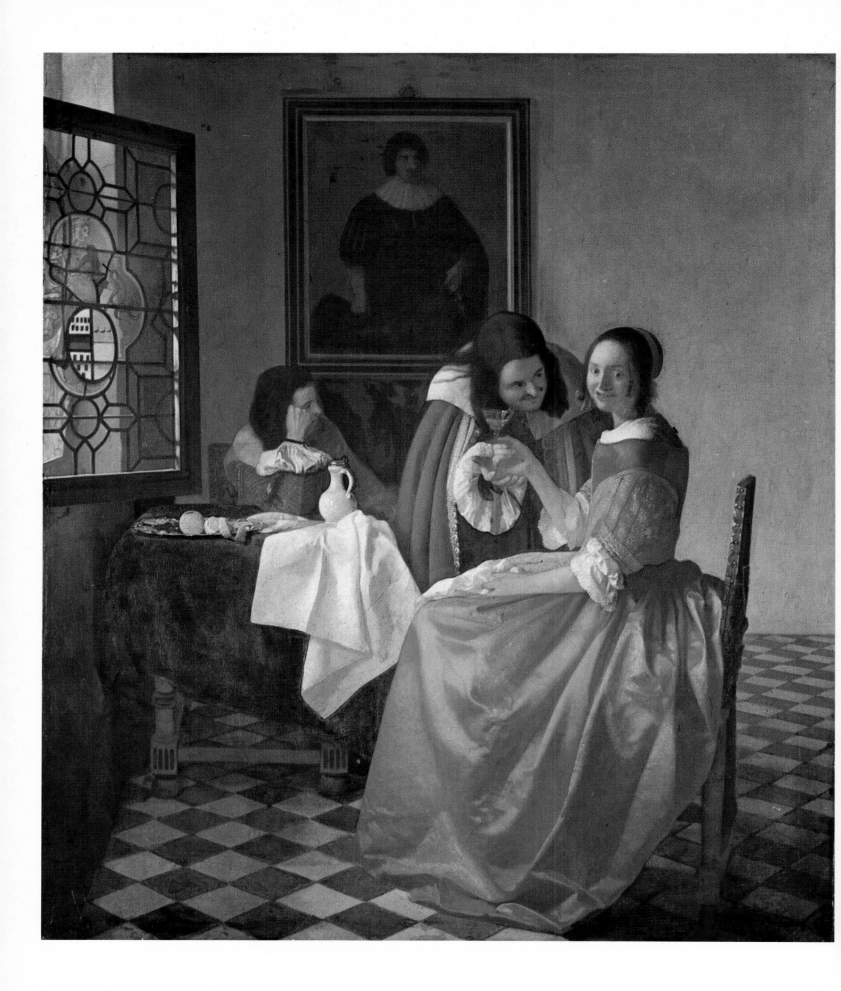

PLATE XXII THE 'COQUETTE' Brunswick, Herzog Anton Ulrich-Museum
Whole (67.5 cm.)

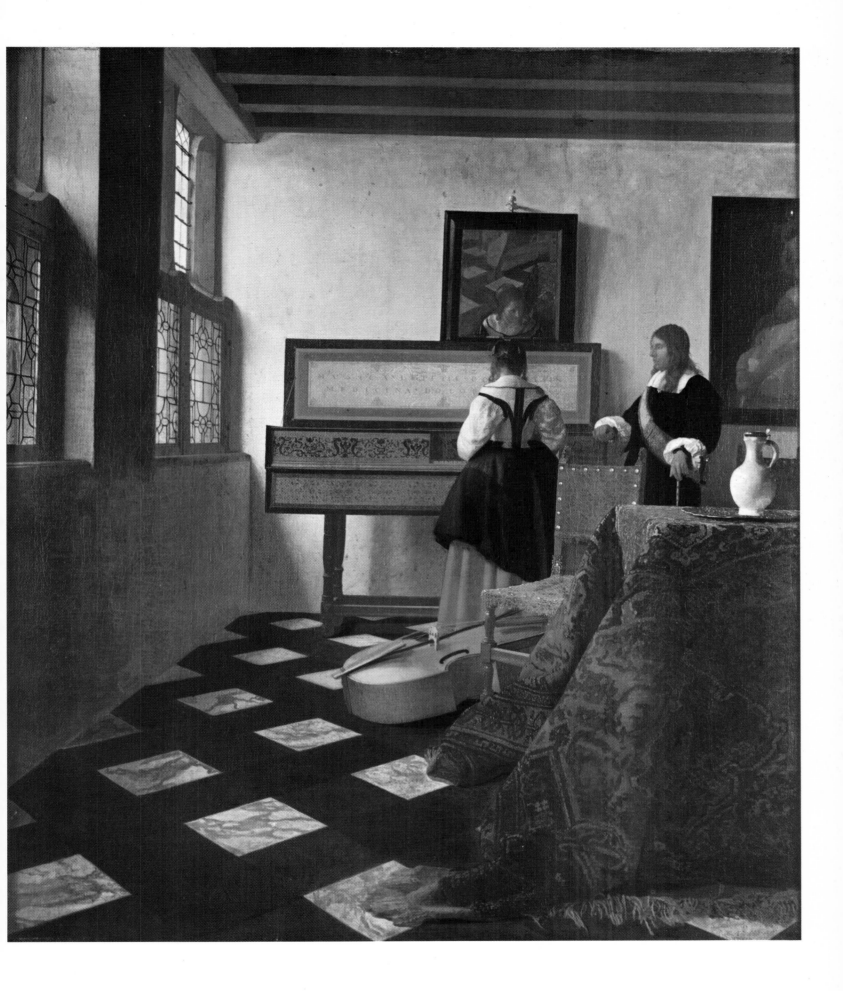

PLATE XXIII LADY AT THE VIRGINALS WITH A GENTLEMAN London, Buckingham Palace
Whole (64.1 cm.)

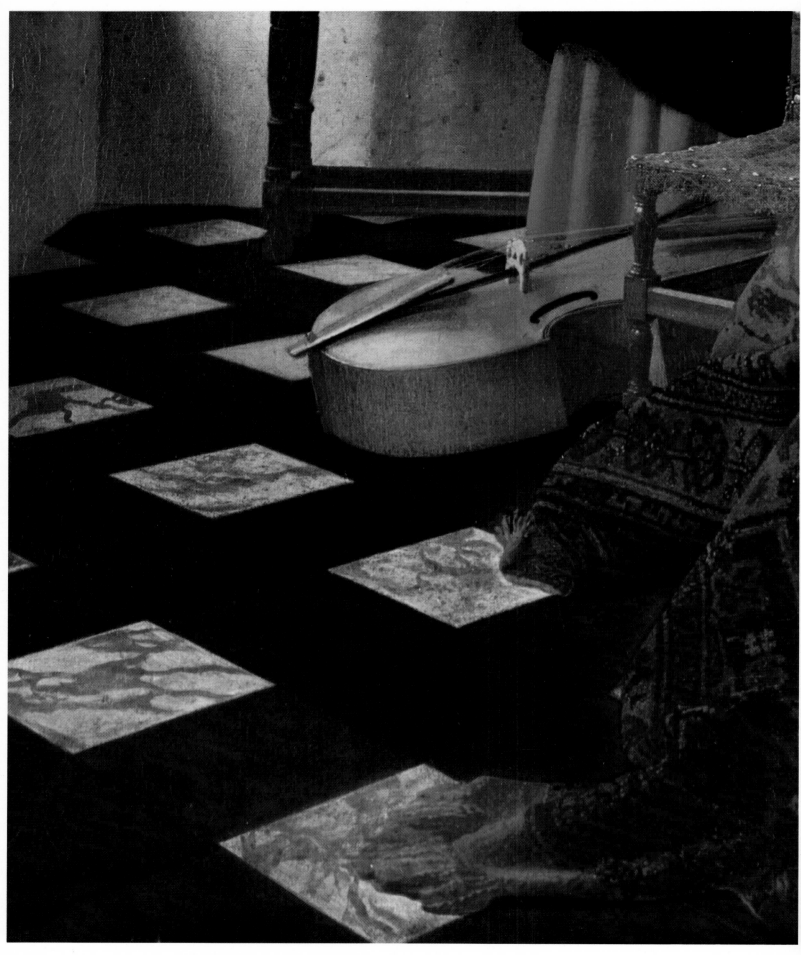

PLATE XXIV LADY AT THE VIRGINALS WITH A GENTLEMAN London, Buckingham Palace
Detail (28 cm.)

PLATE XXV LADY AT THE VIRGINALS WITH A GENTLEMAN London, Buckingham Palace
Detail (28 cm.)

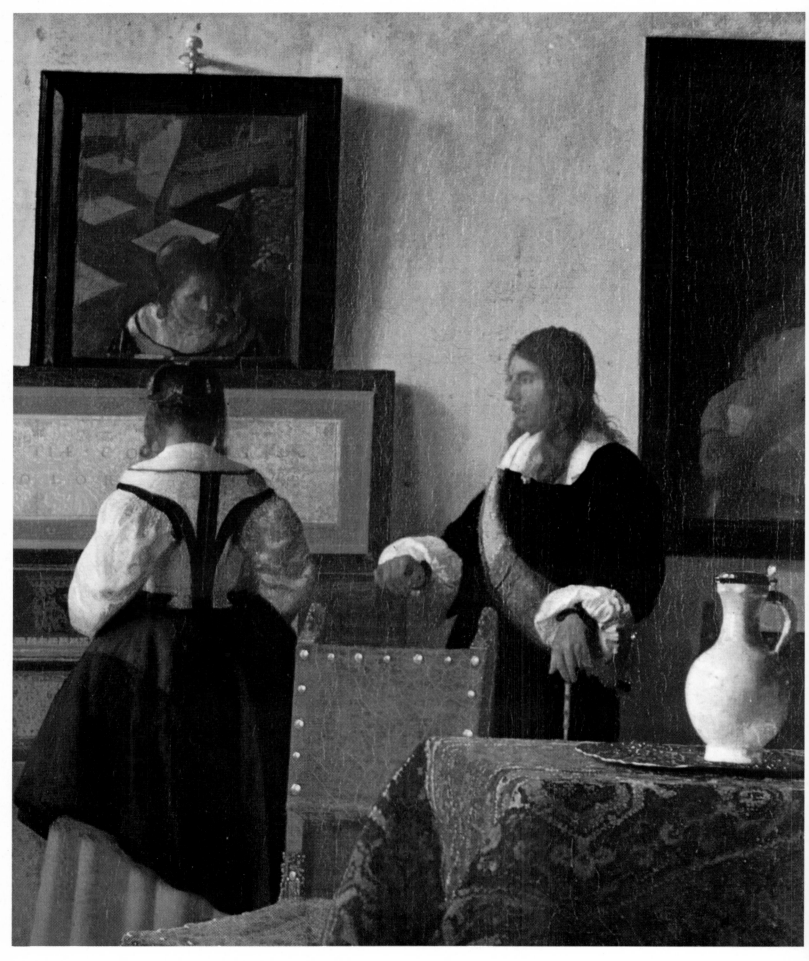

PLATE XXVI LADY AT THE VIRGINALS WITH A GENTLEMAN London, Buckingham Palace
Detail (28 cm.)

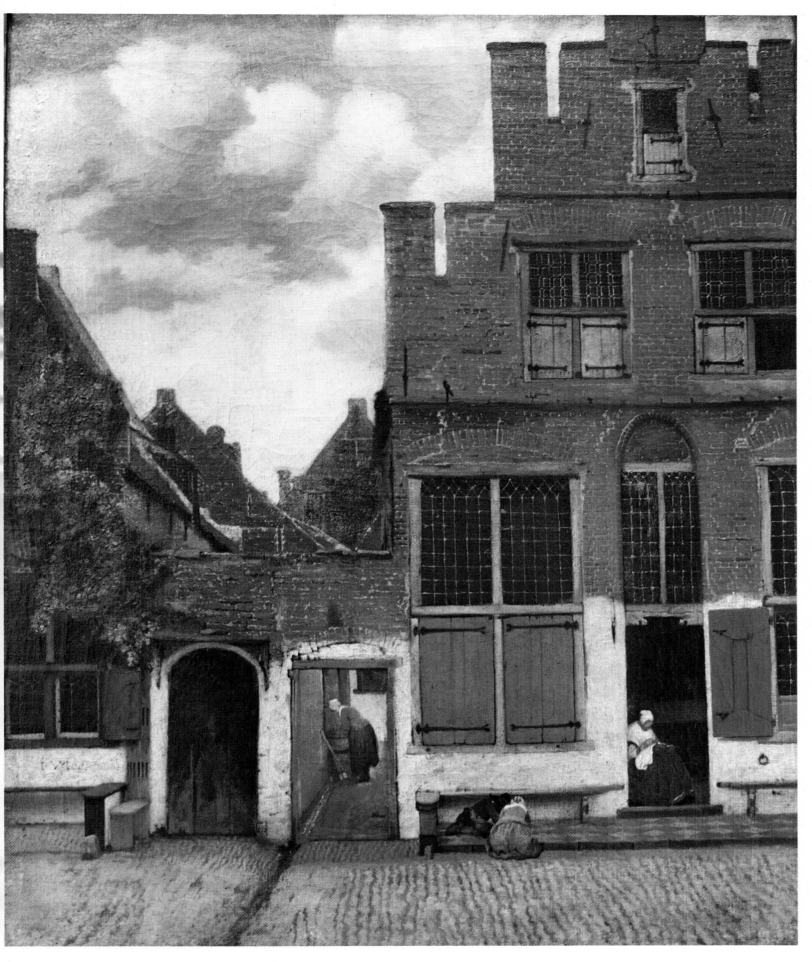

PLATE XXVII THE STREET Amsterdam, Rijksmuseum
Whole (44 cm.)

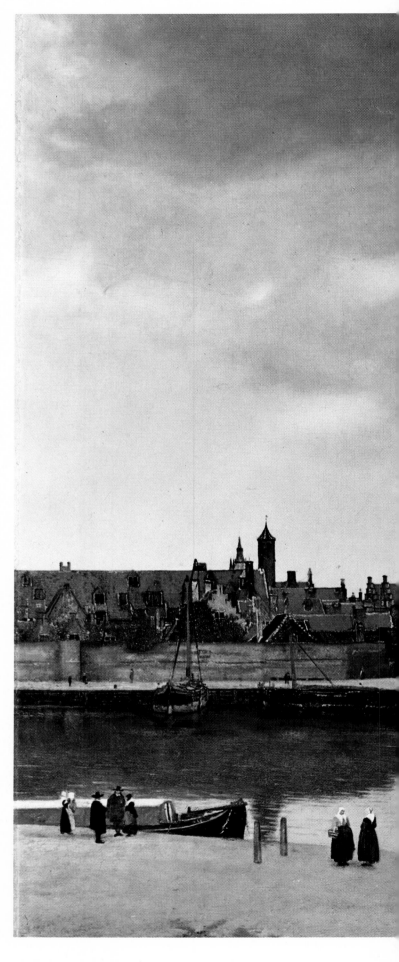

PLATES XXVIII-XXIX

VIEW OF DELFT The Hague, Mauritshuis
Whole (118.5 cm.)

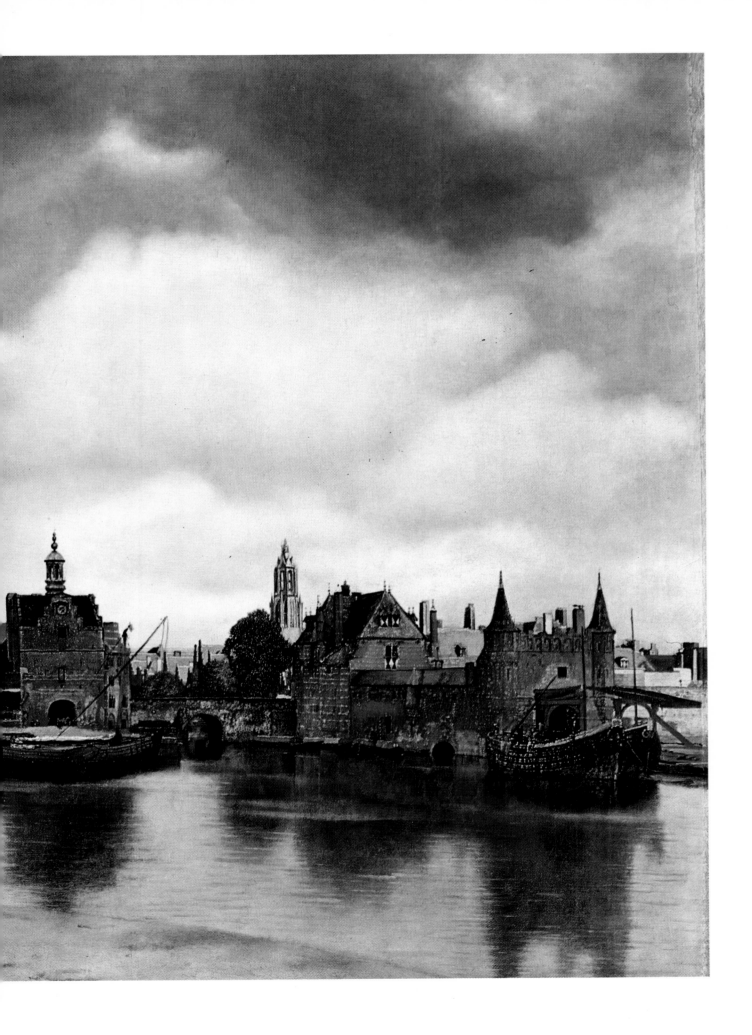

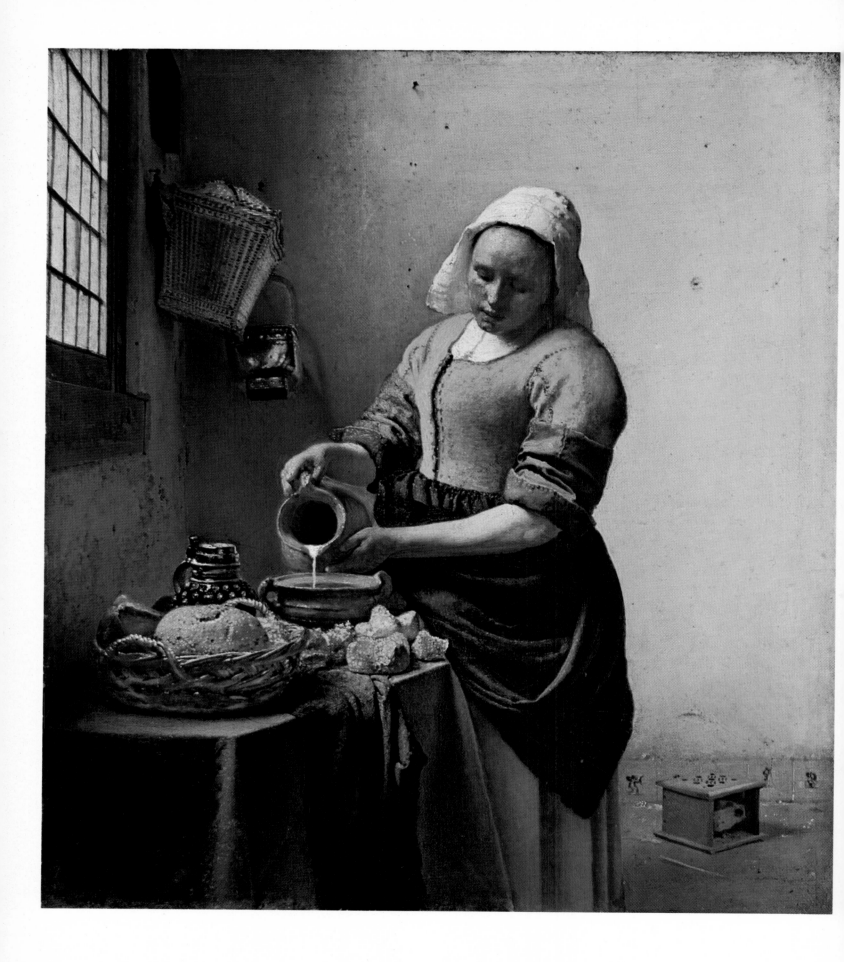

PLATE XXX MILKMAID Amsterdam, Rijksmuseum
Whole (41 cm.)

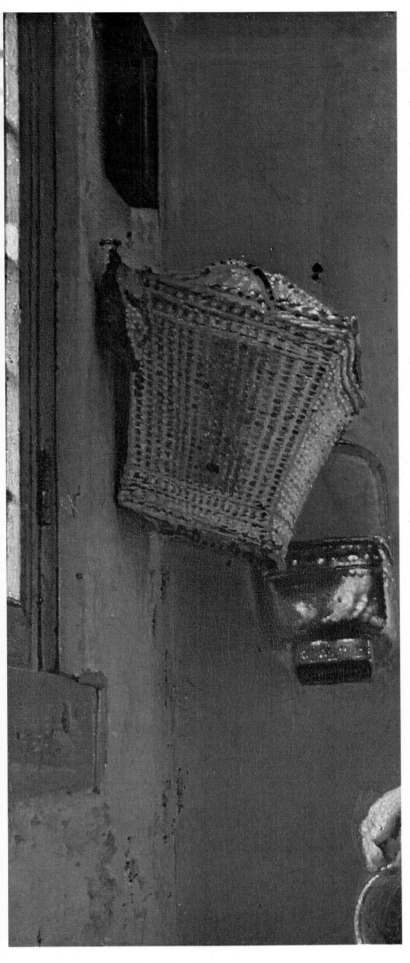

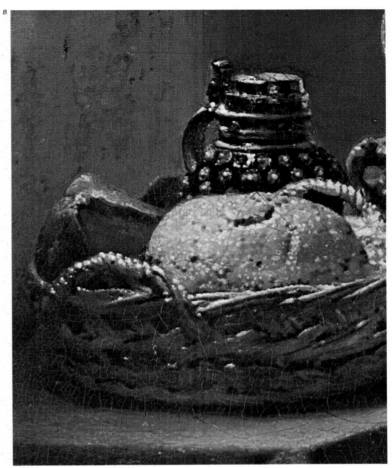

PLATE XXXI MILKMAID Amsterdam, Rijksmuseum
Details (each one life size)

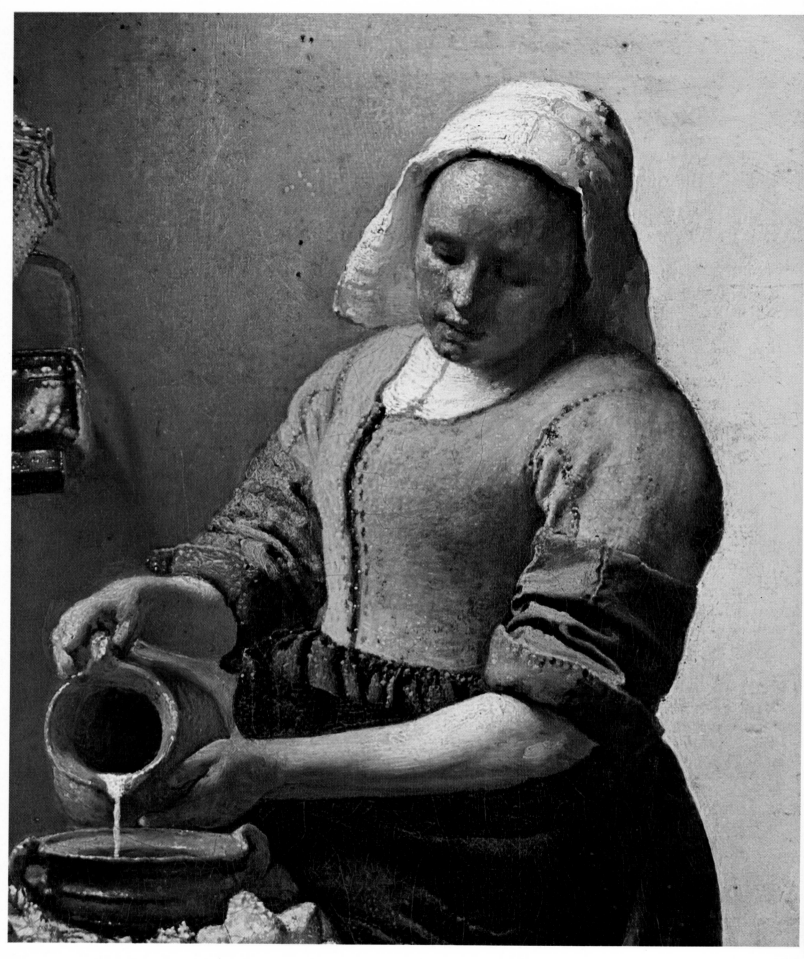

PLATE XXXII MILKMAID Amsterdam, Rijksmuseum
Detail (life size)

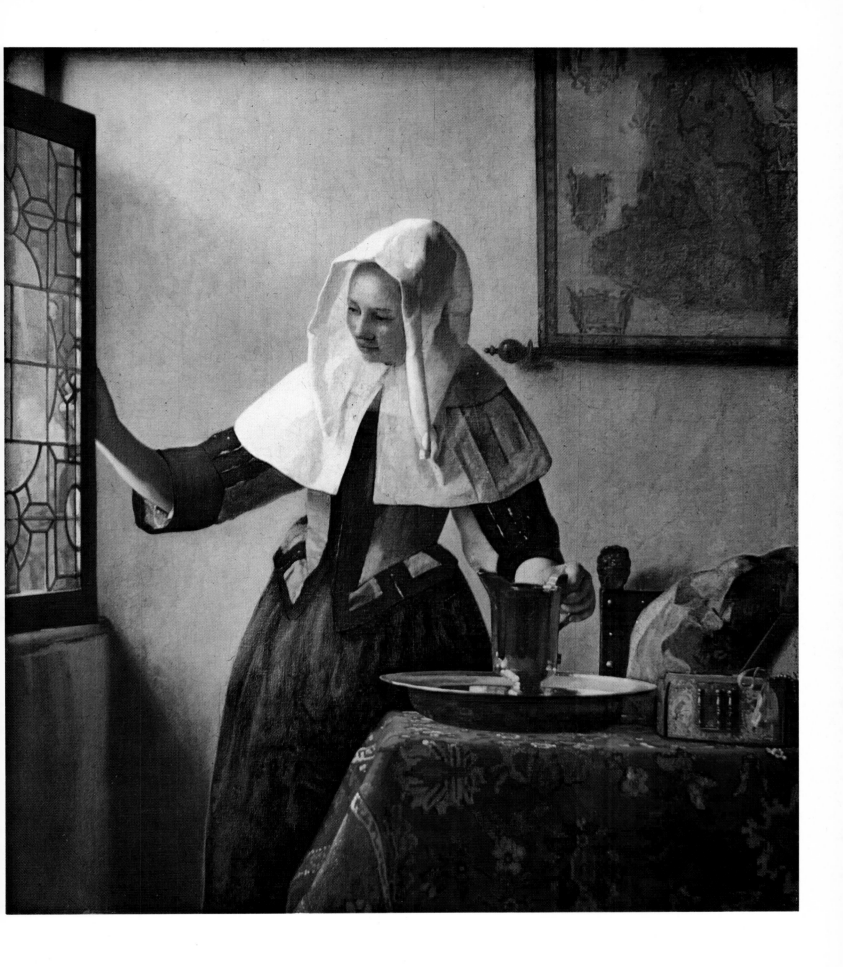

PLATE XXXIII WOMAN WITH A WATER JUG New York, Metropolitan Museum
Whole (40.5 cm.)

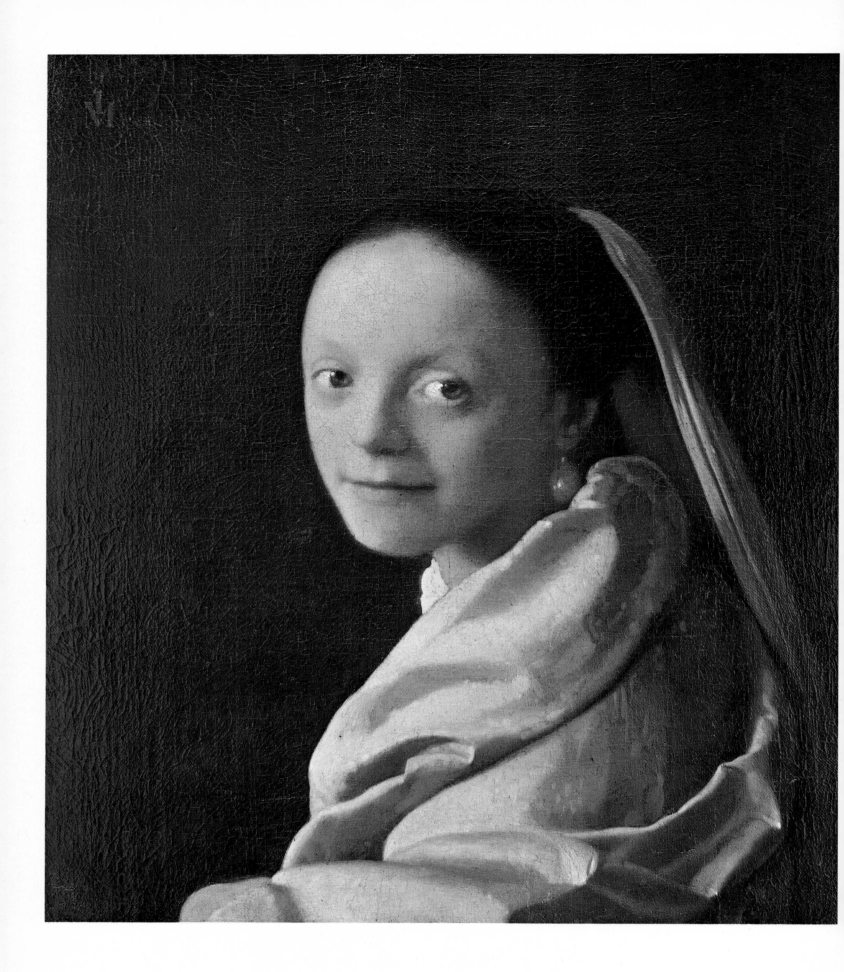

PLATE XXXIV GIRL WITH A VEIL Palm Beach, C. B. Wrightsman Collection
Whole (40 cm.)

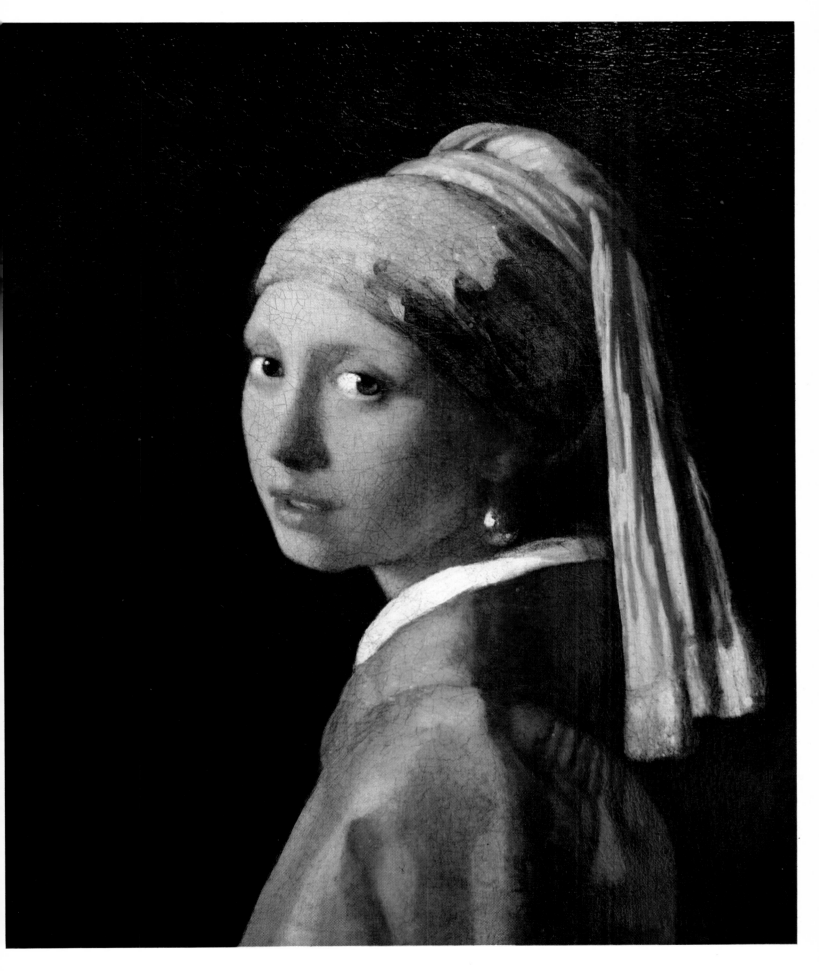

PLATE XXXV GIRL WITH TURBAN The Hague, Mauritshuis
Whole (40 cm.)

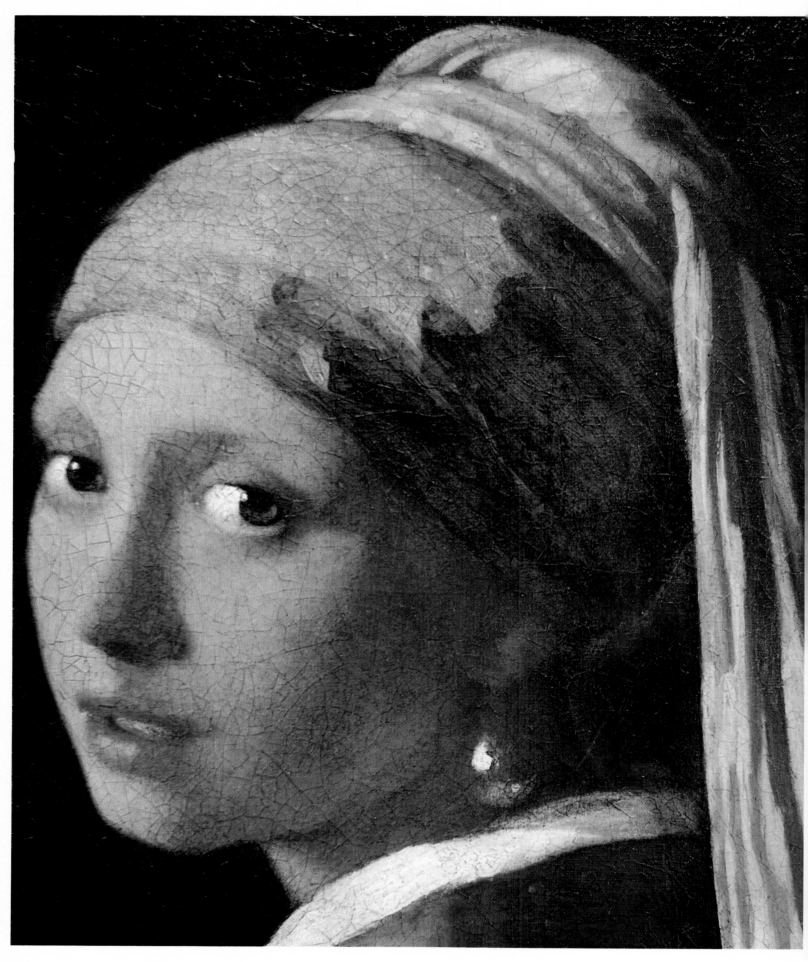

PLATE XXXVI GIRL WITH TURBAN The Hague, Mauritshuis
Detail (life size)

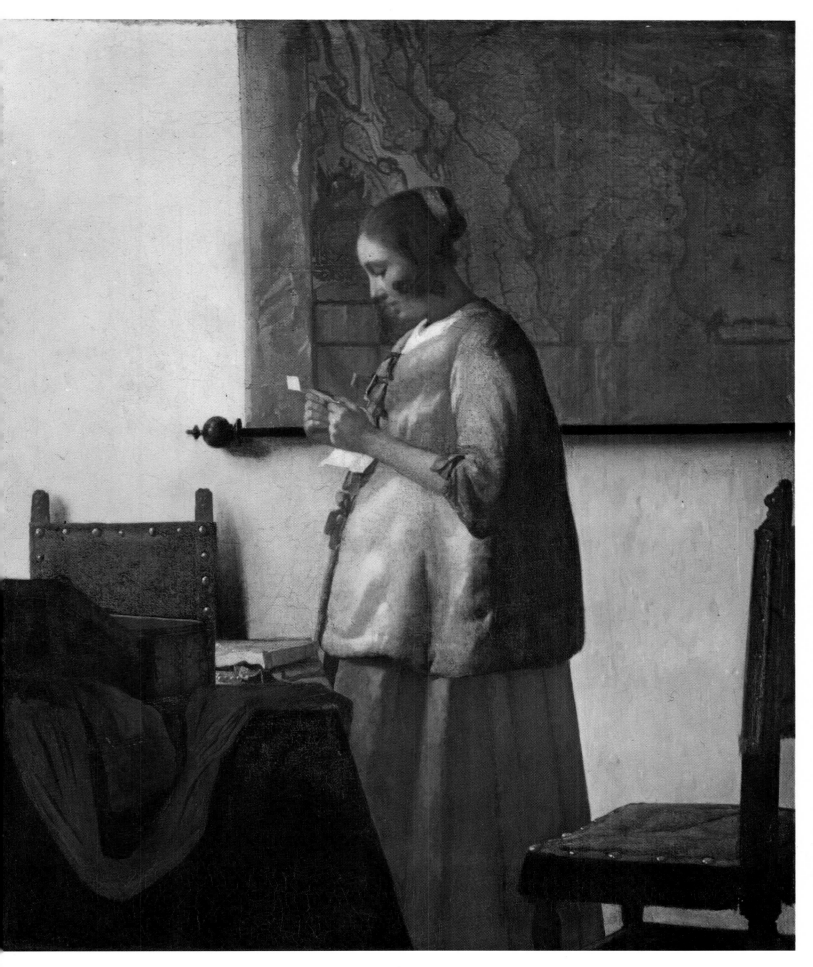

PLATE XXXVII WOMAN IN BLUE Amsterdam, Rijksmuseum
Whole (39 cm.)

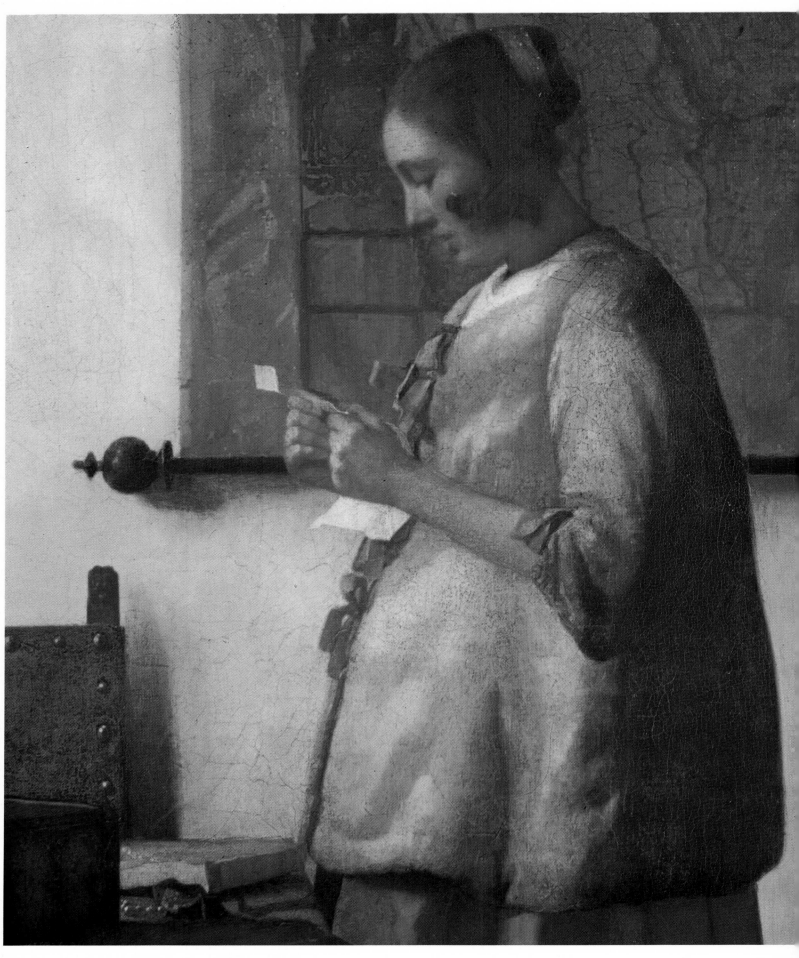

PLATE XXXVIII WOMAN IN BLUÈ Amsterdam, Rijksmuseum
Detail (life size)

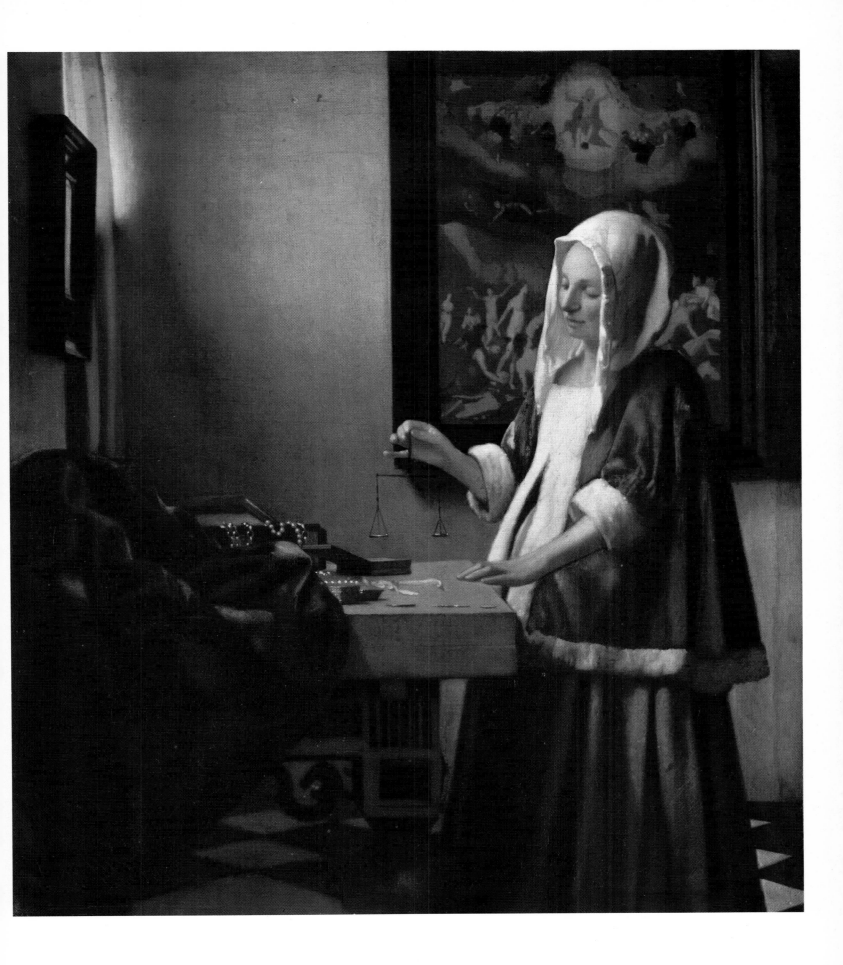

PLATE XXXIX WOMAN WEIGHING PEARLS Washington, National Gallery
Whole (38 cm.)

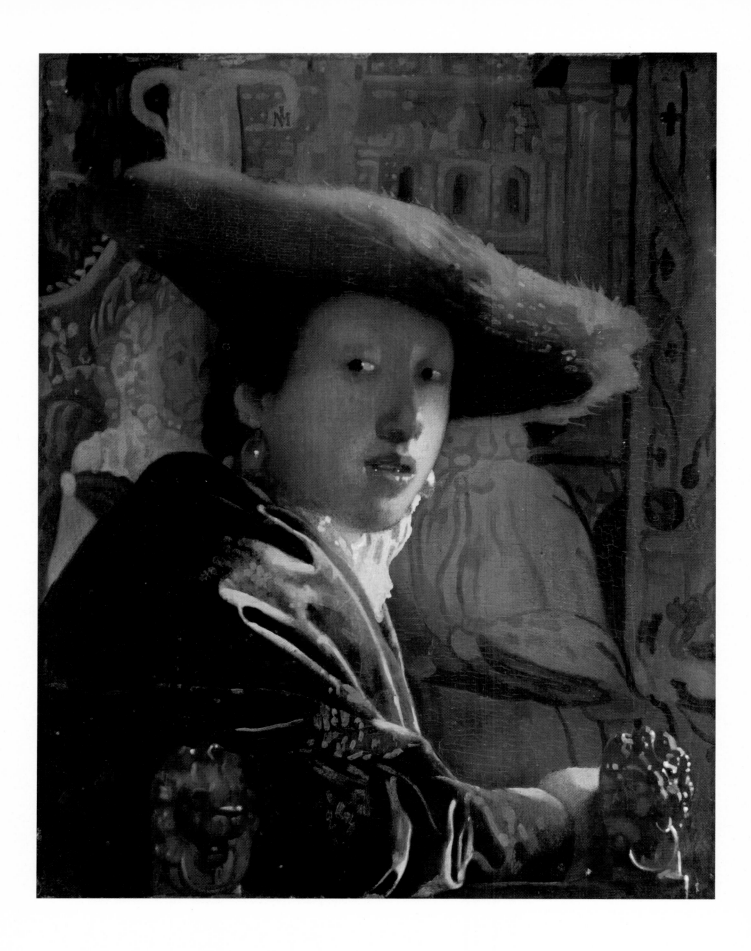

PLATE XL GIRL IN A RED HAT Washington, National Gallery
Whole (life size)

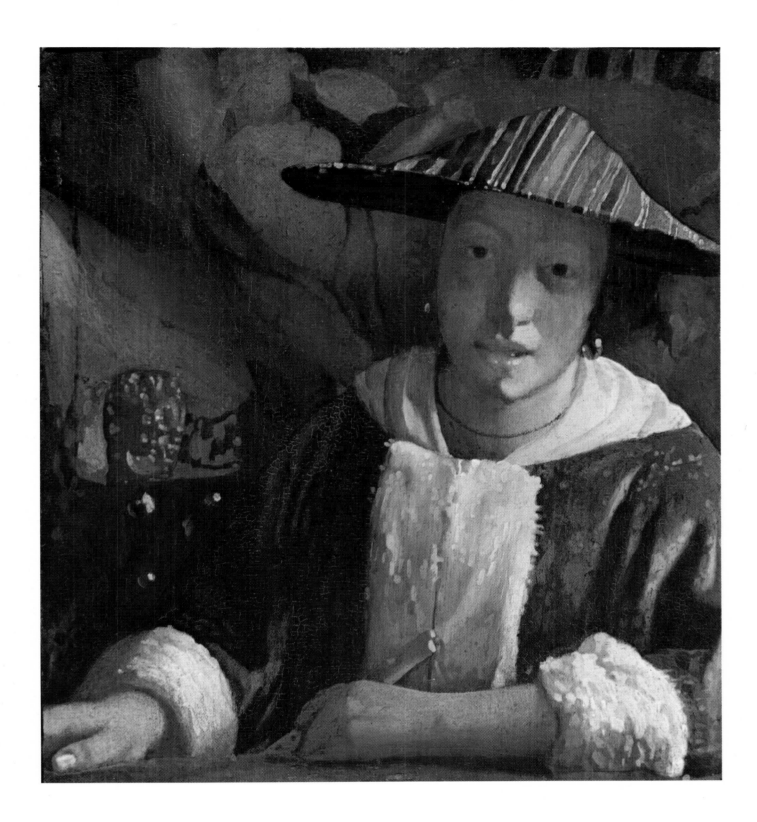

PLATE XLI GIRL WITH FLUTE Washington, National Gallery
Whole (life size)

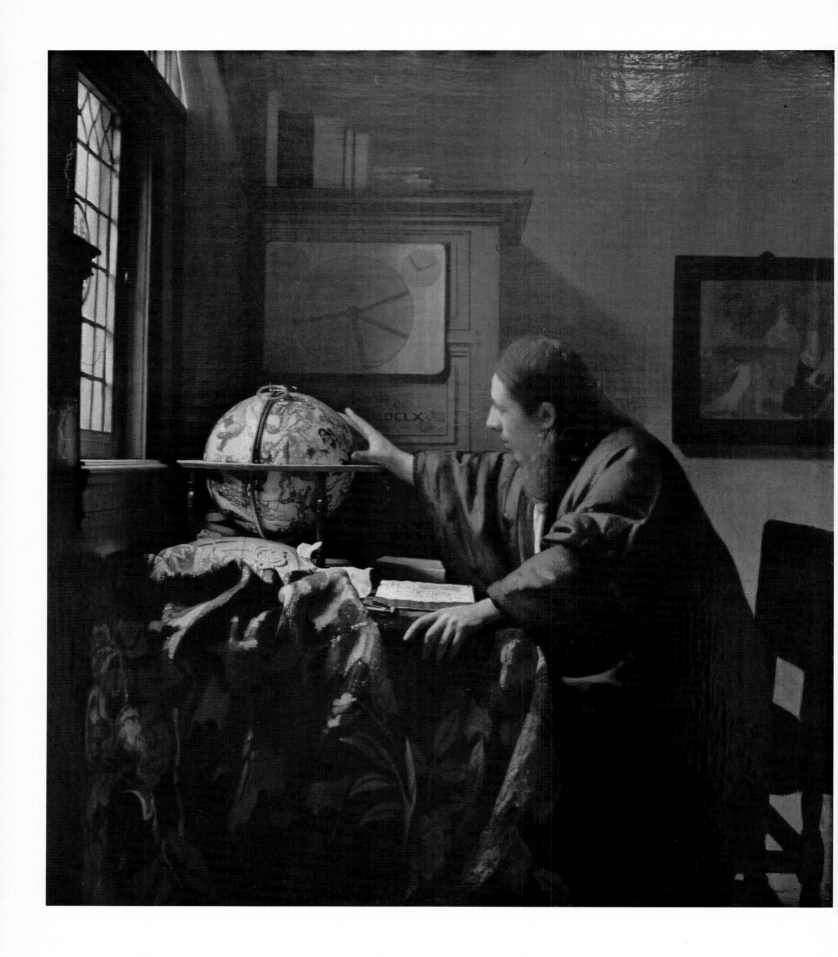

PLATE XLII THE ASTRONOMER Paris, Rothschild Collection?
Whole (46.3 cm.)

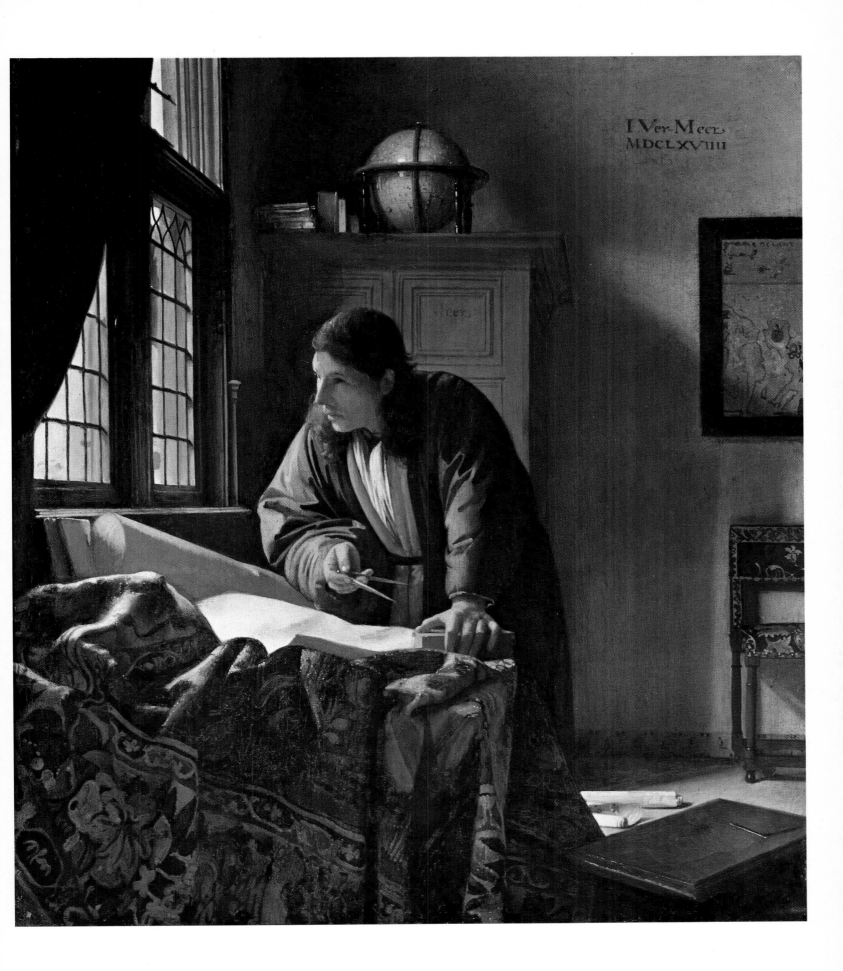

PLATE XLIII THE GEOGRAPHER Frankfurt, Städelsches Kunstinstitut
Whole (46.5 cm.)

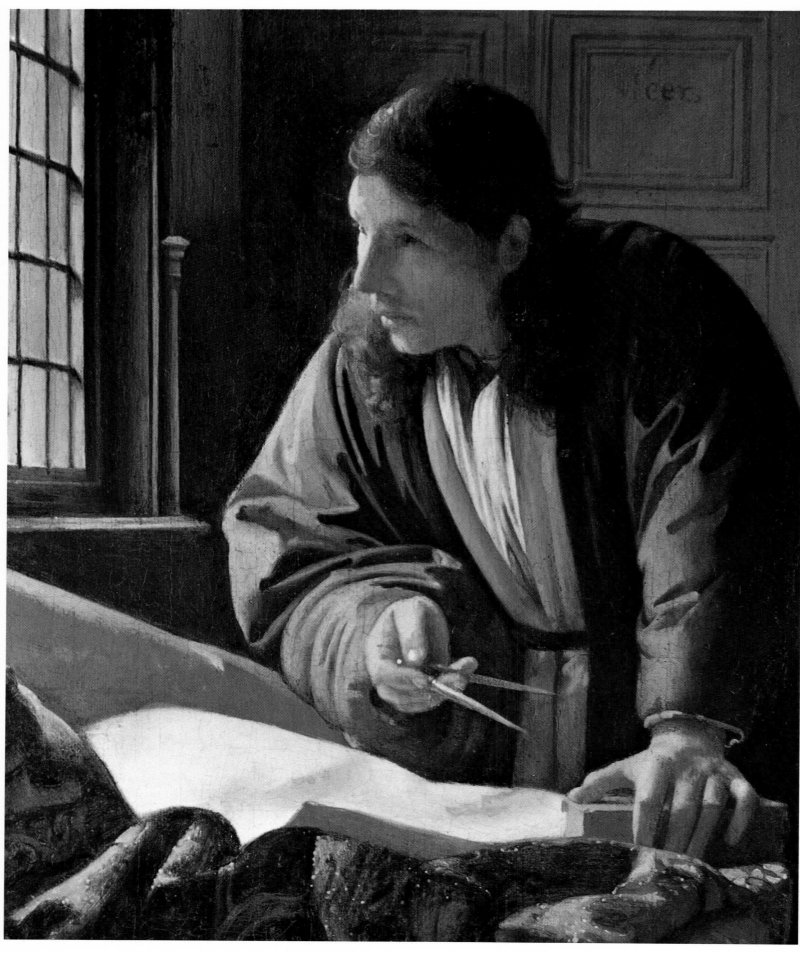

PLATE XLIV THE GEOGRAPHER Frankfurt, Städelsches Kunstinstitut
Detail (life size)

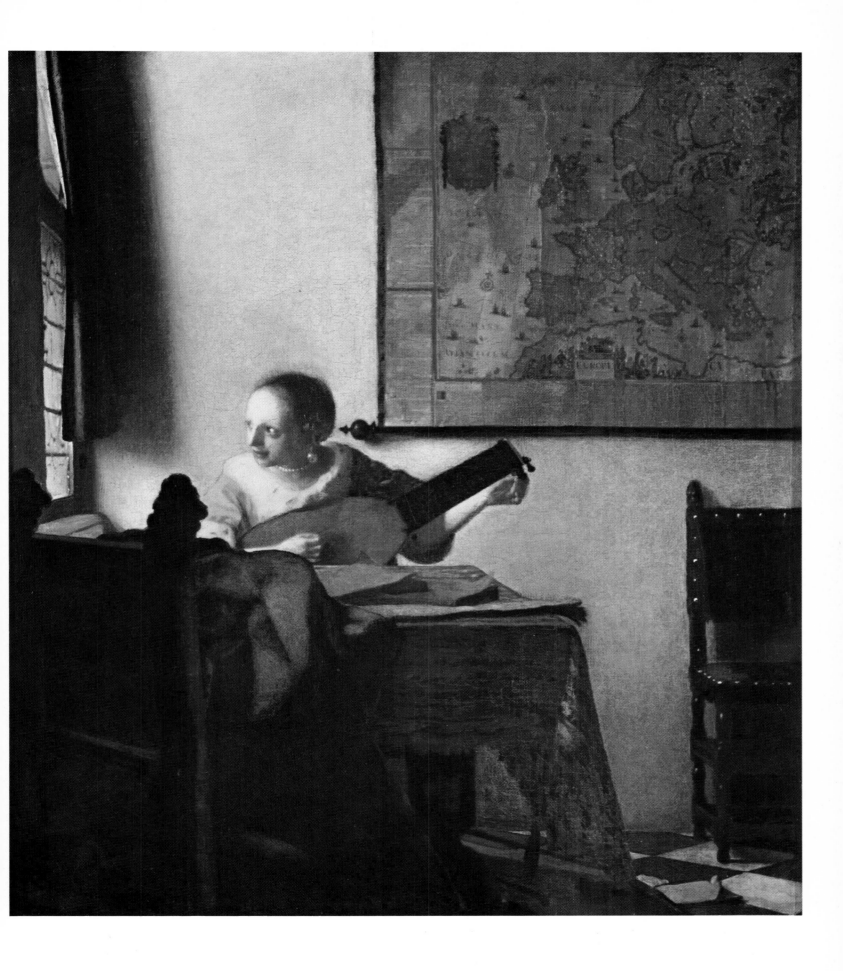

PLATE XLV WOMAN PLAYING A LUTE New York, Metropolitan Museum
Whole (46 cm.)

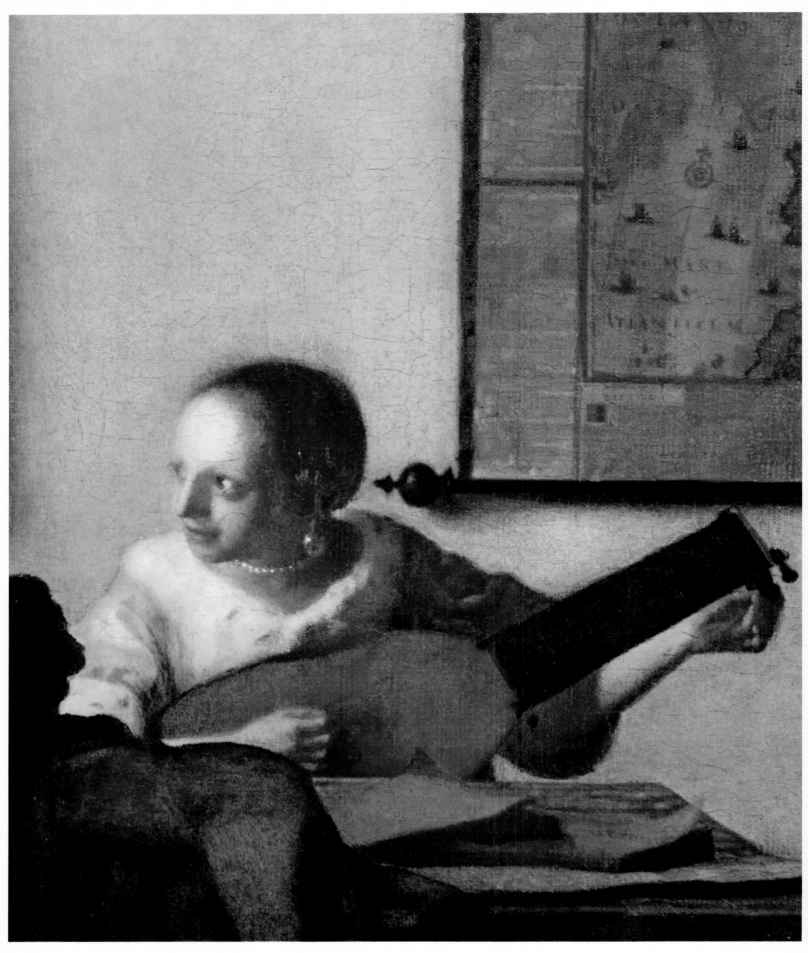

PLATE XLVI WOMAN PLAYING A LUTE New York, Metropolitan Museum
Detail (life size)

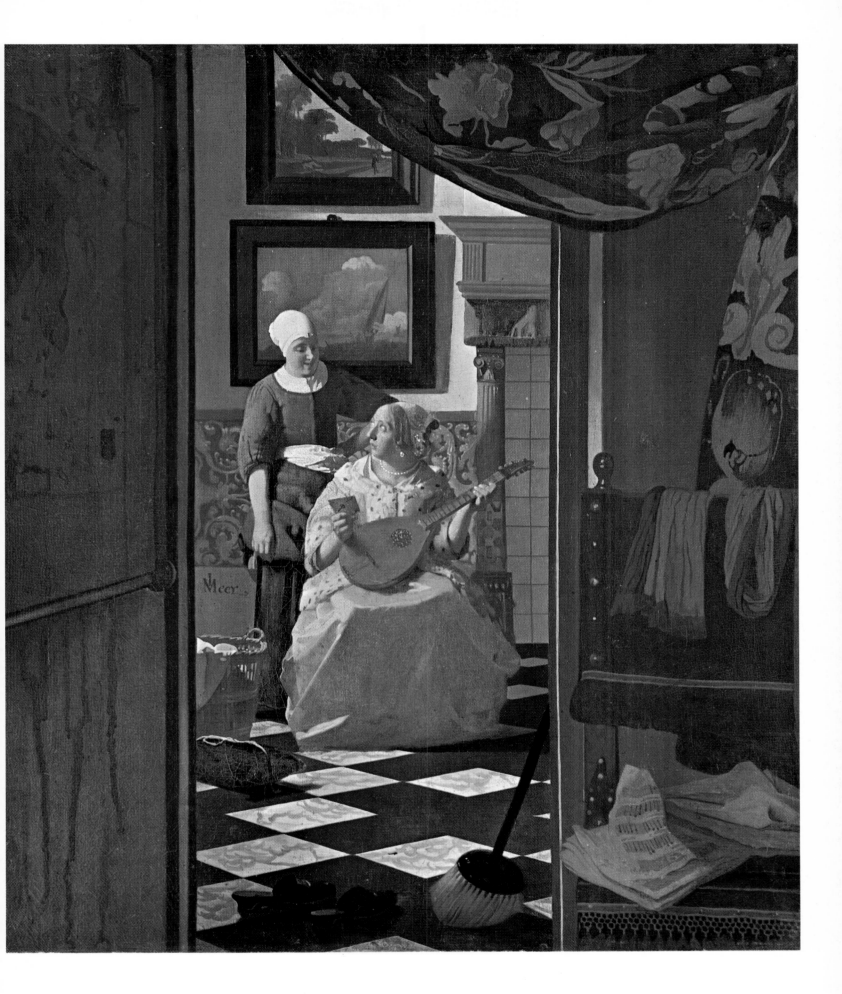

PLATE XLVII THE LOVE LETTER Amsterdam, Rijksmuseum
Whole (38.5 cm.)

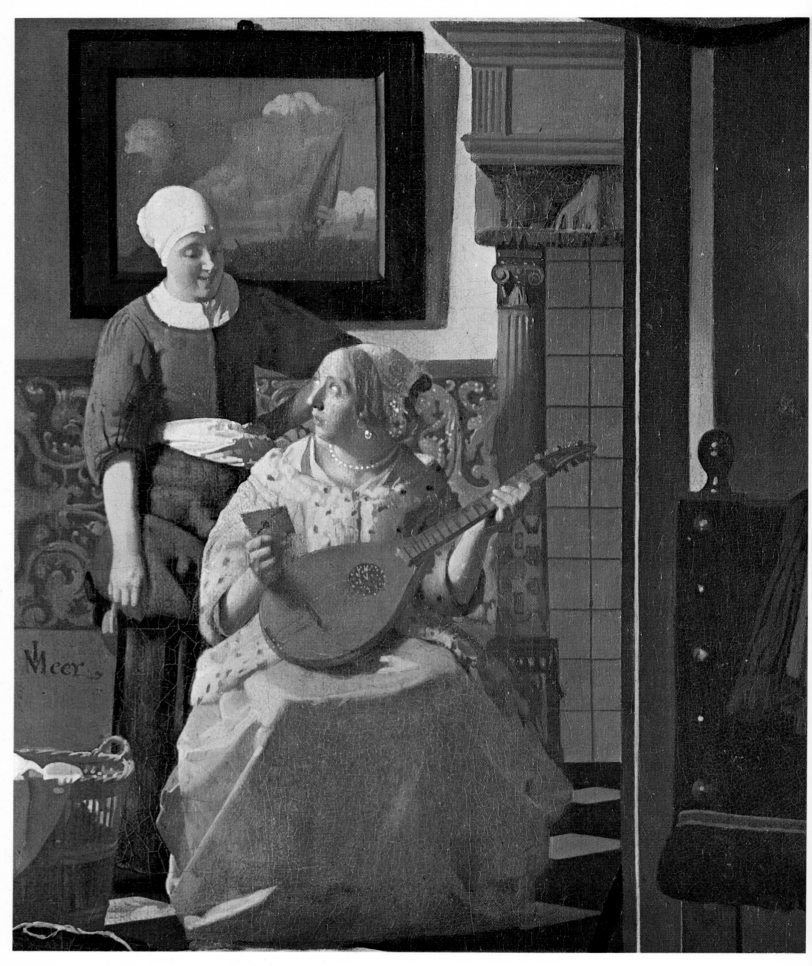

PLATE XLVIII THE LOVE LETTER Amsterdam, Rijksmuseum
Detail (life size)

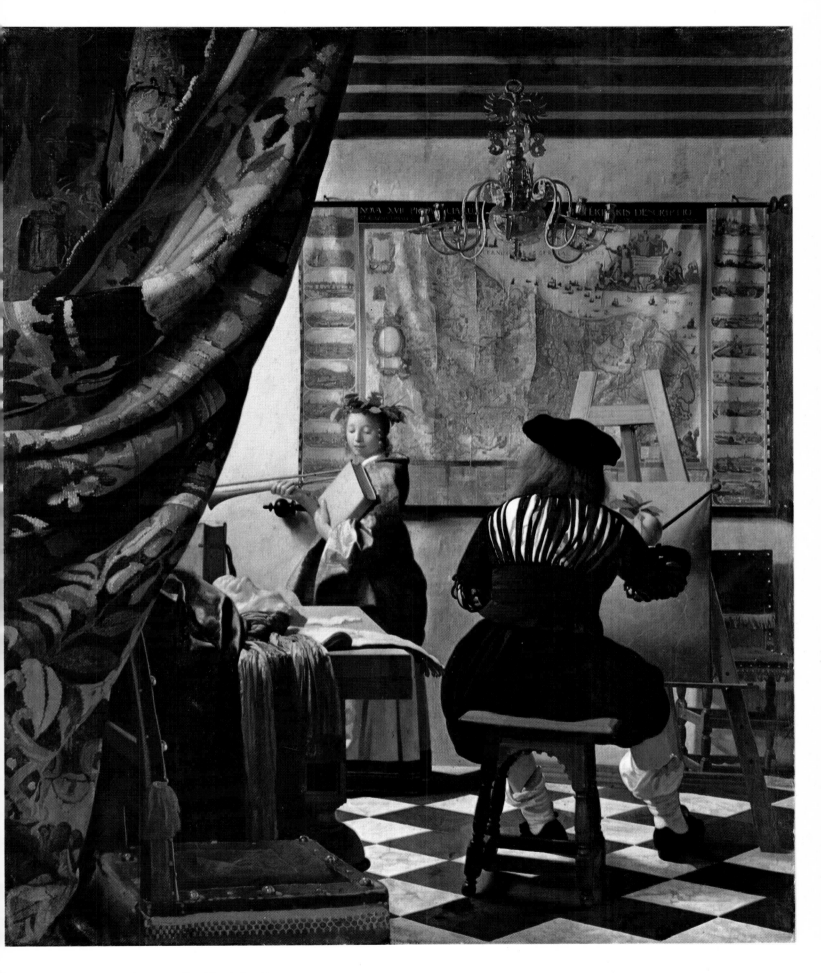

PLATE XLIX THE STUDIO Vienna, Kunsthistorisches Museum
Whole (100 cm.)

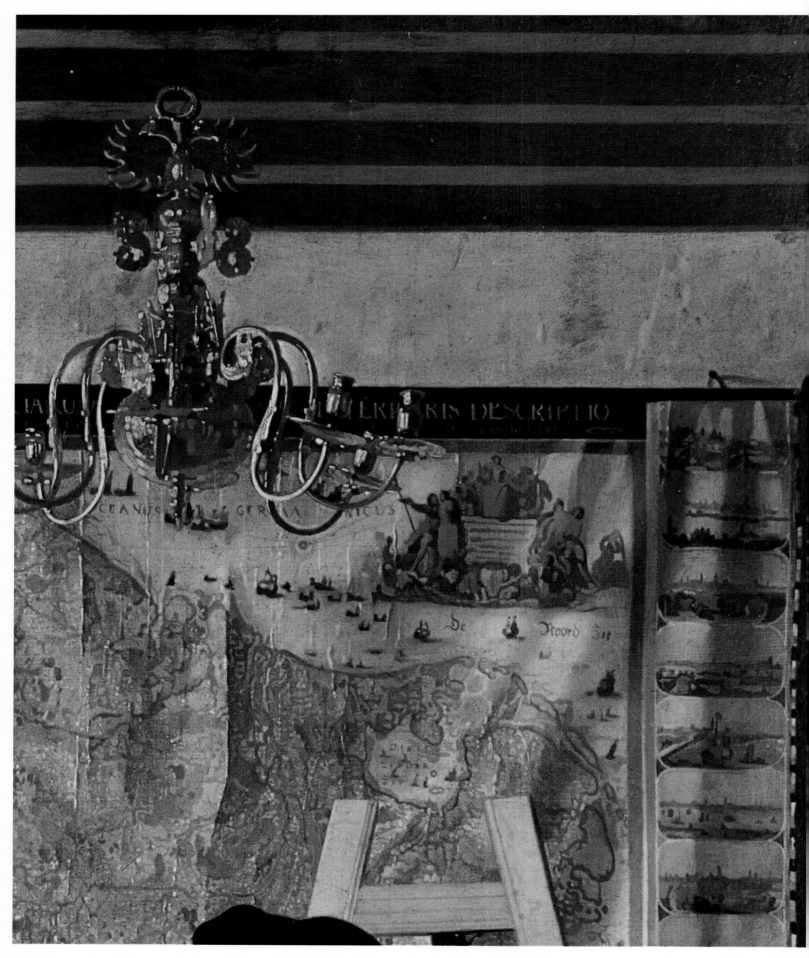

PLATE L THE STUDIO Vienna, Kunsthistorisches Museum
Detail (41 cm.)

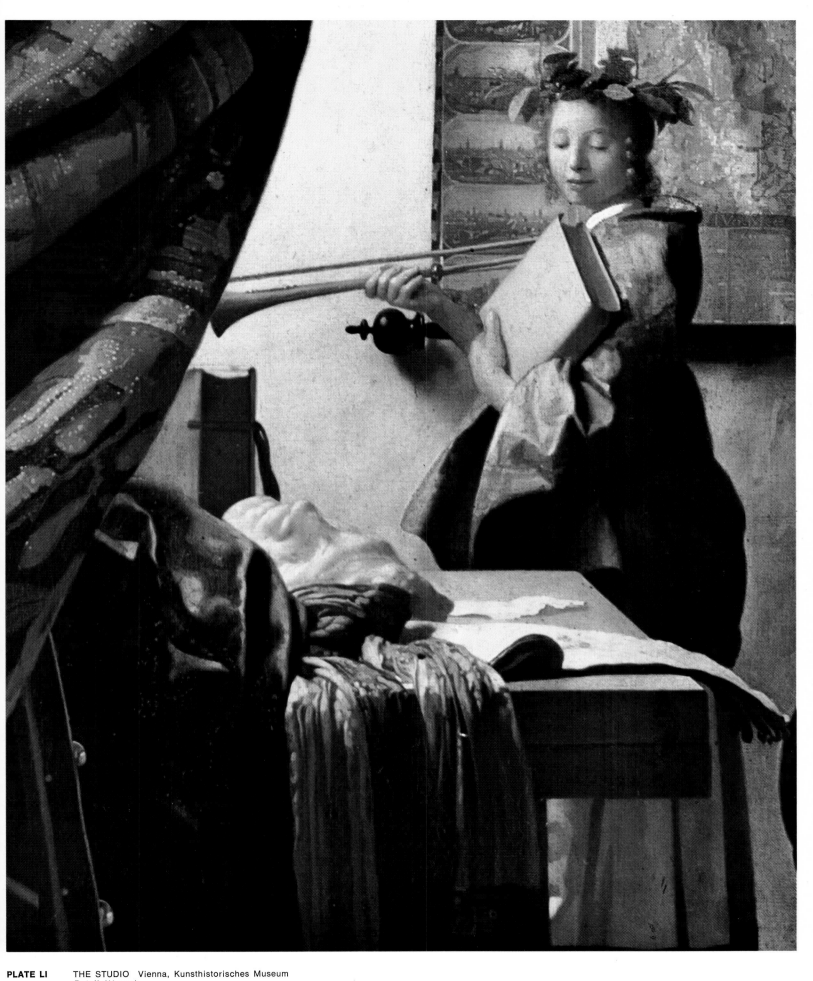

PLATE LI THE STUDIO Vienna, Kunsthistorisches Museum
Detail (41 cm.)

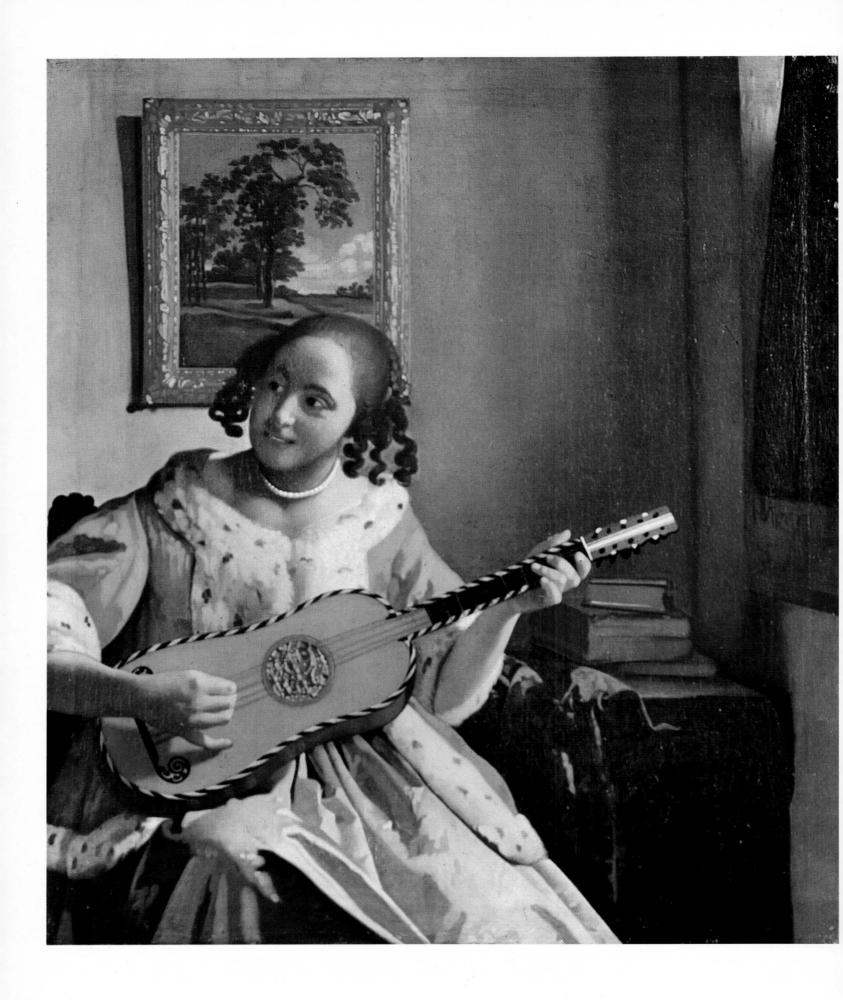

PLATE LII WOMAN PLAYING A GUITAR London, Kenwood House
Whole (46.3 cm.)

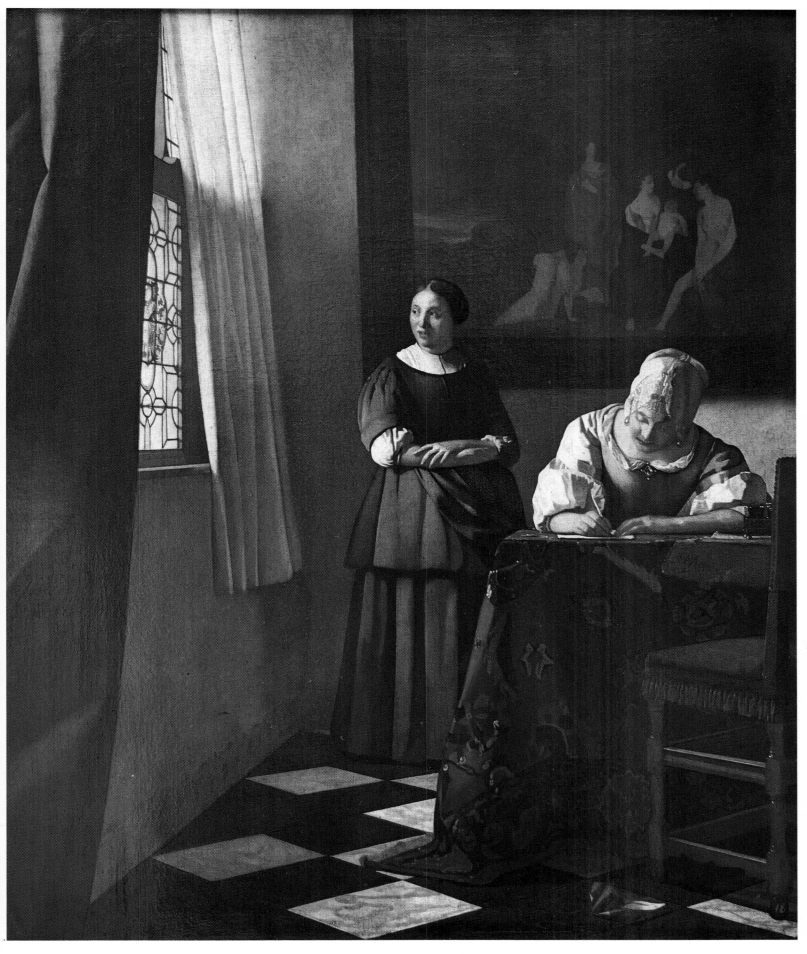

PLATE LIII THE LETTER Blessington, Beit Collection
Whole (60.5 cm.)

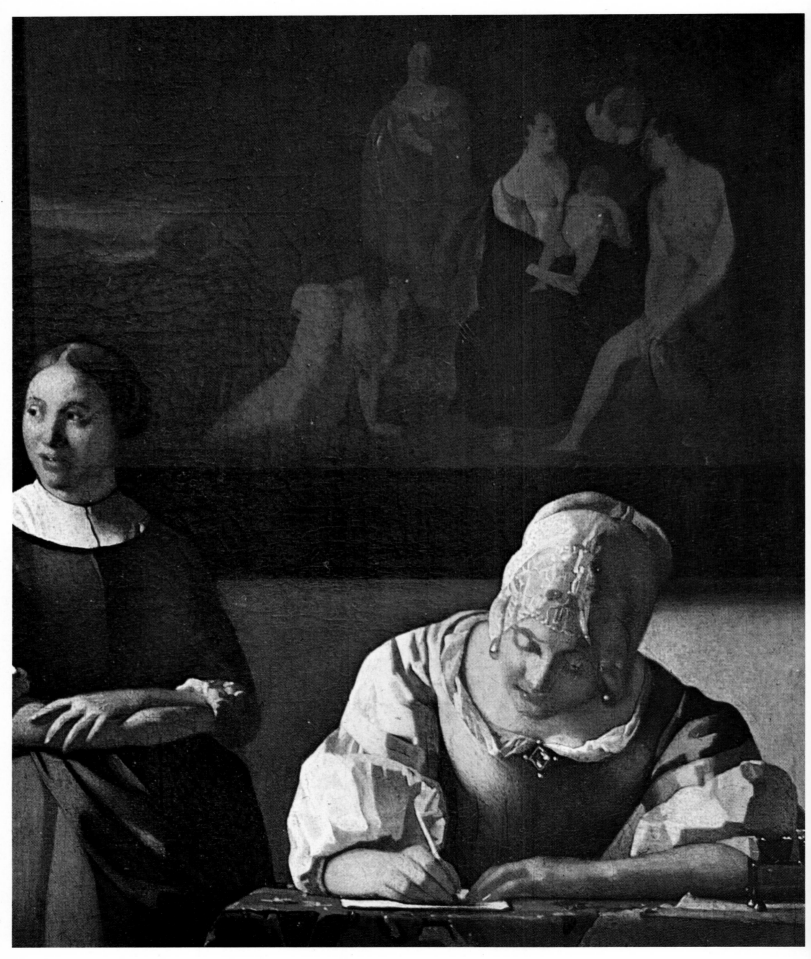

PLATE LIV THE LETTER Blessington, Beit Collection
Detail (28 cm.)

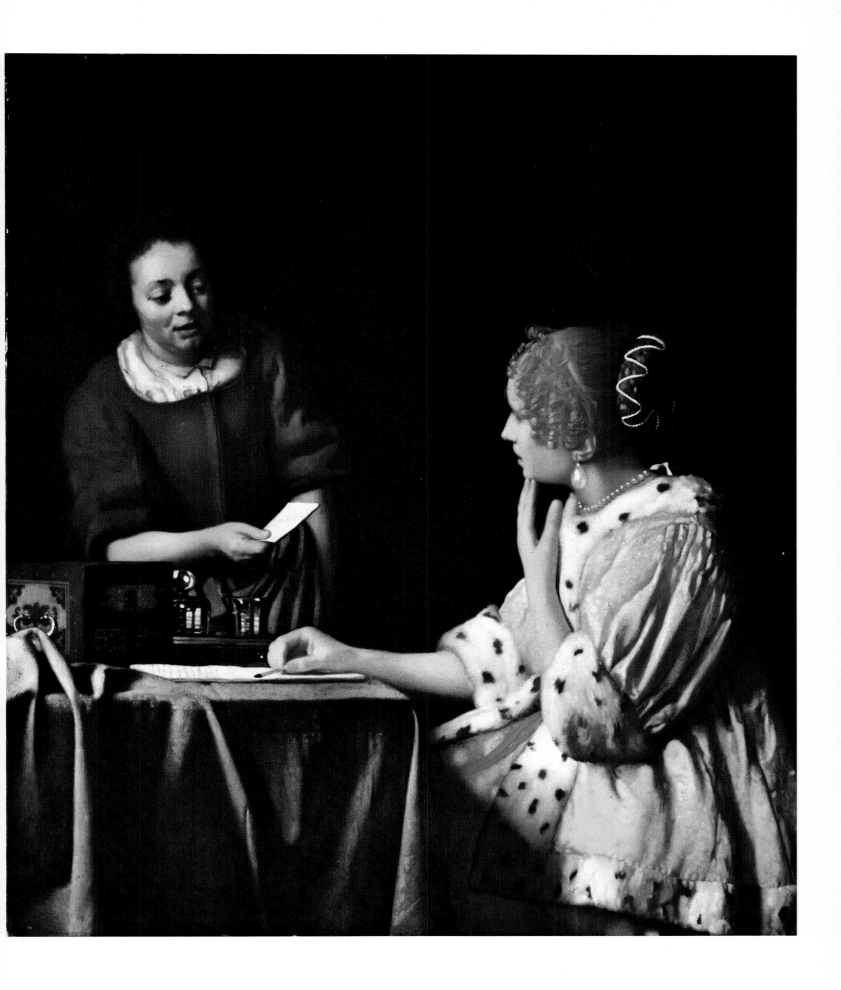

PLATE LV SERVANT HANDING A LETTER TO HER MISTRESS New York, Frick Collection
Whole (78.1 cm.)

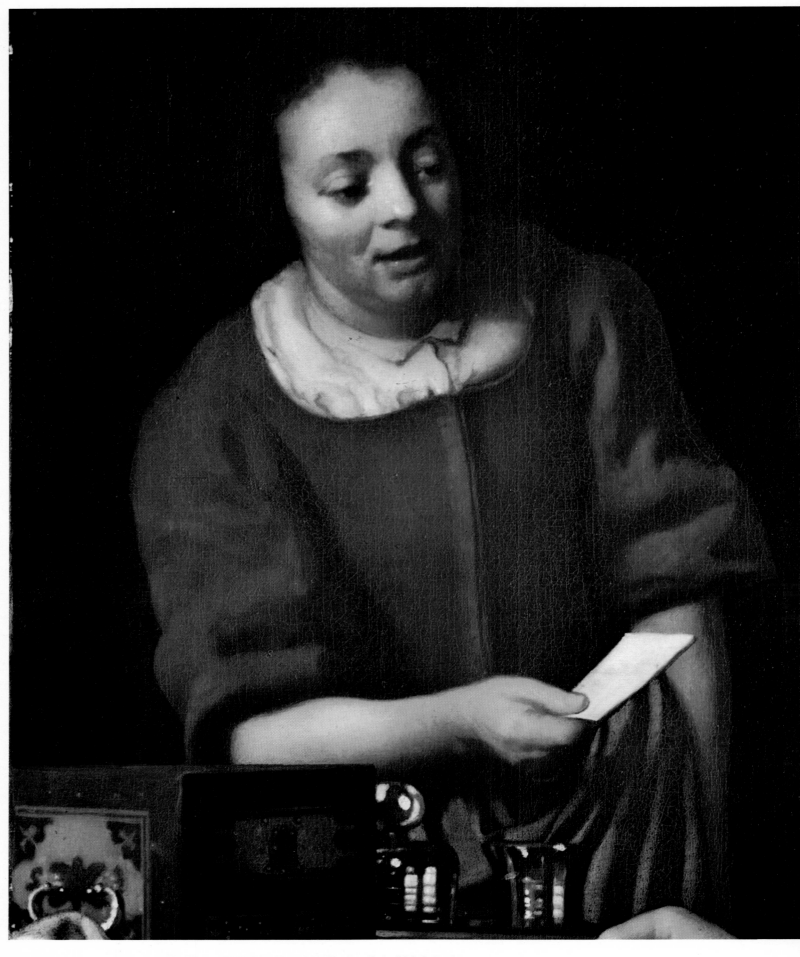

PLATES LVI-LVII SERVANT HANDING A LETTER TO HER MISTRESS New York, Frick Collection
Detail (76 cm.)

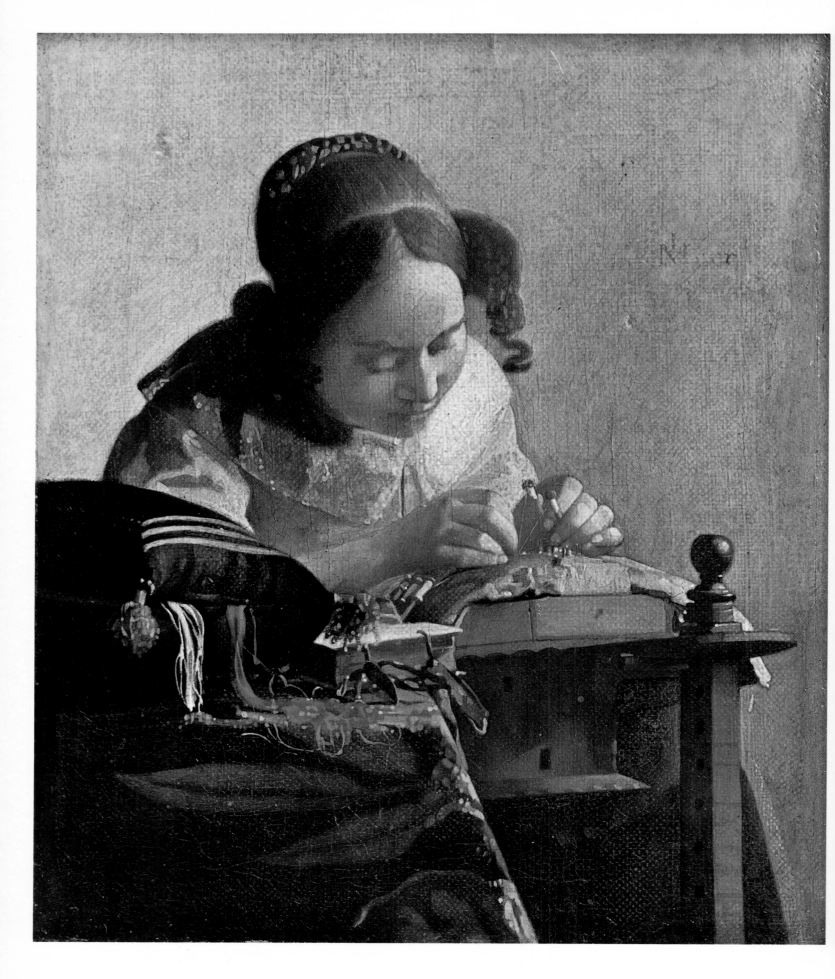

PLATE LVIII LACEMAKER Paris, Louvre
Whole (life size)

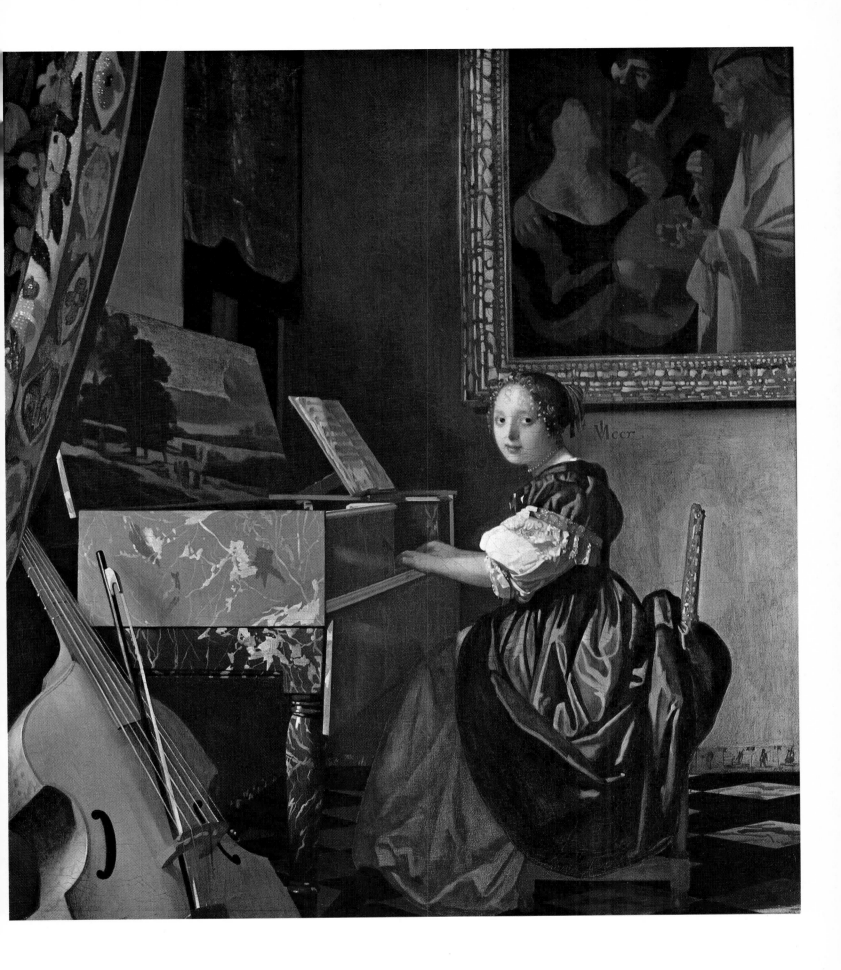

PLATE LIX LADY SITTING AT THE VIRGINALS London, National Gallery
Whole (45.7 cm.)

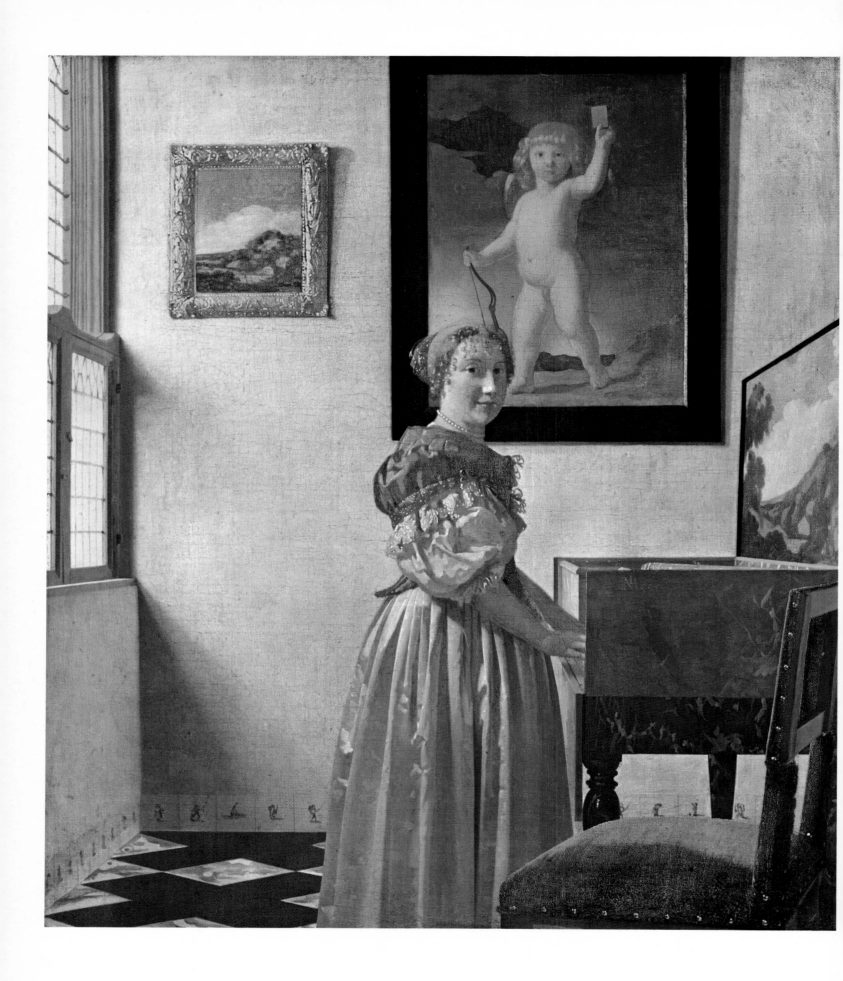

PLATE LX LADY STANDING AT THE VIRGINALS London, National Gallery
Whole (45.5 cm.)

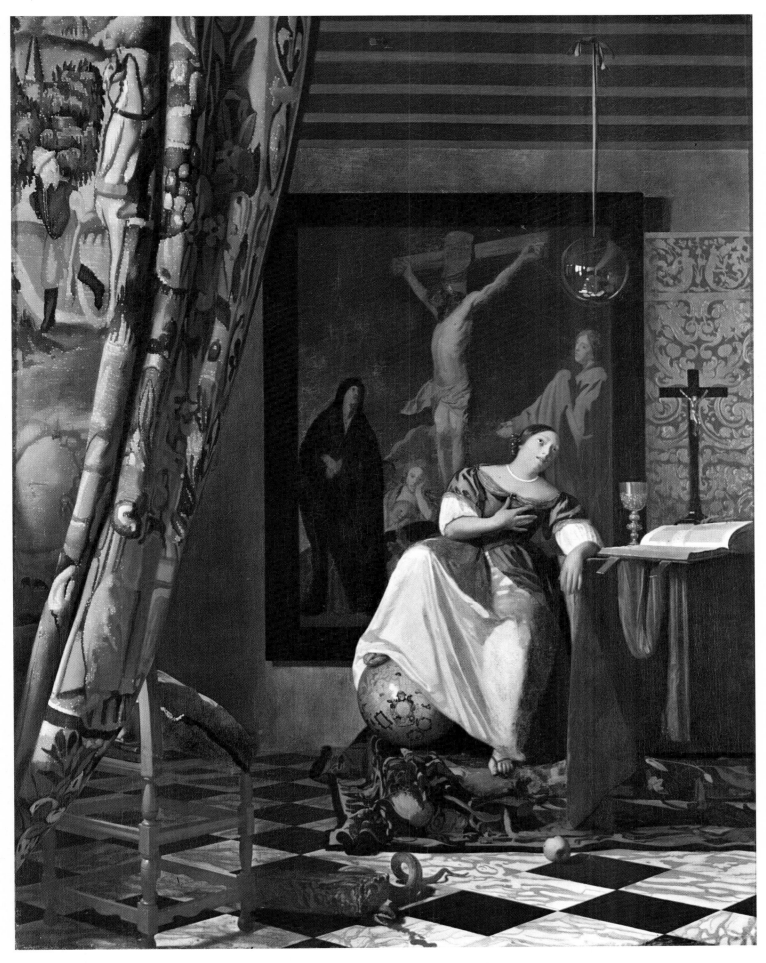

PLATE LXI ALLEGORY OF THE NEW TESTAMENT New York, Metropolitan Museum
Whole (89 cm.)

PLATE LXII ALLEGORY OF THE NEW TESTAMENT New York, Metropolitan Museum
Detail (40 cm.)

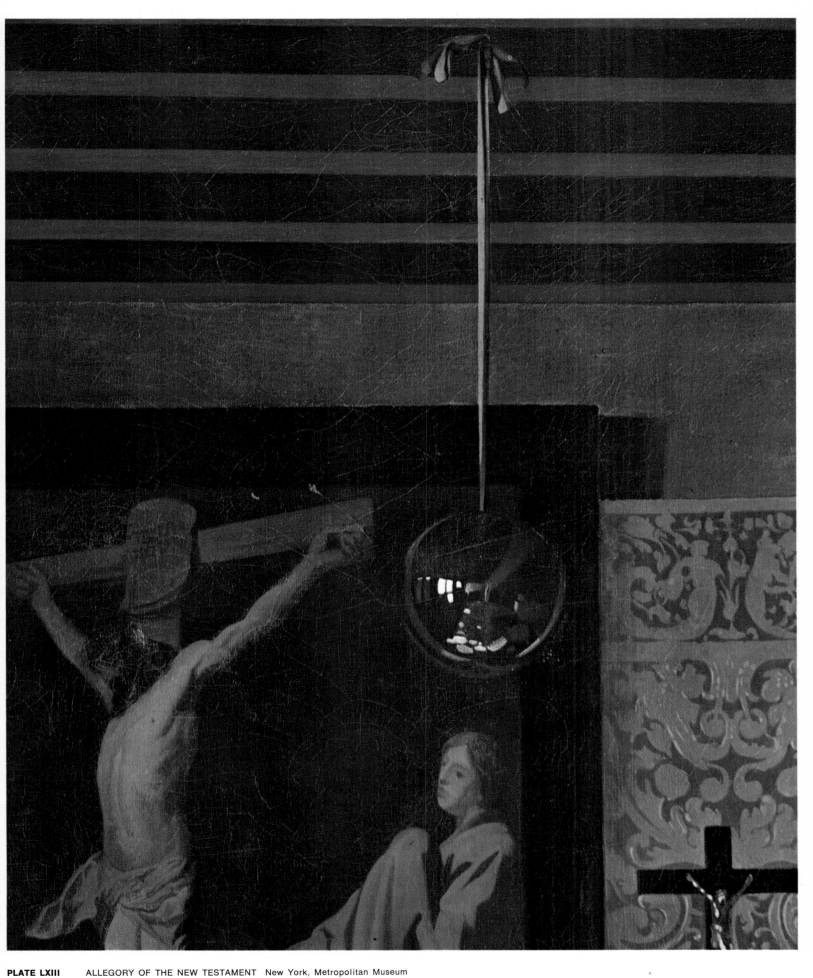

PLATE LXIII ALLEGORY OF THE NEW TESTAMENT New York, Metropolitan Museum
Detail (40 cm.)

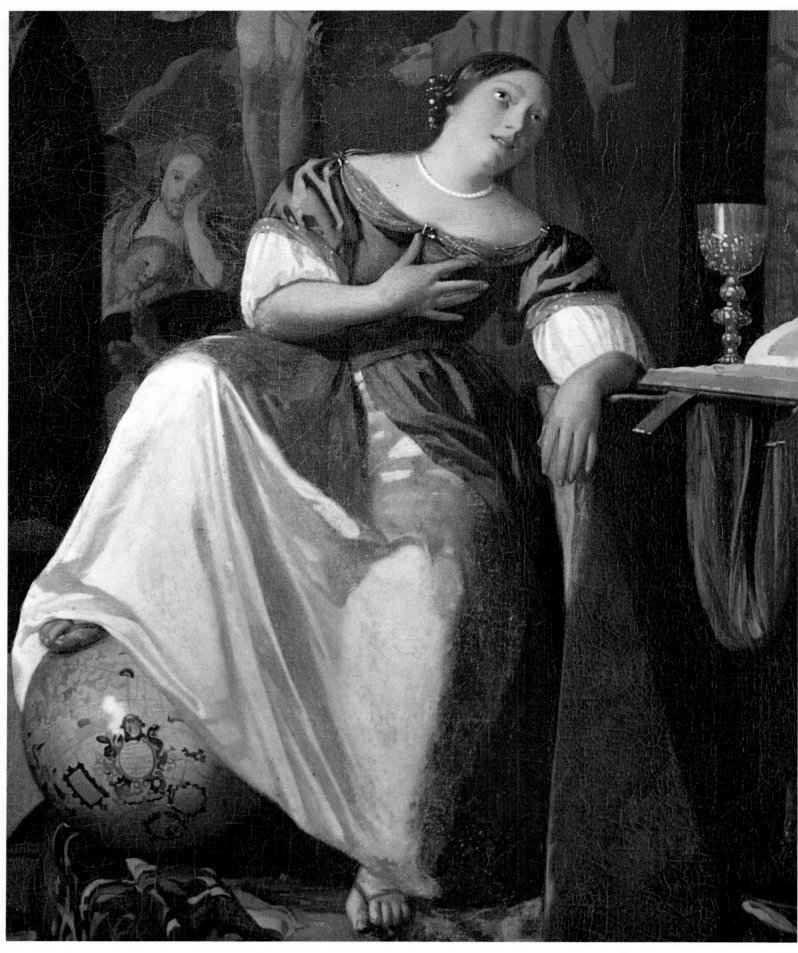

PLATE LXIV ALLEGORY OF THE NEW TESTAMENT New York, Metropolitan Museum
Detail (40 cm.)

The works

So that the essential elements in each work may be immediately apparent, each commentary is headed first by a number (following the most reliable chronological sequence) which is given every time that the work is quoted throughout the book, and then by a series of symbols. These refer to:
1) its execution, that is, to the degree to which it is autograph.
2) its technique.
3) its support.
4) its present whereabouts.
5) The following additional data: whether the work is signed, dated; if its present-day form is complete; if it is a finished work.
Of the other two numbers in each heading, the upper numbers refer to the picture's measurements in centimeters (height and width); the lower numbers to its date. When the date itself cannot be given with certainty, and is therefore only approximate, it is followed or preceded by an asterisk, *, according to whether the uncertainty relates to the period before the date given, the subsequent period, or both. All the information given corresponds to the current opinion of modern art historians; any seriously different opinions and any further clarification is mentioned in the text.

Key to symbols used

Execution

Autograph

with assistance

in collaboration

with extensive collaboration

from his workshop

currently attributed

currently rejected

traditionally attributed

recently attributed

Technique

Oil

Fresco

Tempera

Support

Wood

Plaster

Canvas

Whereabouts

• Public Collection

○ Private Collection

○ Unknown

○ Lost

Additional Data

Signed

Dated

Incomplete or fragment

Unfinished

Information given in the text

Bibliography

Extensive bibliographical information on Vermeer has appeared in E. Trautschold (TB [for these and other similar abbreviations see below] XXXIV 1940) and H. van Hall *Repertorium Geschiedenis Nederlandsche Schilder-en-Tekenkunst*, 1936 and 1949), as well as in the monographs by Hale (1937), De Vries (1948) and Swillens (1950) mentioned below. Acknowledgment for the publication of documents from archives is due to F. D. O. Obreen (ANK 1881–2). A. Bredius (O-H 1885, 1910 and 1916 [p. 91 ff and p. 160 ff]), L. G. N. Bouricius (O-H 1925), A. C. Boogaard-Bosch (NRC 1939), E. Neurdenburg (O-H 1942 and 1951), A. van Peer (KCT 1946 and 1951) and A. J. J. M. van Peer (O-H 1957, AGKN 1960). Very important for sale catalogues; the collection by G. Hoet and P. Terwesten (*Naamlijst van Schilderijen met derzelven prijzen*, The Hague 1752).
The most important essays and monographs are the following: W. Bürger (E. J. Th. Thoré) (*Van der Meer de Delft*, Paris 1886 [German edition by P. Prina, 1906; French edition by A. Blum, 1945]), H. Havard (*Van der Meer de Delft*, Paris 1888), J. Six (*Offizieller Bericht der Kunsthistorischen Kongresses zu Amsterdam* 1896), Th. von Frimmel (BG 1906), W. von Bode (*Rembrandt und seine Zeitgenossen*, 1907²)' C. Hofstede de Groot (*Jan Vermeer van Delft en Carel Fabritius*, Amsterdam 1907 [first supplement 1913; second supplement 1930]). G. Vanzype (*Vermeer van Delft*, Brussels 1908 and 1931), E. Plietzsch (*Vermeer van Delft*, Leipzig 1911, Munich 1929), H. Voss (MK 1912), Ph. L. Hale (*Jan*

Vermeer of Delft, Boston 1912 and 1937 [edited by Fr. W. Coburn and R. T. Hale]), P. Johansen (O-H 1920). W. R. Valentiner (P 1932: *Pieter de Hooch*, Leipzig 1939), V. N. Lazaref (*Vermeer*, Moscow 1933), A. Von Schneider (*Caravaggio und die Niederländer*, Marburg 1933), G. Isarlo (R 1935), R. Huyghe (ADA 1936; and in De Vries [1948]), A. B. de Vries (*Jan Vermeer van Delft*, Amsterdam 1939; Revised edition in German, Basel 1945; English edition, London 1948; French edition, Berne 1948 [with *La Poétique de Vermeer* by R. Huyghe], Th. Bodkin and L. Goldscheider (*The Paintings of Jan Vermeer*, London 1940), B. Nicolson (*Vermeer's Lady at the Virginals*, London 1946), J. Q. van Regteren Altena (*Hollandische Meisterzeichnungen*, Basel 1948; O-H 1960), K. G. Hulten (KT 1949), F. van Thienen (*Jan Vermeer*, London 1949), P. T. A. Swillens (*Johannes Vermeer Painter of Delft*, Utrecht 1950), A. Malraux (*Vermeer de Delft*, Paris 1952 [with extensive anthology]), L. Gowing (*Vermeer*, London 1952), E. Gerson (*Het Tijdperk van Rembrandt en Vermeer*, Amsterdam 1952; *Johannes Vermeer, Encyclopedia of Universal Art XIV*, 1966), V. Bloch (*Tutta la pittura di Vermeer di Delft*, Milan 1954; English edition, London 1963 and French edition, Paris 1966 [text only, with *L'éloge* by Thoré-Bürger), J. G. van Gelde (and J. A. Emmen) (*De Schilderkunst van Jan Vermeer*, Utrecht 1958), L. Goldscheider (*Jan Vermeer*, London 1958 and 1967) and P. Descargues (*Vermeer*, Geneva 1966), J. Mister (*Vermeer*, Paris 1973), J. Walsh (BMM 1973), E. G. Grimme (*Jan*

Vermeer van Delft, Cologne 1974; French ed., Paris 1975), A. Blankert, with R. Ruurs and W. van de Watering (*Johannes Vermeer van Delft, 1632–1675*, Utrecht–Antwerp 1975, 2nd [corrected] ed., Oxford 1978), C. Wright (*Vermeer*, London 1976), G. W. Menzel (*Vermeer*, Leipzig 1977), H. Read (*Johannes Vermeer*, New York 1978), A. K. Wheelock Jr (*Jan Vermeer*, London 1981), L. J. Slatkes (*Vermeer and his Contemporaries*, New York 1981), J. M. Montias (*Artists and Artisans in Delft in the Seventeenth Century*, Princeton 1982), M. Pops (*Vermeer: Consciousness and the Chamber of Being*, Ann Arbor 1984), *Masters of Seventeenth-Century Dutch Genre Painting* (exhibition catalogue, Philadelphia Museum of Art 1984). For particular technical aspects and Vermeer's use of perspective see: J. Six (BNOB 1908), C. F. de Wild (BNOB 1908), A. Peltzer (*Uber Malweise und Stil in der holländischen Kunst*, Heidelberg 1943), A. Hyatt Mayor (BMM 1946), H. E. van Gelder (KM 1948–9), K. Boström (KM 1949) and P. T. A. Swillens (TR 1950), C. Seymour (AB 1964), H. Schwarz (P 1966), S. Kostow (O-H 1967), D. A. Fink (AB 1971), A. K. Wheelock Jr (NkJ 1973; *Perspective, Optics, and Delft Artists Around 1650*, New York 1977).
On Vermeer's cartographic sources: J. A. Welu (AB 1975).
On the interpretation of his work and some iconographic problems: A. P. de Miramonde (GBA 1961), M. Kahr (MMJ 1972), E. de Jongh (S 1975). Finally, for the fakes, see: V. Bloch (ADA 1946), A. Chastel (LM 5 March 1955), and especially P. B. Coremans (*Van Meegeren's faked Vermeers and De Hooghs*, Amsterdam 1949), C. L. Ragghianti (CA 1950 and SA 1955) and O. Kurz (*Fakes and Fakers*, Venice 1961). (See also Appendix).

A: *L'arte* (Rome, Turin, Milan)
AA: *Art in America* (Springfield, New York)
ADA: *L'amour de l'art* (Paris)
AGKN: *Archiev voor de geschiedenis van de katholiek Kerk in Nederland* (Utrecht)
ANK: *Archiev voor Nederlandsche Kunstgeschiedenis* (The Hague)
BG: *Blätter für Gemäldekunde* (Vienna)
BM: *The Burlington Magazine* (London)
BMM: *Bulletin of the Metropolitan Museum of Art* (New York)
BNOB: *Bulletin van den Nederlandschen Oudheidkundige Bond* (Leyden)
CA: *La critica d'arte* (Florence)
FHJ: *Festschrift für Hans Jantzen* (1951)
GBA: *Gazette des Beaux Arts* (Paris)
ILN: *Illustrated London News* (London)

JKSAK: *Jahrbuch der Kunsthistorischen Sammlungen des Allerhöchsten Kaiserhauses* (Vienna)
KCT *Katholiek Cultureel Tijdscrift* ('s-Hertogenbosch)
KK: *Kunst und Kunstler* (Berlin)
KM: *Kunsthistorische Mededeelingen van het Rijkbureau voor kunsthistorische documentatie* (The Hague)
KT: *Konsthistorisk Tidskrift* (Stockholm)
LM: *Le Monde* (Paris)
Lumière 1966: *Dans la lumière de Vermeer* (Catalogue of the Paris exhibition, 1966)
M: *Le Moniteur* (Paris)
MBK: *Maandblad voor beeldende Kunsten* (Amsterdam)
MK: *Monatshefte für Kunstwissenschaft* (Leipzig)
NKJ: *Nederlans Kunsthistorisch Jaarboek* ('s-Gravenhage)

NRC: *Nieuwe Rotterdamsche Courant* (Rotterdam)
O-H: *Oud-Holland* (Amsterdam)
P: *Pantheon* (Munich)
R: *La Renaissance de l'art français* (Paris)
RDP: *Revue de Paris* (Paris)
RFK *Repertorium für Kunstwissenschaft* (Berlin and Leipzig)
S: *Simiolus* (Amsterdam–Utrecht)
SA: *SeleArte* (Florence)
SU: *Seminars der Universitat* (Munich)
TB: *Allgemeines Lexicon der bildenden Künstler* by U. Thieme and F. Becker (Leipzig)
TR: *Technical Review*
VA: *Vita artistica* (Rome)
W: *Die Weltkunst* (Munich and Berlin)
ZAK: *Zeitschrift für Aesthetik und allgemeine Kunstwissenschaft* (Stuttgart)

Outline biography

To show how far the idea of producing a full biography of Vermeer had been abandoned we will quote a comment by Gault de Saint-Germain (*Guide des amateurs de tableaux*, 1818): "Jan van der Meer called 'of Delft,' born in Schoonhoven, Haarlem or Utrecht." This negative reference seems the more shocking when we reflect that the author was not a charlatan nor an idle historian; it simply contains everything that was known. All we have is a slender collection of snippets in which information about our Vermeer is mixed with details about contemporaries of the same name: Jan (Johannes, Johannis) Vermeer (Van der Meer) "de Oude (the Elder)" (Haarlem c. 1600/01–1670), and his son Jan Vermeer "de Jonge (the Younger)" (Haarlem 1638–91), both landscape artists and forming part of a "dynasty" which includes at least three other contemporaries of the same name. There were Jan Vermeer (Van der Meer) whose dates are given as 1598–1632, Johannis van der Meer, documented in 1694 and Jan Vermeer (1656–1705). To this same family – called the Vermeers "of Haarlem" – belongs another local man Izack (Isaak, Isack) Vermeer (Haarlem 1635–65), besides Barent Vermeer (Van der Meer), a specialist in still-life, also from Haarlem. Then there is a figure painter, Johannes van der Meer called "from Utrecht," who was really born in Schoonhoven about 1640 and died after 1693. And one might mention yet another compatriot, A. van der Meer (registered in 1641; perhaps identifiable with a certain Abraham van der Meer from Leyden, died 1669) and a certain Catherine van der Meer, about whom we know only that in 1675 she dated a picture of birds. Or, take Proust for example: "As for Vermeer of Delft, she asked

him if he had ever suffered because of a woman, whether it had been one woman who had inspired him; and since Swann had confessed to her that nothing was known about him, she had lost interest in the artist"; and despite the researches of Obreen, Bredius, Bouricius, Neurdenburg and the Van Peers, which began soon after 1880 and continued for several decades, the Proustian hero would still not be equipped to appease Odette's romantic curiosity. Not a letter by Vermeer, not a page of a diary exists: not a single peg to hang a lifelike picture on. And this has particularly roused various critics' imagination to suggest every kind of theory: Vermeer had a squalid existence or was unable to afford to work very much, he was a Catholic or a Calvinist, loved his wife, did not love, he had all manner of complexes; to these and other questions even the understanding of his paintings was subordinated. So that the reader may appreciate the full importance of such interpretations, in which Freud always makes a significant appearance, we shall try to give as full an account as possible of the painter's life, at the cost of including snippets that might equally well be left out of a critical biographical study.

1615 27 June Publication of the marriage banns of the painter's parents in Amsterdam. His father, a native of Delft, aged 32, appears under the name of Reynier Janszoon; at the time he is a draper specializing in "caffa", a silk material used for wall-hangings and upholstery. His wife is named as Digna Baltasars (or Baltasadr), a native of Amsterdam; in later documents she is called variously Dignum, Dingenom, Dyna or Dymphna Baltens (abbreviation of Baltasars). In 1623 Reynier and Digna are living in the Broerhuis in Delft. From about 1625 Reynier is an innkeeper as

 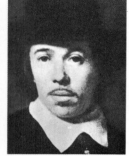

(Left) Detail of an engraving by Joannes Meyssens which reproduces a painting (39) supposed to be a self-portrait of Vermeer. (Right) Detail of a painting attributed to Nicolas Maes (57) formerly believed to be a self-portrait of Vermeer.

well as a draper, running an establishment called "De Vliegende Vos" ("The Flying Fox") in the Voldersgracht, from which derived the name Vos, Voos or Vosch that appears in most of the documents concerning him from this period onwards. However, the name Vermeer (or van der Meer) appears as early as 1620: it is in fact the family name – in 1625 it is used on the certificate of baptism of a nephew of Reynier's and in 1640 a document refers to "Reynier Jansz. Vermeer alias Vos".

1619–20 The father and brother of Digna, Balthasar Claes Geritsz and Reynier Balthensz, are involved in a case of counterfeiting in The Hague. On the testimony of Balthasar Claes two of their accomplices are sentenced to death. Reynier Balthensz is imprisoned but subsequently released after Reynier and Digna Vermeer stand substantial bail on his behalf. He then lives in Gorcum and follows the profession of a contractor for military fortifications.

1632 31 October At a baptism in the New Church ("Nieuwe Kerk") in Delft the birth was recorded of "Johannis," second child of Reynier and Dymphna Vos, who had already had a daughter Geertruyt. Among the witnesses was a certain Pieter Bramer, perhaps a relative of

the artist Leonard Bramer from Delft. In Dutch the complete name of the new child is "Johan" or "Johannes" (as he was to sign himself) but the abbreviated form of it, "Jan," prevailed. As for his surname (see also **1615**), the contraction Vermeer (like that of "Van der Does" into "Verdoes") appears to have been preferred by contemporaries during the painter's life, and he himself used it to sign his pictures. In the catalogue to the 1696 sale (q.v.) "Van der Meer" and "Vermeer" are used without distinction; the long name was used mostly during the second half of the nineteenth century but the shorter one is used nowadays. Since the contracted form also designated other Dutch painters of the same period (see above), to distinguish him from them we are using the formula "Vermeer of Delft," which is analogous to the Dutch "Vermeer de Delftsche" (often misspelt "Delfsche," "Delfze," or "Delfse") or "Delftian Vermeer." When Vermeer was born, Delft was a beautiful, quite prosperous

city, though of declining importance compared with Utrecht and The Hague. Moreover, because of the inn kept by his father, Vermeer's childhood is assumed to have been passed in a somewhat squalid atmosphere similar to that of certain "cabarets" painted by Brouwer. In fact there are documents relating to a row which took place at the "Mechelen" (Malines), an inn in the market square in Delft at the corner of Oudemanshuisteg, which Vermeer's parents were to acquire some fifteen years later (see **1641**): a youth was injured and, Reynier having fled, his wife was forced to pay a fine in order to avoid prosecution.

1631 13 October "Reynier Vos alias Reynier van der Minne" (from the name by which his mother's second husband, Claes Corstiaensz van der Minne, a tailor and musician, was known) starts an art-dealing business and enrolls as a dealer in the St Luke's Guild.

1632 is also the year in which the painters Luca Giordano and Nicolas Maes were born, likewise Spinoza (see **31**) and, also in Delft, the naturalist Anthony van Leeuwenhoek (*id*) who was to perfect the microscope, to discover red corpuscles and spermatozoa, and to become executor for his fellow citizens, including Vermeer's own estate and the sale of the pictures still in his widow's possession after his death. In 1632 Rubens had just finished his greatest ecclesiastical work, the altarpiece of St Ildefonso, Velazquez was painting Philip IV of Spain; Bernini was finishing the baldacchino in St Peter's; Van Dyck was becoming the court painter to

Signature of "Joannes ver Meer," with the date 1662, written by the artist in the register of the artists' guild of St Luke in Delft.

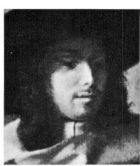

Charles I of England; and Rembrandt was signing *The Anatomy Lesson* in Antwerp.

1641 March Reynier Vermeer buys the "Mechelen" inn (see above) for 2,700 florins, and probably continued his art-dealing from the new premises. On contemporary prints the two-storey building is among the biggest in the market place.

1652 12 October Funeral of Reynier Vermeer at the New Church. The Vermeer family then seems to suffer certain financial problems, mainly due to Digna's supporting her brother Reynier in Gorcum (see **1619–20**). It is likely that the artist's mother continued to run the "Mechelen" inn after her husband's death, but there is no evidence that Vermeer himself was involved in inn-keeping. On the other hand, a later declaration by his wife (see **1676**) shows that he was concerned with art-dealing. This was quite usual for painters of all kinds, at least from the Middle Ages onwards, as is proved by the existence of precise regulations aimed at restricting the practice. Inn-keeping too became a common occupation for Northern European painters.

1653 5 April Jan Vermeer, aged 22, marries Catharina Bolnes, aged 23, the daughter of a wealthy and prominent, but deeply divided, Gouda family (Catharina's parents, Reynier Bolnes and Maria Thins, had been separated since about 1640 and her brother Willem seems to have suffered severe mental problems). Among the witnesses at the civil ceremony in Delft was the 57-year-old painter Leonard Bramer (see **1632**). It is almost certain that the religious ceremony took place on 20 April at Schpluyden and followed the Catholic rite (Catharina's religion). The opposition shown at first by Catharina's mother to the marriage can be explained by the differences in social rank and religious belief which separated the two families. It has always been assumed, without any actual evidence, that Vermeer converted to Catholicism. It is possible that after his marriage the artist drifted apart from his own family. Indeed, there is no documentary evidence that he continued to keep the "Mechelen" inn like his father before him, and by 1660 we find him living in his mother-in-law's house in Oude-langendijk, the "papist" quarter of Delft. His relationship with Maria Thins seems to have improved rapidly, so much so that after the artist's death, she was to continue to support the Vermeer household and her grandchildren.
On 22 April 1653, two days after his wedding, Vermeer co-signed a legal document

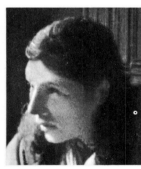
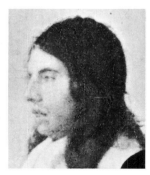

Various scholars, above all Malraux, believe that these figures in works by Vermeer show the features of the artist himself and draw from their apparent age indications of the dates of the paintings in question. Beside each detail the number of the relevant painting in the catalogue is given.

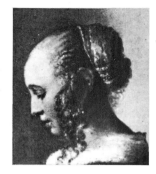

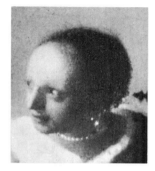
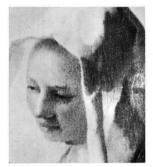
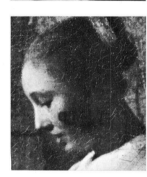

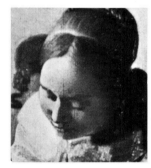
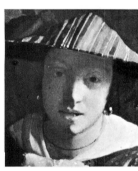
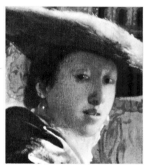
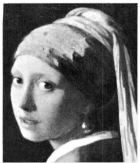
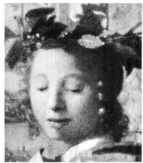

The six details at the top are examples of the so-called portraits of Vermeer's wife; the two at the center, portraits of his eldest daughter; the two at the bottom, of his youngest daughter. They are all taken from paintings by Vermeer and are shown with the numbers which they bear in the catalogue. Most of the suggestions relating to this identification come from Malraux. Recent critics tend to reject them because, besides lacking historical foundation, they involve a chronology, at least for the present paintings, which does not conform to Vermeer's logical development as an artist.

with G. Terborch, who was living at the time in Deventer. On 29 December Vermeer is received as a painter into the St Luke's Guild, paying only a part of the subscription due, the rest of which he paid on 24 July 1656. This delay in paying suggests that the Vermeer family was going through a period of serious financial difficulty at this time. But, as we shall see (1661, 1663, 1671 and 1672), this misfortune was not to last long. It is worth noting here that the other painters enrolled in the St Luke's Guild in Delft were Emmanuel de Witte (1642), Paulus Potter (1646), Carel Fabritius (1652) and Pieter de Hooch (1655).

1654 12 October The powderhouse of Delft explodes; ninety thousand pounds of gunpowder destroy more than two hundred houses and probably the "Mechelen" is damaged. Carel Fabritius is killed in the disaster, and his death is recorded by Arnold Bon who takes the opportunity to praise Vermeer (see Critical Outline).

1655 Vermeer acts as a guarantor for a loan of 250 florins taken out by his father but never repaid.

1656 Date of *The Courtesan* (3).

1657 Receives a loan of 200 florins. On 27 June in the inventory of the estate of an Amsterdam merchant, J. de Renialme, a painting by Vermeer, *The Three Marys at the Tomb*, is valued at only twenty florins.

1661 11 April Catharina inherits from her maternal aunt, Cornelia Thins, an estate at Bonrepos, near Schoohaven, for which Vermeer is to pay homage to the Grand Pensionary Jean de Witt. The artist acts as guarantor for a loan of 78 florins granted to a certain Clement van Sorgen.

1662 18 October Even allowing for Thoré-Bürger's theory that Vermeer went to stay with Rembrandt in Amsterdam, perhaps after 1654, his presence in Delft was documented for certain when he was elected Vice-President of the Guild of St Luke. The Guild decided to increase its apprenticeship charges from 10 stuyvers to 2 florins, 10 stuyvers.

1663 Balthasar de Monconys, counsellor to the French Crown, alchemist and art-lover, travels in Holland. As in previous trips to other countries, he pays many visits to local artists. In Leyden he meets Gerard Dou and Frans Mieris, in Rotterdam Anton Delorme etc. In Delft he writes in his diary (*Journal*, 1666), "On 11 August I visited the painter Vermeer who did not have any of his own paintings [in his studio]. But I was able to see one at a baker's shop, which fetched 600 livres; as it showed only a single figure I should have thought it too much to pay 6 pistoles for it." Monconys thought pictures in general in the Netherlands were too expensive; furthermore he preferred the "finished" style of Dou and Mieris. Vermeer's lack of his own works has given rise to all manner of speculations: that this information was the result of a misunderstanding, that Monconys did not give assurance as a buyer, that Vermeer had no pictures to dispose of because they were not in great demand. Clearly the opposite would equally well be true, that he had nothing to dispose of because he had already sold everything. On 18 October Vermeer is nominated Deacon of St Luke's Guild for one year.

1665 The repeated violent behaviour of Catharina's brother Willem forces Maria Thins to place him in a house of correction.

1667 Dirk van Bleyswycks publishes his *Description of Delft* in which Vermeer is mentioned, but without any critical comment. However, the work also includes a poem by the publisher Arnold Bou who describes Vermeer as the successor and equal of Carel Fabritius (see *critical history*, p. 10). On 27 September Maria Thins draws up her will, leaving five-sixths of her fortune to Catharina and one-sixth to Willem.

1668 The date, although this is not certain, of *The Astronomer* in Paris (*31*).

1669 Possibly the date of the Frankfurt *Geographer* (*32*). On 2 January the "Mechelen" is put up for sale by Digna Vermeer, who, failing to obtain the asking price, lets it on 1 February for three years. Vermeer's brother is now living in the Vlamingstraat. On 18 October Vermeer is re-elected Vice-President of the St Luke's Guild.

1670 13 February Funeral of Digna Vermeer in the New Church. On 13 July Vermeer inherits the "Mechelen". On 18 October he is again chosen as Vice-President of the St Luke's Guild.

1671 Vermeer receives 648 florins as legacy from his sister Geertruyt who has died in the previous year; not a great sum, but still equivalent to two years' pay for a mason (one of the best paid professions).

1672 On 14 January he lets the "Mechelen" at (at 180 florins per annum) for six years to his name-sake, Johannes van der Meer, who takes up residence on 1 May. In May he goes with his colleague and fellow citizen, Hans Jordaens, to The Hague. Here, with several other artists, including Karel Dujardin, he has to value thirteen paintings that the best-known dealer in Amsterdam, Gerrit Uylenburgh (son of Rembrandt's dealer), had sold to the Elector of Brandenburg for 30,000 florins. The latter had rejected them as "clumsy copies and rubbish." The experts who had been summoned confirmed his negative opinion and declared that far from being by important Italian masters – as the dealer had stated – the paintings were quite unworthy of the painters to whom they were attributed and "were therefore absolutely valueless." It has been thought strange that Vermeer who, unlike many of his colleagues, had never been to Italy, should be invited to give an opinion of "Italian" paintings. And it has been said that expert advice was an organized activity, controlled by the Guilds and affording artists ample rewards. Vermeer is alleged to have been chosen because of his penetrating judgment, perhaps in his capacity as art-dealer, or – and why not? – because of the great reputation he enjoyed. The following month, Holland was invaded and savagely sacked by the French, who did not withdraw until the end of 1673.

1675 Vermeer's mother-in-law delegates responsibility over the matter of a will to him. The relevant document provides some certain biographical details: "This day, 5 March 1675, has appeared before me, Cornelis Pietersz Bleiswyck, public lawyer, at the Dutch tribunal in Delft, Mrs Maria Tins (*sic*) widow of the later Reynier Bollenes (*sic*) and mother and guardian of her son Willem Bollenes who has empowered her son-in-law Johannes Vermeer, a well-known painter, to represent her in the matter of the succession of the late Henrick Hensbeeck who has died in Gouda; and also to proceed with the division of his property, to take the necessary legal steps and pay the sum due to Willem Bolnes (*sic*). He will also cash the annual income of her son Willem Bolnes and deliver it to him, managing and executing the above-mentioned duties as a legal administrator should and in conformity with the mandate which my client confers upon her son-in-law in good faith . . ." There follow the signatures of Maria This (*sic*) and of a witness Pieter Roemer, a glass worker. On 5 July Vermeer contracts a loan of 1,000 florins, for which Maria Thins becomes guarantor in 1678. On 15 December "Jan Vermeer, an artist living in Oude Langendijk" is buried in the Old Church ("Oude Kerk"). The relevant document records that the master died at the age of forty-three, leaving eight children, all minors. He would thus have had twelve children in all, four having died in infancy in 1660, 1667, 1669 and 1673; however, Catharina certified in 1676 that she had eleven dependants, so it seems the total must have been fifteen. We know the names of nine of them: Johannes, Ignatius, Maria, Aleyda, Geertruyt, Catharina, Lysbeth, Beatrix and Johanna. Since their baptismal certificates have not been preserved, it is thought that they were brought up as Catholics (the name Ignatius, after the founder of the Jesuit Order, with which Vermeer is thought to have had dealings in Delft [see catalogue no. 35], is eminently Catholic). The naturalist Leeuwenhoek is named as Vermeer's executor.

1676 Vermeer's widow cedes two paintings to the baker Hendrick van Buyten to settle a debt of 617 florins, but reserving the right to buy them back at 50 florins per annum. The paintings might have been the Beit *Letter* and the *Lute-player* (28 and 29). Another debt owed to Maria Thins, his mother-in-law, was settled on 24 February with a *Self-portrait*, perhaps, but not certainly, *The Artist's Studio* in Vienna (24). Before this, on 10 February, Catharina had deposited 26 paintings with the painter and art-dealer Jan Coelenbier of Haarlem as a guarantee for a debt of 500 florins due in part to the grocer Jannetje Stevens. The following year, when this debt had been discharged, the executor Leeuwenhoek sets about re-establishing the Vermeer family's rights to these paintings, apparently in order to put them up for sale. On 29 February the inventory of the artist's possessions was drawn up. It reads as follows: "Inventory of items recognized as the property of Catharine Bolnes, widow of the late Johannes Vermeer who lived in Oude Langendijk at the corner of Molepoort. These items are actually in the aforementioned house: In the hall: A still-life with fruit, a small lake, a landscape. A small painting by Fabritius. "In the large drawing room: A picture of a poor farm. Another picture. Two portraits by Fabritius. Portraits of Vermeer's deceased parents. A design for a coat of arms for Mr Vermeer in an ebony frame. Furniture, some armour, a helmet and other small things; a Turkish cloak belonging to the aforementioned deceased Vermeer. Clothes and

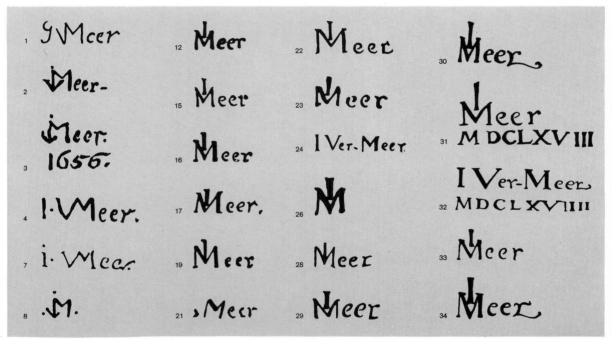

Extant signatures (some doubtful) from Vermeer's works. The numbers refer to those of the catalogue.

domestic utensils.

"In the dining room: A large painting of Christ on the Cross. Two portraits by Hoochstraten. A painting of various feminine garments. A painting of Veronica. Two portraits in Turkish costume. A seascape. A painting with a violoncello and skull. Seven panels of gilded leather on the wall. In the ground-floor room: Christ on the Cross, a Woman in a Necklace, without the artists' names.

"In the outer room: a walking stick with ivory inlay. Two easels, three paint brushes, six squares of wood, ten canvases, three packets of various colors, a writing desk and trifles.

The same day they drew up the inventory of the "items of which one half belongs to Mrs Maria Thins, widow of Mr Reynier Bolnes and the other half to her daughter, Catharina Bolnes, widow of the deceased Joannes (sic) Vermeer, which are actually in the house of the aforementioned widow (Catharina) in Ouden Langendijck (sic) in Delft: "Paintings: A Mars and Apollo; eight other pictures. Family portraits, a picture of the Three Wise Men, a Madonna. Eleven more paintings. A stone table for grinding colors, and the relevant pestle . . ."

Critics have concentrated their attention, not so much on the works of art (some of which must be Vermeer's own and the remainder examples of the paintings he dealt in), as

on the small number of brushes in the "outer room": three in all, giving scope to the theory that Vermeer worked little towards the end of his life. Perhaps it was because of his illness, but to judge from the documented record of the events of 1675, his death does not appear to have been preceded by a long decline. We should do better to avoid further guesswork and remember his widow's declaration, which is reported below. On 30 April Catharina petitioned the authorities with a declaration that she was unable to meet her debts. During the French invasion her deceased husband had painted little or not at all; worse still he had been constrained to liquidate his business to provide for his large family. However his widow continued the struggle to rescue her husband's works from compulsory sale. Finally, on 25 September 1676 Maria Thins cancels all previous arrangements and names as her heirs the children of Vermeer and her daughter Catharina (her son Willem having died in May of this year).

1680 27 December Funeral of Maria Thins, buried in the New Church next to her son-in-law.

1681 In July Catharina, in grave financial difficulties, contracts two loans of 200 florins each.

1682 Inventory of the estate of Jacob Abrahamsz Dissius,

a painter of Delft, includes nineteen paintings by Vermeer. In the catalogue of the Antwerp banker and jeweller Diego Duarte, dated the same year, one work by Vermeer is also listed.

1688 2 January Catharina Vermeer's burial in the Old Church. It appears from her death certificate that at the time of her death she was living in a house at the sign of the "Blue Hand" on Verversdijk.

1696 16 May in Amsterdam the dealer Gerard Houet arranges an auction of 134 pictures, 21 of them by Vermeer. The list of works and the prices quoted was discovered by Thoré-Bürger. Below we give the section relating to Vermeer, showing in parentheses – for the paintings which have so far been identified – the number in our catalogue:

1. A young woman weighing gold in a small dish; by J. van der Meer from Delft; painted with skill and exceptional power (18) – 155 florins.
2. A maidservant pouring milk; extraordinarily fine; by the same artist (9) – 175 florins.
3. Portrait of Vermeer in a room, with various accessories; of rare beauty; painted by himself (24) – 45 florins.
4. A young woman playing the lute; excellent; by the same artist (29) – 70 florins.
5. In which a gentleman is

washing his hands in a room on the second floor (doorsiende) with other figures; perfect and unusual – 95 florins.
6. A young woman playing the harpsichord in a room with a gentleman listening; by the same (15) – 80 florins.
7. A young woman handing a letter to a maidservant; by the same (27) – 70 florins.
8. A drunk maidservant asleep at a table; by the same (4) – 62 florins.
9. A jolly gathering in a room: energetic and fine; by the same – 73 Florins.
10. Gentleman and young girl making music in a room; by the same (13 and 14) – 18 florins.
11. A soldier with a smiling young woman; very fine; by the same (6) – 44 florins and 10 stuyvers.
12. A young woman working; by the same (23) – 28 florins. There follow, up to 30, works by other artists. Then:
31. View of the city of Delft, seen from the south side; by J. van der Meer from Delft (8) – 200 florins.
32. View of a house in Delft, by the same (7) – 72 florins.
33. View of some houses – 48 florins.
For some unknown reason (Perhaps owing to a printer's omission) 34 is missing.
Then:
35. A young woman writing; absolutely perfect; by the same (22) – 63 florins.
36. A young woman adorning herself; very fine; by the same (19) – 30 florins.
37. A young woman playing the harpsichord; by the same

(33 or 34) – 42 florins and 10 stuyvers.
38. A bust in ancient costume; extremely skilful – 36 florins.
39. Another one; by the same Vermeer – 17 florins.
40. A counterpart; by the same – 17 florins.

As for the prices quoted we might note that a *Head* by Rembrandt in the same sale was quoted at 7 florins and 5 stuyvers; a *Beheading of the Baptist*, attributed to Fabritius, and perhaps to be identified as the large painting in the Rijksmuseum in Amsterdam which was formerly attributed to Rembrandt and later to Drost, reached 20 florins. As for the remainder, it must be remembered that the auction under discussion was directly related to Vermeer's death (Van Eyden; Van der Willigen) and it was thought that the works put up for sale had all belonged to him. Conclusions of an almost biographical order have been drawn from the presence, among these works, of paintings ascribed to Titian, Bassano, Tintoretto, Palma the Elder, Ribera, Domenichino, etc., besides those of a large number of Dutch artists. However, Thoré-Bürger was in a position to oppose this theory and to assert that the sale might have been the *post mortem* auction of Jan van der Meer of Haarlem, who died in 1691 and had been an art-dealer as well as a landscape painter. But this supposition also seems to be without foundation.

Catalogue of works

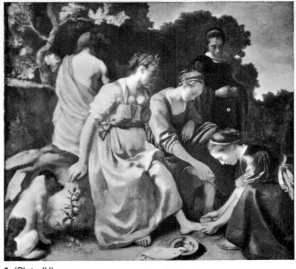

1 (Plate IV)

J. van Loo, Diana and the Nymphs *(formerly in Berlin, Kaiser Friedrich Museum); a detail reproduced in reverse to show its affinity with 1 more clearly.*

Nothing is known about Vermeer's early artistic development. To make up for this lack of information and the scarcity of youthful work, historians have come up with all sorts of conjectures. Bearing in mind that he enrolled in the guild of artists in Delft in 1653 (and that this must have followed an apprenticeship of at least six years to comply with the rules of the guild) they dismiss early theories that he undertook study tours; since there is no evidence for them in his paintings and no documentary confirmation, and instead embark on a close scrutiny of what his native city might have had to offer him round about 1647, which was probably the first year of his apprenticeship.

Swillens came up with the name of Leonard Bramer, a painter strongly influenced by Rembrandt who was much older than Vermeer (born in 1596) and came from a family which was probably in contact with that of his supposed pupil. But such Rembrandt-esque characteristics as may be seen in the very few works of the younger man hardly afford definite proof and they can be explained in other ways. A later suggestion was Emmanuel de Witte, who had settled in Delft at the age of twenty-four in 1641. He had, it is true, a taste for views bathed in light; but the only picture that could be offered as evidence of his influence on Vermeer is an *Interior of a House* in the Boymans-van Beuningen Museum in Rotterdam which some scholars consider to have been painted in Delft. I. Manke, however, convincingly assigns this painting to the year 1660, when De Witte had already been living in Amsterdam for some time. (If Vermeer knew a work such as the *Interior of the Oude Kerk at Delft* [1651; The Hague, Mauritshuis] it would be strange if he remained unaffected by it; its minute realism, spatial vigor and luminous atmosphere in many ways anticipate his own researches.) Goldscheider tentatively put forward the name of Hendrick van der Burgh, a member of the guild in Delft from 1649 to 1654: but in this case, too, the key work, an interior in the Berlin Museum, is not definitely attributed to him. Later suggestions are Paulus Potter, who arrived in Delft in 1646 and remained there until 1648 (though any relationship between his flocks of sheep, gleaming white in an earthy landscape, and the dignified interiors of Vermeer is not easily perceptible); Pieter de Hooch, who lived in the city

for about twelve years but only from 1654 onwards (if an example subsequent to that date is sought, it is perhaps enough that *The Artist's Studio* in Vienna [24] has been attributed to him); and Jan Steen who also came to Delft in 1654 (but what is there in common between his sharp humor and the majestic serenity of his putative pupil?); and above all Pieter de Hooch who lived for about ten years in the town, but only from 1654 onwards. However, even if one has to restrict de Hooch's influence to the period after that date, it is not enough that the *Allegory of Painting* in Vienna (34) has been attributed to him; the most that can be said is that there is good reason to believe that slightly before Vermeer, de Hooch was painting these domestic and intimist genre scenes, the pretexts for poetic studies of perspective and light and a faultless rendering of appearances, which, like the *Church Interiors* of E. de Witte or G. Houckgeest, responded to the same tendency towards plasticity characteristic of products of the Delft School in the years 1650–60. The most recent archival research (Montias) has also drawn attention to two other figures with whom Vermeer and his famiy seem to have been in close contact: firstly, Gerard Terborch of Deventer who co-signed a legal document with Vermeer in Delft on 22 April 1653, two days after the latter's wedding, which Terborch may have attended (the thematic and psychological analogies between the works of the two masters are often pointed out); secondly, the still-life painter Evert van Aelst, the teacher of de Witte, who borrowed money from Vermeer's father in 1643 and, together with L. Bramer, witnessed a document concerning his mother in 1653. Finally, it is interesting to note that of the eight painters whose names appear in documents connected with Reynier Vermeer, six specialized in still-life (notably P. van Steenwijk, B. van Ast and E. van Aelst) while the only two mentioned in connection with Vermeer himself are figure painters (L. Bramer and G. Terborch).

Faced with such difficulties it seems better – to say nothing of being fairer – to establish the absolutely definite elements in the young painter's life and bearing them in mind all the while to consider the various possibilities. *The Toilet of Diana* and *Christ in the House of Mary* (1 and 2) reveal Italianate characteristics which Italian interpreters

associate with the Caravaggesque style of the Utrecht school and with Orazio Gentileschi. Dutch scholars maintain that we must be still more precise. In about 1650 the last painters of Caravaggio's style were, it is true, still active in Utrecht: Jan van Bijlert and Jan van Bronckhorst were painting gay mythological scenes and pretty shepherdesses with Caravaggesque lighting, but the connection is not definite enough to place the early works of Vermeer in the same school; moreover in so doing one would lose sight of Gentileschi, with whom a more valid connection could be seen in Gerard van Honthorst, then a painter at the court of the House of Orange. Besides, if we accept that the two paintings mentioned recall Jacob van Loo, why not see in him Vermeer's probable teacher? Thus, for lack of any definite proof, the most we can do is acknowledge that Vermeer's mysterious training had some connection with the international Caravaggio style and that the figurative manner of the Utrecht school acted in some way as a mediator.

Shortly after his *Christ*, the young painter shows in *The Procuress* (3) the influence of the methods of Rembrandt, or rather of some of his pupils, in particular Carel Fabritius and Nicolas Maes and maybe even the German Christoph Paudiss. If we pause to consider the case of Fabritius, we know for certain that at thirty he left the studio of Rembrandt and went to live in Delft in 1652, staying there until his tragic death on 12 October 1654. His paint, the richest used by any of the Rembrandt circle, justifies the supposition that Vermeer derived from it the type of paint used in his Dresden canvas. (On the subject of Rembrandt, it is worth recording that Thoré-Bürger's theory, according to which the young Vermeer was associated with him in Amsterdam, gave birth to a tradition which some journalists still seem to accept with delight. For example, in a recent exhibition of Vermeer in Paris [1966] we read [*Epoca*

No. 842] an edifying tale about the father who, regardless of cost, led Jan to the celebrated master. The latter, struck "all of a heap" by his "seething imagination" and appropriating a mere "100 florins," agreed to teach the young boy. A tit-bit that Vasari at his most racy would surely have appreciated.) To return to Carel Fabritius: it is worth asking whether it is not precisely the more personal, least Rembrandtesque aspects of his art that had the most lasting influence on Vermeer: his taste for bright painting, the modulated depths in his light, the creamy texture, the daring treatment of space, almost trompe-l'oeil, and his intuition for subtle relationships between persons, things and their surroundings. At any rate these are what all Vermeer's later work reveals, to an even greater extent than the three works already mentioned.

As regards the chronology of the paintings the experts agree on the whole, usually with differences of not more than two or three years; though even these may not be overlooked in a period of activity as relatively short as Vermeer's. Yet not one of Jan's works is documented, and the dates added to several give rise to serious doubts. Only Valentiner and Malraux disagree. The former judges a rather high proportion of the paintings as juvenilia, concluding that they are earlier than those of De Hooch which may be dated about 1655. Malraux, on the other hand, dates the main body of Vermeer's master-pieces between 1660 and 1670, a view deduced from the age of the people in the paintings, amongst whom the connoisseur may recognize various relatives of the painter, although this does not offer any conclusive proof.

If, as seems reasonable, we suppose that the two *Girls* (4 and 5) in New York and Dresden are Vermeer's first achievements in a mature personal style (admitting, at most, traces of Willem Kalf in the still-life in the second picture), it is possible, with the aid of contemporary attempts at dating, to outline

the artistic progress of Vermeer as one of gradual refinement; we notice increasingly vigorous design and a more careful definition of volume, and above all a growing subtlety in color-light relationships which control the arrangement and gradation of planes. In this sense his progression from the *Girl* of Dresden to the Frick canvas (6) shows a considerable improvement, while the lofty calm of vision in *The Maidservant pouring Milk* (9) and its color structure, enriched with bright blobs of light (an exclusive characteristic of Vermeer) achieve a perfect harmony, a pure poetry. The same is true of the two *Views* (7 and 8), whether or not, as is frequently and often derogatively asserted, their structure is the result of recourse to the camera obscura: at the same time they show clearly – were such a demonstration necessary – that the use of that instrument required the liveliest sensitivity and discernment as well as the most vivid powers of invention.

Then, after the almost ob-sessive strain of measuring space he achieved an extreme formal delicacy (*The Woman in Blue* and *The Studio* [20 and 24]). In these, where ab-sence of measurable space gave no opportunity for dis-playing the charms of per-spective, the master wrought the glorious harmony of blues, yellows and whites (*his* colors), which were destined to reveal such ethereal figures as the *Girl wearing a Turban* (16); painting has never, perhaps, come closer in the use of these colors to the threshold of absolute, perfectly lyrical abstraction. It was a peak, the very limit of refinement; yet recent critics, in varying degrees, interpret it as a slackening of expressive force in comparison with his earlier work. At the same time one cannot deny that the artifice of view-painting, pursued to the point of exasperation and the achievement through color of the utmost luminosity, saved Vermeer from falling into mere anecdote. This is true even when – as in his

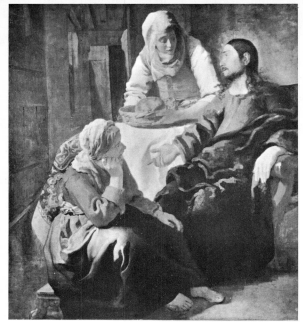

Works relative to 2 (top) A. Vaccaro, The Death of St Joseph (Naples, Capodimonte Museum). (above) J. Bilivert, Christ and the Samaritan (Vienna, Kunsthistorisches Museum). Only details of both pictures are reproduced here, the latter in reverse.

2 (Pls I–III)

Allegory of Faith (35) – he crowds the canvas with pictorial accessories endowed with symbolic value.

Vermeer does not appear to have had any pupils, although there are clear signs of his influence in the work of Gabriel Metsu, Michiel van Musscher, Cornelius de Man and perhaps other painters. So that if we want to talk of Vermeer's true followers we have to go forward to the "discovery" of Vermeer by nineteenth-century critics; these followers were eager, but were never strong enough to raise the problem of distinguishing between their works and their master's; we have only to think of Claus Meyer (1835–1919).

The study of Vermeer was strongly affected by recent forgeries which at first aroused enthusiastic acclamation and were discovered only when the forger himself confessed (see Appendix); several of the most distinguished Dutch art historians fell headlong into this trap. After this critics displayed extreme caution (too extreme in some cases) in reconstructing the catalogue of Vermeer's work, removing any work that offered the slightest doubt. Not that this revision was useless: quite the contrary; and in any case it had been going on for some time. The seventy-six pictures attributed by Thoré-Bürger to Vermeer were reduced by Havard, twenty years later, by fifty-six; and in 1907 by Hofstede de Groot to thirty-four. Then the number rose to thirty-eight or more; nowadays some experts only accept about thirty. What does seem unjust is their attitude to earlier paintings attributed to Vermeer which have now fallen from favor; they are no longer discussed, not even to confirm their illegitimacy, as though a critical optimum had been reached and there were no obvious problems left. This much at least should be said as indirect evidence of the difficulties encountered in presenting this study of reproductions and notes about the paintings which, for good or ill, retain their connection with the posthumous history of Vermeer.

1 98,5 × 105 *1654

Diana and Nymphs (The Toilet of Diana)
The Hague, Mauritshuis
Behind the brown and white puppy (the only animal to appear in Vermeer's *oeuvre*) on the rock on which Diana is seated, there was once a signature which is all but invisible since the cleanings of 1932 and 1952. The museum catalogue published in 1895 records it: "J(ohannes) R(eyniersz) V(er) Meer." The picture was purchased for 10,000 francs at the sale by auction of the Neville D. Goldschmidt Collection in Paris in 1876; Goldschmidt had got it from Dirkens, a dealer in The Hague, for 175 florins. The young woman, the nymph, kneeling on the right, in the act of drying the feet of the goddess (identified by the diadem with a half-moon) has the same clothes, if not the same features, as the *Young*

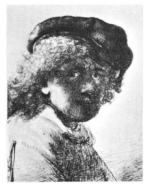

Rembrandt. Self-portrait (engraving). A detail, shown in reverse to offer a point of comparison with the first figure on the left in 3.

Girl asleep in New York (4). Since the latter is often acknowledged to be the painter's wife, there has been considerable speculation about the subordinate

position of this figure who might, in fact, also be Catharina Vermeer (Goldscheider). The painting was attributed by its former owners to Nicolas Maes, whose fake signature had been added; in the 1895 catalogue a false interpretation of the now visible signature caused it to be attributed to Jan van der Meer of Utrecht. After 1907, when Bode definitely accepted it and Hofstede de Groot tentatively acknowledged it, all the critics agreed upon its attribution to Vermeer of Delft, except Hale (1937) who inclined to Anthonie Palamedesz, and Swillens who, curiously, attributed it to the painter's father, Reynier. The superiority of this picture to the identical subject painted by Jacob van Loo and dated 1648 (formerly in the Kaiser Friedrich Museum in Berlin, destroyed in 1945) has been generally recognized again thanks to Bode.

The work in question was shown in 1951 in Milan at the Caravaggio exhibition to display Vermeer's debt to the Caravaggesque painters of

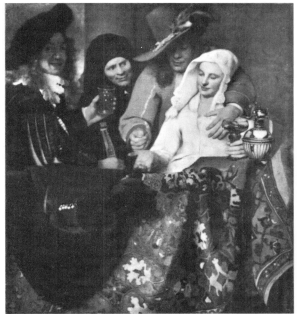

3 (Pls V–VI)

Utrecht as well as to Orazio Gentileschi (cf. R Longhi, A 1916 and VA 1927); nowadays the brilliant colors remind several scholars of Venetian painting (Goldscheider etc.) and Martini suggests Giorgione in particular. The work's outstanding merits are to be seen in the texture of its coloring, but this does not mean that we share the reservations expressed about the choice of composition. Complex as this may be it is certainly in no way diminished by the prominence of feet at the bottom of the picture which – says Descargues – Vermeer probably attempted to correct by means of the bowl and the small towel which looks like a dove about to drink. Marcel Proust (whose passion for Vermeer is revealed in this passage) talks about the painting in connection with the story that his own Swann had initiated concerning the master of Delft. "He was convinced that a *Toilet of Diana* acquired by the Mauritshuis at the Goldschmidt auction as a Nicolas Maes was, in fact, a van Meer." Successive

cleanings have considerably spoiled the quality of this picture.

2 160 × 142 *1654–55

Christ in the House of Martha and Mary
Edinburgh, National Gallery of Scotland
The signature, on the stool in the lower left-hand corner, was discovered in 1901. Towards the end of the last century the painting was bought for £8 by a furniture dealer from a man in Bristol; it then belonged to Arthur Leslie Collie of London, and later to the London antique dealers Forbes and Patterson (where the signature was discovered). Eventually it went to W. A. Coats of Skelmorlie Castle in Scotland, whose sons presented it to the gallery. The subject is taken from the Gospel of Saint Luke (X 38): and we may recognize Mary in the woman on this side of the table, with Martha on the other side. There have been attempts to compare the figure of Mary with the kneeling figure in *Diana* (1) and then, of course, to discover a portrait of Vermeer's wife with the usual, vaguely Freudian theories about the similar subordinate position (Goldscheider). And again, as with *Diana*, reservations have been expressed about the composition, that it is heavy and oppressive, and "colored rather than painted" (Descargues). The color is certainly very forcefully achieved by means of broad, solid brush strokes closely resembling the style of the Caravaggesque Terbrugghen ("whose foreshadowing of Vermeer has already been noted": R. Longhi, in the catalogue of the Caravaggio exhibition in Milan, 1951). A forerunner of the figure of Christ has sometimes been pointed out in *The Death of St Joseph* painted by Andrea Vaccaro (Naples, Gallery of Capodimonte); comparisons have also been made with works by Erasmus Quellin (Valenciennes, Museum) and Alessandro Allori (Vienna, Kunsthistorisches Museum). As Goldscheider comments, such figures were widely used in Italian painting between 1500 and 1600. Goldscheider suggests another comparison with *Christ and the Woman of Samaria* by Jan Bilivert, painted in about 1640 (Vienna, Kunsthistorisches Museum). He also states that the style of the drapery recalls Jacob van Loo. After the discovery of the signature, authenticity was generally agreed; only Swillens attributes it to Johann van der Meer of Utrecht, instancing (but not very convincingly) the two signed works by him in the Warsaw Museum. The Redeemer's right hand reveals a slight repainting in a different position; and the index finger on the left hand has also been altered by the·

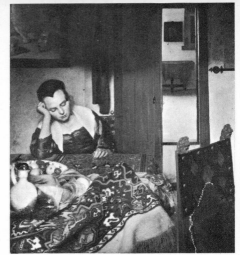

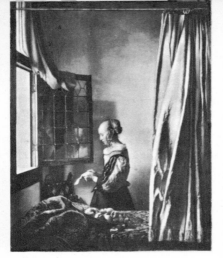

4 (Pls XIII–XVI)

5 (Plate X)

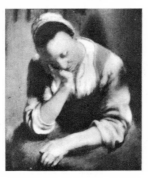

Work related to 4: Mourner from a Greek tomb, fourth century BC (Berlin, Staatliche Museen) Nicolas Maes, Sleeping Girl (1655, London, National Gallery, detail reversed).

painter himself. The lower part of the figure of Mary may also have been retouched in the course of restorations (Goldscheider, p. 133).

3 143×130 1656

At the Procuress's: The Courtesan

Dresden, *Gemäldegalerie*
It is signed and dated 1656 in the lower right-hand corner. Renoir, who said that he had travelled from Bayreuth to Dresden specially to see this work, writes: "In spite of the title, this young woman has a most honorable expression. There are two men standing beside her, one of whom has a hand on her breast; only thus may we understand that she is supposed to be a courtesan." Malraux recognizes in this woman the painter's twenty-six-year-old wife, while Goldscheider, who agrees with this thesis, expresses surprise that Vermeer should have gone so far after only three years of marriage, but he goes on to

note that Rembrandt went almost as far in the portrait of himself with Saskia on his knees (Dresden, Gemälde-galerie), a fact which Thoré-Bürger had recorded earlier. In the young man on the left, who seems to be an obliging musician friend, René Gimpel (Congress of Art History, Brussels 1930) discovered Vermeer himself. He bases this on the somewhat questionable fact that the figure is wearing the same clothes as those of the painter in *The Artist's Studio* in Vienna (24). His view has found wide support (Huyghe Van Thienen, etc.); and it has even been suggested that the bawd was inspired by the artist's mother-in-law; all this with the irritating aim of extracting every possible ounce of biographical detail. This painting is one of many which found their present home in 1741 when they were acquired from the collection of Count Wallenstein of Dux (in modern Czechoslovakia). Until 1862 it was catalogued as a work by Jacob van der Meer of Utrecht: then it was unanimously attributed to Jan Vermeer, Swillens alone casting grave doubts. For a time it was compared with the work of Rembrandt, especially because of the magnificent play of light and shade on the face of the man presumed to be the artist. Thoré-Bürger conjectured that, after the death of Carel Fabritius in 1654, Vermeer had gone to Amsterdam and that the present work was painted there, actually in Rembrandt's studio. But Fabritius himself may have introduced Rembrandtesque characteristics in Delft after 1650. Besides, the courtesan was a frequent theme in the work of the Utrecht School; Dirck van Baburen's version of it appears twice on the wall in paintings by Vermeer: *The Concert* (14) and *Woman seated at the Virginals* (34). Those who revere academic rules usually point out serious faults in the composition of this work, discovering that these rules have quite clearly been broken, in that the four figures are all depicted on the same plane (Blum), or else because the whole picture can be divided in two, both horizontally and diagonally (the imaginary line runs along

the young woman's out-stretched arm and divides the light area from the area which is predominantly in shadow) thus making two triangles of contrasting tones and leaving three hands at the center (Hale). Even Goldscheider admits these so-called weaknesses (although he acknowledges that they do not invalidate the superb quality and calls the painting a "beginner's masterpiece", but it is all the more noticeable that space is not yet an essential factor in the basic composition and that the faces reveal psychological intentions which the artist was soon to abandon. Notice, on the other hand, the exquisite play of colors, the brilliant lemon-yellow of the prostitute contrasting with the grandeur of the rug and with the red of the young client's costume. The latter's left hand has been repainted smaller than it originally was. The shadowy areas are badly cracked.

4 87,5×76 *1655-60

Young Woman (or Girl) asleep

New York, Metropolitan Museum (Altman)
This title has been generally accepted, but it does not seem to suit the interpretation of the subject. The seated figure leaning on one elbow has long been used, in the figures on Greek tombs or in Gothic miniatures etc., as a personification of grief. Moreover in the picture hanging behind the woman the figure of Cupid can be seen with a mask at his feet. This creates so strong a sense of disappointed love that the

woman may not be asleep but overwhelmed by grief (Swillens). But many are inclined to see in it an erotic meaning, or at least "a fantasy of love" (Gowing). Others are doubtless more correct in seeing it as an allegory of idleness, or even as a warning against the dangers of sensual pleasures (Kahr, MMJ 1972). Again, this could be yet another picture of Vermeer's wife; a possibility which, together with the suggestions of erotic meaning, has not failed to give rise to the usual psychoanalytical interpretations. It is worth noting that this picture, which was sold in the 1696 auction as no. 8 for 62 florins, was described in the catalogue there as "A drunk girl sleeping at a table." It is almost unanimously agreed that the picture on the wall at the back is the *Cupid* of Cesar van Everdingen, which belonged to Vermeer who reproduced it both in the Frick *Music* (13) and in his *Woman standing at the Virginals* (33). The work reappeared in 1881 at the J. W. Wilson sale in Paris; it stayed in Paris, in the possession of the dealer Charles Sedelmeyer, and later belonged to R. Kahn. In 1907 it was purchased by the firm of Duveen in London; and the following year became part of the collection of B. Altman in New York, who presented it to the Metropolitan Museum. Evidence of the influence of it on Nicolas Maes is widely acknowledged; he might have stayed in Delft in 1653 after the period he spent with Rembrandt, and this picture has much in common with his *Servant Girl asleep* (London, National Gallery). The superiority of 4, however, to the work which is supposed to have inspired it is also widely accepted. This is true despite the fact that the composition and perspective that Vermeer here employed are still not entirely successful, not so much because the steep recession of the table is not in harmony with the rest, as Blum maintains, but because of a kind of arbitrary quality such as one does not find in his happiest achievements (whence the assumption that this is an early work). But the rendering of the gleaming blobs which appear here for the first time – on the lion's-

head chair which features in so many of the master's later works – and the painting of the superb still-life in the foreground are already masterly. Unfortunately this, and especially the glass of wine, have suffered from unskilful cleaning. Acceptance of its authenticity is unanimous, and Swillens considers it to be the first known work of Vermeer. Only Hale rejects it, quoting the contrary opinion of certain other painters whom he had consulted.

5 83×64,5 *1657

Young Woman (or Girl) reading a Letter near a Window.

Dresden, Gemäldegalerie
There are traces of a signature in the background on the right, near the figure. It is unanimously agreed that the young woman is reading a letter. Malraux again sees a likeness to Vermeer's wife, at the age of twenty-seven. Goldscheider notes that the woman is similarly dressed to the girl with the soldier in the Frick painting (6); and the reflection in the leaded panes of the window does suggest that she is the same. The same critic discovers in the whole composition a likeness to various *Annunciations*, by Crivelli, Grünewald and others. It was bought in Paris in 1742 by de Brais for Augustus III, Elector of Saxony. In the old Dresden catalogues it was attributed to Rembrandt and classified under the name of Govert Flinck; more recently it was attributed to Pieter de Hooch; since 1862 it has been generally accepted as a Vermeer. It is probably an example of the first complete work on Vermeer's favorite theme: the play of light from a window upon a single figure. There is a fine still-life of fruit (which Gerson calls "in the style of Kalf") on the heaped rug (the foreground "barrier" so common in Vermeer); there are the usual lions'-head chair and window; and a motionless girl in profile whose hair is intricately dressed and whose clothes are strewn with "blobs of light" which lighten them; and even the reflection in the panes is reduced, in the economy of its composition, to a mere hint (without the

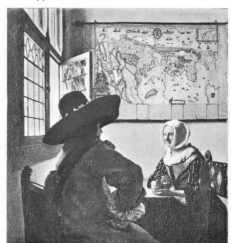

6 (Pls VII–IX)

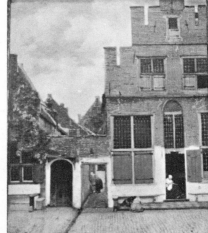

7 (Plate XXVII)

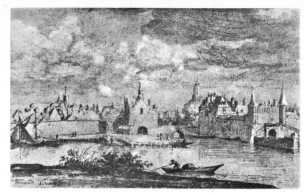

View of Delft *(pencil and brown watercolor, with pen touches and lighting in white lead, on blue paper. Frankfurt, Staedelsches Kunstinstitut; it was acquired in 1833 for ninety-two florins at the Vos auction in Amsterdam). Thoré-Bürger and various other critics thought it was an autograph sketch, in preparation for painting 8; according to Swillens, it may date from the eighteenth century, as the nature of its ground would indicate.*

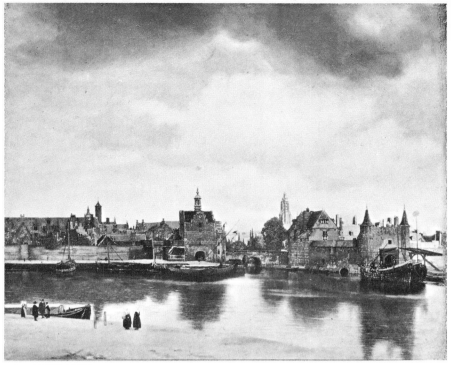

8 (Pls XXVIII–XXIX)

faintest trace of any attempt at naturalism. There is a curtain hanging in folds (a typical feature in Dutch painting): in other words we have here the customary elements of Vermeer's work. But in his so-called "monotony" he displays an undeniable eloquence, an exquisite harmony of color and light which speaks for itself. The general coloring seems to be rather dark but this is probably a result of the deepening of the blues (Goldscheider).

6 50,5 × 46 *1657*

Soldier and smiling Girl
New York, Frick Collection
The girl is wearing the same dress as in the previous picture as most scholars have noted; the window and the chair are also the same. The question of whether the scene is of a lodging house with a prostitute and an adventurer has been discussed *ad infinitum* by those experts on Vermeer who cannot shake off a persistent curiosity about his subject-matter. Their idle speculations should be disposed of once and for all by Havard's shrewd observation (1888) that the importance of Vermeer's characters depends on "the mark they make and not on the idea they express." The map is of Holland and Friesland (now a province of the Netherlands) as the inscription makes plain NOVA ET ACCURATA TOTIUS HOLLANDIAE WESTFRISIAE Q. TOPOGRAPHIA. It was drawn in 1620 by the cartographer Balthasar Florisz van Berckenrode, and nine editions were published by Willem Jansz Blaeu between 1621 and 1629. It also appears in the Amsterdam *Woman in Blue* (21). The painting may be identified with no. 11 in the 1696 Amsterdam sale (44 florins, 10 stuyvers). Acquired at the C. Scarisbrick sale (London, 1861) by L. Mainwaring (£87 3s.). Thoré-Bürger noted it in Paris in the collection of L. Double, who had bought it in London for £246 15s. 0d. as a work by Pieter de Hooch; in 1881 it came into the possession of Prince Demidoff of San Donato (Florence); and thence

traveled to London to S.S. Joseph. In 1911 it became part of the Frick Collection. Swillens believed he could establish that the painter was working about six feet away from the window. Gerson is more convincing when he says that "for the first time" in Vermeer's work "we find ourselves in front of an absolutely limpid picture." It was cleaned in 1951.

7 54,3 × 44 *1658-60*

A Street in Delft
Amsterdam, Rijksmuseum
Signed in the bottom left-hand corner, below the window. Swillens says that this is the view from the back of the "Mechelen" on the Voldersgracht side; the alley opposite led to an old people's home, while the house to the right would be the one pulled down in 1661 to make way for the new building for the Guild of St Luke. From this he deduces a *terminus post quem non* for the picture. It can be identified as no. 32 *(View of a House in Delft)* of the Amsterdam auction in 1696 (72 florins). The work came to light again in 1800, at the G. W. Oosten de Bruyn sale in the same city Delft; it then went through the collections of Van Winter and Six van Hillegom and was bought in 1921 for 680,000 florins by Sir H. Deterdin, who presented it to the Rijksmuseum. It is believed that Vermeer made use of the camera obscura in working on this picture. Liebermann's comment that this was "the most beautiful of easel paintings" may be banal, but it gives an idea of the enthusiasm aroused by this work. Writing in almost the same terms in 1866, Thoré-Bürger declares, "Vermeer portrays only a little street and a sliver of sky between two roofs: nothing at all, but exquisite." Even better, Malraux points to a successful resolution of spatial problems comparable with that found by modern painters. This gives the *Street* "among so many pictures with the same bricks, its incorruptible style". The blue of the foliage on the left (see plate XXVIII) has been caused by the weakening of the

yellow; Goldscheider finds a special fascination in it, not unlike that of similar changes in the *View of Delft* (8). Like that painting, and unlike other works by Vermeer, the *Street* has been copied several times.

8 98,5 × 118,5 *1658-60*

View of Delft
The Hague, Mauritshuis
Signed on the boat, in the bottom left-hand corner. Bloch gives a careful topographical description of it. "The town of Delft is viewed from the Rotterdam canal; the Schiedam gate is in the center, to the right the Rotterdam gate; between the two gates in the background the tower of the New Church where Vermeer was baptized; the other tower, further left, belongs to the Old Church where he was buried." In the Amsterdam sale in 1696 it was no. 31 ("View of Delft seen from the south side") and made 200 florins. The subsequent history of the picture is not as Thoré-Bürger retold it; it appears that the picture was actually sold in 1822 at the S. T. Stinstra sale in Amsterdam to the Dutch government for 2,900 florins. It is among Vermeer's most famous and most highly praised works. Modern critics notice that the painter paid particular attention to the weather and as a result have

called it the first Impressionist painting. Rather than a mere "view in perspective" it is a glimpse of sun on the city after a storm, and the play of light and shade is the picture's most enchanting feature. On the right the sun has caught Delft and lit some of its roofs and façades in such a way that they almost merge into the intensely bright sky, while the buildings in the left cut sharply into it, still covered with a cold, uniform light. Everything seems to be still wet, but fresh, an effect achieved by the *pointilliste* technique which causes us with surprise to "compare the painting with embroidery" and to recall the "brilliant enamel of Oriental ceramics" (Bloch). The boat on the left, for example, if viewed from the appropriate distance, seems to be rendered naturalistically and enriched with reflections of the light in which it appears. A closer examination reveals "an indecipherable gleam of drops of light; a handful pearls which have fallen by accident" (A. Martini). This time the reference to Impressionism seems justifiable; and still more so if we consider the detail (this really is *à la Monet*) of the exact time chosen: the clock on the Schiedam gate says 7.10. In 1842 Thoré-Bürger was already enthusiastic

about the *View* and from this enthusiasm originated the rediscovery of Vermeer. After him many French writers were fascinated by it, from Théophile Gautier and Maxime du Camp ("painted with a vigor, solidity, and firmness of impasto very rare among Dutch artists" [RDP 1857]), to Marcel Proust, who described it as "the most beautiful painting in the world" (see *Critical History*). A little later, in *La Prisonnière* (1924) it inspired his famous passage on the "little area of yellow wall" by which Bergotte dies. On the right of the woman with her back to us there was definitely once the figure of a man which Vermeer himself painted out, though it can still just be seen. The blue in the trees (but not the blue in the water) has intensified as the yellow has faded (see 7). A drawing in the Staedelsches Kunstinstitut in Frankfurt (pencils and watercolor with highlights in white lead, 183 × 290 mm.) was long held to be the sketch for the present painting, and was highly thought of even in the last century (it fetched 92 florins in the De Vos sale in Amsterdam in 1833); but, since at least the time of Swillens, it has been thought to be a copy, probably dating from the eighteenth century.

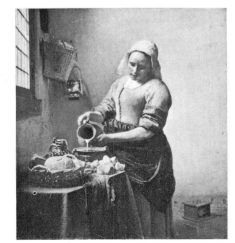

9 (Pls XXX–XXXII)

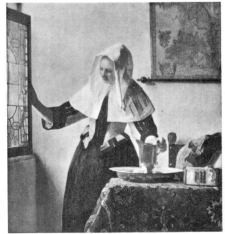

10 (Plate XXXIII)

89

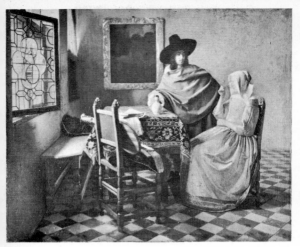

11 (Pls XIX–XXI)

12 (Plate XXII)

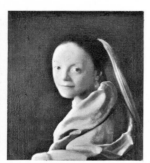

Jan Steen, The Music Lesson (c. 1656 Rotterdam, Boymans Museum). *This is a detail in reverse to offer a comparison with the figure to the left in 12.*

9 45,5 × 41 *1658–60*

Woman pouring Milk (The Milkmaid: The Cook)
Amsterdam, Rijksmuseum

As well as the components of the unusual still-life in the foreground, and the basket and warming-pan hanging high up on the left, a foot-warmer can be seen in the opposite corner, in front of the skirting of painted tiles. This is no. 2 of the Amsterdam auction in 1696. "A young woman pouring milk, extraordinarily good," valued at 175 florins. It appeared in five later auctions in the same city and the prices obtained tell the history of Vermeer's work; 320 florins (1701), 126 florins (the J. van Hoek sale in 1719), 500 florins (P. Leendert of Neufville, 1765), 1,550 florins (J. J. de Bruyn, 1798), 2,125 florins (H. Muilman, 1813). Eventually it became part of the famous J. Six Collection in Amsterdam, reaching its ultimate destination in 1908, apparently for half a million florins. Even in the time of Sir Joshua Reynolds (*Journey to Flanders and Holland*, 1781) it was among the most popular of Dutch paintings: a kind of emblem of the Netherlands. The critics have especially drawn attention to its realism – *'Le monde est devenu peinture'* (Maulraux, 1951) – and to the monumental modeling of the woman. This very realism, which is certainly more emphatic here than in any other of Vermeer's works (*Lumière*, 1966), has led many interpreters to see in it the effects of recourse to the camera obscura, and to criticize its use. The answer to such criticism lies in the grandeur achieved and even more in the splendid harmony of yellows and blues so typical of Vermeer, to say nothing of the extraordinary Crivelli-like blobs of gold on the basket, rolls and jug, giving them an irresistible physical presence.

10 45,7 × 42 *1658–60*

Woman with a Water Jug (Woman at the Window)
New York, Metropolitan Museum

The urge to supply a narrative element has given rise to the assumption that the woman is about to water some flowers

on the window-sill. The window panes and frame, the little chest, the Oriental rug, the lions'-head chair, the map of Europe and the woman's clothes are all features from Vermeer's usual repertory. The map of the Netherlands is identical to the one published by Huyck Allart in 1671, and is no doubt an earlier edition of it. In 1877 it was bought, as a work of Gabriel Metsu, in the Vernon sale in London by the dealer Colnaghi, who sold it to Lord Powerscourt of Enniskerry (Dublin); in about 1880 it was on the market again, offered by the Parisian firm Bourgeois Frères; and in 1887 it was bought from the dealer Pillet, also in Paris, by H. G. Marquand of New York, who presented it to the Metropolitan Museum in 1888. Because of its exquisite calm, it is one of the most important of Vermeer's variations of this, his favourite theme. "This is one of Vermeer's most skilful paintings. It is free from falterings or weak passages. Its color scheme resolves itself into blues and yellows, interspersed with a certain amount of grey. Hardly anyone but Vermeer had conceived of such a color scheme in his day" (Hale). Moreover a veil seems to hang like a grey-blue breath over the density of the skirt, the stripes of the bodice, the coif and the starched mantlet, and also in the "aquarium" light which strokes the smooth wall and makes the limpid dish reflect the rug. These indescribable effects may be the result of a change in the blues.

11 65 × 77 *1660*

Gentleman and Girl drinking
Berlin, Staatliche Museen

The framed window is almost identical with the one in the previous painting and also in several others. But because of the coat-of-arms it most closely resembles the window of the Brunswick canvas (12); the heraldic emblems are probably those of Jannetje J. Vogel, the first wife of Moses J. van Nederveen, a neighbor of Vermeer in the main square in Delft (Neurdenburg O-H 1942). On the chair, a guitar with a difficult musical part dangling from a cushion; in the background, a painting of a wooded landscape by an

unknown artist. Information about this picture dates back to 1736, when it was priced at 16 florins in J. van Loon's sale in Delft; in 1891 it appeared in the catalogue of Lord Pelham Clinton Hope's Collection in London; and a few years later (1898) it belonged to the dealers Colnaghi, also in London; in 1901 it was purchased by the Berlin Museum for £5,000. A photograph taken at the time reveals that, where the window now is, a landscape had been painted, perhaps to conceal the coat-of-arms which might have been an embarrassment to dealers, or – as one can deduce from other details – to disguise the work as Terborch. Cleaning, undertaken at the time of its acquisition (1901) under the direction of Bode and Friedländer, has damaged it slightly (the light area of the bench, the part of the chair which is in shadow, the head-dress etc.; the woman's left hand has been retouched).

12 78 × 67,5 *1660*

Two Gentlemen and a Lady (or a Couple) with a Glass of Wine (The Coquette)
Brunswick, Herzog Anton Ulrich Museum

Signed on a window pane in the lower right-hand corner. The window itself with the coat-of-arms is the same as in 11. The serious figure in the portrait at the back has not been identified. Descargues believes that he has some ironic significance. He also thinks that the picture recalls the composition of 65. The gentleman on the left, whom Thoré-Bürger thought was asleep, reminds Goldscheider of a similar figure (though with eyes open) in *The Music Lesson* painted by Jan Steen in about 1656 (Rotterdam, Boymans Museum). Since

1813 it has been in the Duke Anton Ulrich Collection in Brunswick in the Castle of Salzdahlum (Wolfenbüttel). It was already there by 1711; in 1776 it was catalogued as Jan Vermeer (Eberlein), whereas an old catalogue of the museum attributes it to Jacob van der Meer. Descargues points out the difference in color texture between this painting and others of similar subject and composition. But it is obvious that the picture is in poor condition. Plietzsch describes it as "ruined" and declares that the only part which gives any idea of the picture's original quality is the still-life on the table (a dish with oranges and a jug). It is clear that careless restoration is responsible for the alleged coquette's mawkish expression. See in particular her eyes, her mouth and her right hand; the man's face has also suffered. The tone of the varnish is too warm and has darkened the picture.

13 38,7 × 43,9 *1660*

Gentleman and Girl with Music (The Music Lesson: The Duet; The Visit; Interrupted Music)
New York, Frick Collection

De Vries and Plietzsch mistakenly call it a painting on wood. Of the various titles given, *The Music Lesson* is the more appropriate since the man – a visitor – is wearing a cloak. The painting in the background is the same *Infant Cupid* visible in 4 and clearly depicted in 33; a violin, bow etc. had been crudely painted over it; the little cage hanging on the left must also be an apocryphal addition (Swillens). On the table are the same lute as in 11 and the same jug as in 14; the window is the same as in several other paintings of this period. The woman's posture,

with her face turned towards us, is unusual, though not unique in Vermeer, and suggests a portrait. Thoré-Bürger relates it to no. 10 of the 1696 sale ("Gentleman and a girl making music in a room"), an identification which modern critics have mostly ignored: they maintain – uncertainly – that it is the Boston work (14). There is no doubt that it was no. 57 at the De Smeth van Alphen auction in Amsterdam in 1810, in the catalogue of which the "gentleman" is called a "music master" while the violins and other accessories hanging on the wall are duly mentioned; at this sale a certain De Vries bought it for 610 florins. The following year it was at the H. Croese sale (399 florins); and then in 1820 at that of C. S. Roos (330 florins): but Thoré-Bürger suggested that the painting in question might have been the one now in Buckingham Palace (15). In 1859 it belonged respectively to the collections of Woodburn, Francis Gibson, and L. Fry (Bristol); then in 1900 to Lawrie, a London dealer, where it was bought in 1901 by H. Frick. It was cleaned in 1900 and 1949; it still shows marks of the overpaintings (especially in the girl's skirt) and, although the various restorers may not be responsible, it can be seen that the colors have changed (the blue of the notes on the sheet of music, for instance, has probably been intensified). For these reasons it is difficult to know when to date it between 1658 and 1662.

14 69,2 × 62,8 *1660*

Concert Trio
Boston, Isabella Stewart Gardner Museum

Although this painting is sometimes considered to be a pendant to 15, Goldscheider points out that their different size makes this unlikely. The first known reference is in the catalogue of the J. L. Strantwijk sale (Amsterdam, 1780), at which the painting was acquired by D. van Leyden van Vlaardingen. It reappeared at the van Leyden sale in 1804 in Paris (sold to Pallet for 350 francs), then in London for the first time at Foster's in 1835, and later at the Lysaght sale at Christie's in 1860, where Tooth acquired it for £21. In 1866 it was bought by Thoré-Bürger at the Demidoff sale (Paris), and then on behalf of Isabella Stewart Gardner by Berenson at the Thoré-Bürger sale (Paris, 1892; 9,000 francs). As for the two paintings on the back wall, on the left is a wooded landscape by an unidentified artist; on the right is *The Procuress* by Dirck van Baburen, signed and dated 1622, which belonged to Vermeer himself and is now in Boston (Museum of Fine Arts). Here it has a black frame; we shall find it in a gold frame in 34.

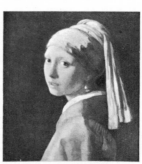

16 (Pls XXXV–XXXVI)

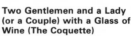

17 (Plate XXXIV)

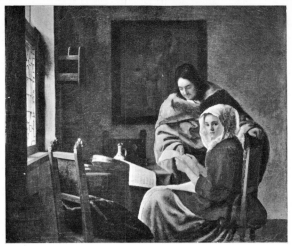

13 (Pls XI–XII)

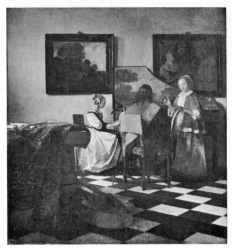

14 (Pls XVII–XVIII)

15 (Pls XXIII–XXVI)

The subject is alleged to have been introduced as a hint of profane love, with reference to the music-makers (De Mirimonde, G.BA 1961).

15 ⊞ ◉ 73,3 × 64,5 *1660* 🗒 ⁝

**Lady at the Virginals with a Gentleman
(The Music Lesson)**
London, Buckingham Palace
Signed on the right, above the jug, on the frame of the painting hanging on the back wall. The second title is rejected by Descargues, who is certain that the woman is not, at most, playing but, at most, strumming. He also thinks that the instrument is most likely the work of Ruckers of Antwerp or their school. On its frame is clearly written: *Musica Letitiae Co(me)s – Medicina Dolor(um)*; the incomplete words, which are partly hidden by the woman's head, have also been read as *consors* and *doloris*, but the sense is little different: Music is the companion of joy (or its "consort"), and medicine that of pain (or grief). The picture to the right of the mirror may represent *Roman Charity* (Gowing) (the moving story of Cimon and Pero was very frequently depicted by the Dutch Caravaggisti, see Pigler, *Barockthemen*, II, 1956) and to judge from the little of it that can be seen it recalls the style of Dirck van Baburen. The gentleman dressed like a Spaniard could be Vermeer himself (Huyghe, Malraux *et al.*) since he resembles other figures which are presumed to be self-portraits. The figure of the woman is that of 5 (Dresden) and 6 (New York). The picture is certainly no. 6 of the 1696 auction ("A young woman playing the harpsichord in a room and a gentleman listening"; 80 florins). It may have been included in a sale in Amsterdam in 1714, in which case it would have been acquired for 55 florins by the Venetian painter and picture dealer G. A. Pellegrini, whose widow sold it around 1741 to the British consul in Venice, J. Smith, who resold it, as a work by F. van Mieris to George III (W. van de Watering, in Blankert 1978). Among the works on a similar theme that we have already discussed this one is quite outstanding. The sense of

space seems to be superbly stated from the table and 'cello to the ground (and compared with the previous painting their function in the perspective of the picture is very much enhanced by the light) and this gives the tiling on the floor a more obvious importance. The mirror reflecting the woman's face, and the crystal-clear light – the good condition of the painting enables us to appreciate its atmospheric quality – give the picture a faintly magical atmosphere.

16 ⊞ ◉ 46,5 × 40 *1660-65* 🗒 ⁝

Short Bust (or Head) of a Girl in a Turban (or with a Pearl in her Ear)
The Hague, Mauritshuis
Signed on the edge of the upper left-hand corner. Malraux identifies the girl as Vermeer's youngest daughter; not many experts, however, hold the same view, especially since the probable dating of the picture precludes it. The turban might be part of one of the Turkish costumes which were among Vermeer's possessions at his death. Moreover, it is doubtful whether it could have been no. 38 in the 1696 sale ("a bust in antique dress; extremely artistic – 36 florins"), or one of the related works bearing the numbers 39 and 40 (see commentary on the following painting). It came on the market at the modest Braam sale (Amsterdam 1882) and was bought for only 2 florins, 30 stuyvers by A. A. des Tombe (this is the name usually cited, but it does not seem to be correct). He presented it to the Mauritshuis in 1903. Goldscheider thinks it possibly the best of Vermeer's works; it is certainly extremely famous, to the extent of having been called the "Mona Lisa of the North" and has given rise to the most passionate comments. Let that of Jan Veth (MBK 1938) suffice for the present: he calls the painting "a fusion of ground pearls" (more plausibly, H. Gerson points out that "the white of her eyes reflects the light like the pearl hanging from her ear") and says that the girls is like "a consoling star which shines alone in the vast night sky" (see also Critical

Outline). Bloch asserts that no less appropriate comparison could be made than that with the Leonardo. One ought rather to remember Bellini's *Virgins*, the famous Woman of Petrus Christus in Berlin, or the *Madonna of Senigallia* by Piero della Francesca (Urbino, Galleria Nazionale) in which Longhi discovered something which anticipates Vermeer's style. Thus, Bloch continues, "it is not surprising if recent criticism has often detected a similarity between Vermeer's vision and that of Jan van Eyck: a close-up view; positive, clear color, contemplation in the face of silent figures, these characteristics are common to both." Critics tend to date it at about 1665. Maulraux, following his own theory of iconography, places it no earlier than 1672; Tolnay and many other modern critics reject this view, holding that it is much earlier than the Wrightsman *Girl* (17), possibly about 1660. These conclusions are drawn from the style and the abstract element which are more striking in the latter than in the picture under examination, but the actual state of the Wrightsman picture (q.v.) tends to render the conclusions invalid. Even the present picture, however, is not in perfect condition; the eyes, particularly the left one, have been restored, as well as the cheek; the shadows in the costume and the left ear have

been retouched.

17 ⊞ ◉ 45 × 40 *1660-65* 🗒 ⁝

**Short Bust (or Head) of a Girl with a Veil
(The Woman with the Veil: Portrait of a Girl)**
Palm Beach, Florida
Wrightsman Collection
Signed in the upper left-hand corner. The wide-apart eyes, the long thin lips and the emphatic mouth suggest more strongly than any other known work of Vermeer's (*Lumière* 1966) that this is a portrait, but the model is still unknown. The pearl ear-ring has caused much less excitement among critics than that in the previous painting. Thoré-Bürger cautiously identifies it with no. 38 of the Amsterdam sale in 1696. But in the same catalogue one could suggest no. 39 and no. 40; but because of the "ancient costume" Goldscheider rejects these identifications. Similarly he continues, the work under consideration cannot be – as Thoré-Bürger again suggests – the "Head of a young girl," no. 92 of Dr Luchtman's 1816 sale, also in Amsterdam (3 florins), because its measurements are different. So the work first appears in history as belonging to the Duc d'Arenberg in Brussels (catalogue of the collection, 1829; catalogue of the d'Arenberg gallery by Thoré-Bürger, 1859) and in about 1953 it was bought by its

present owners for about £150,000 (Van Gelder, Catalogue of the Metropolitan Museum of Art in New York, where it was exhibited in 1955 and 1957). Thoré-Bürger, notes the "utterly fantastic" look of the pale apparition, as though revealed by moonlight in the darkness of the background, and likens it to the "evocations of Rembrandt and Correggio and, apart from its different features, to Leonardo's Mona Lisa. After this scholars had little opportunity to examine it, since the Belgian government sequestrated the painting in 1941 and it was inaccessible for several years. Gowing and Bloch both date it betwen 1660–5 because its subject matter is similar to that in the Frick and Brunswick works (12 and 13). Later critics (Goldscheider, Descargues) tend to give it a later date, certainly later than that of the *Girl* in The Hague (16), because it is more abstract and because the impasto of its color is more noticeably light. But the painting needs a strict technical examination and restoration, especially towards the center, where it has been spoiled by cleaning.

18 ⊞ ◉ 42 × 35,5 *1662-63* 🗒 ⁝

**Woman holding a Balance
(Woman weighing Pearls; Woman weighing Gold)**
Washington, National Gallery of Art (Widener Collection)
The woman was described by

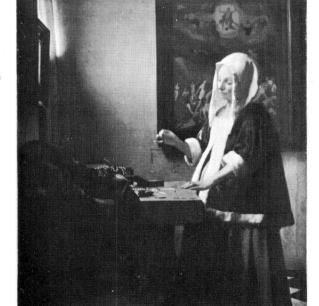

18 (Plate XXXIX)

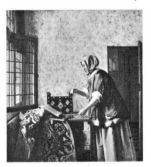

Pieter de Hooch, Woman weighing Gold *(canvas, c. 1664, Berlin, Staatliche Museen; it was believed by Thoré-Bürger to be a Vermeer (partly because the restorer Horsin assured him he had discovered the monogram reproduced here) identifying it in some way with* **18**.

91

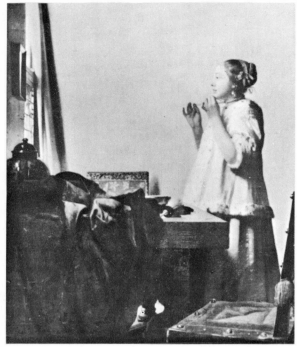

19

Thoré-Bürger as very young (*jeune et jolie fille*) while others have thought her more womanly (indeed, she could be pregnant). Malraux identifies her as Vermeer's wife at the age of thirty-three, but his opinion has met with little support. The same carpet on the table is found in the *Pearl Necklace* in Berlin (19) and in the *Lady writing a Letter* (22), formerly in Nassau. The painting in the background, a *Day of Judgment*, has not been identified: some think that it is a version of a painting by Jean Bellegambe, others attribute it to Jacob van Oostzanen or Bernard van Orley, or it could be a copy of the *Last Judgment* by Lucas van Leyden (Leyden, Lakenhal Museum), others even suggest that it is Vermeer's own invention. Thoré-Bürger formerly saw an allegorical relationship between the woman's contented action and the painting hanging behind her. "Aha, are you weighing jewels? You yourself will be weighed one day!" This confrontation was not altogether new: Rembrandt had already illustrated it by hanging the picture of a snake entwined round the cross on the walls of his own figure weighing gold, Uytenbogaert, in 1619 (Descargues). It is generally identified as no. 1 of the 1696 auction: "A young woman weighing gold, in a small case [*kastje*], by J. van der Meer of Delft, painted with exceptional skill and power" and quoted at 155 florins (the highest quotation in the sale after *The Milkmaid* [9]). Because of its title, Thoré-Bürger associated the description in the 1696 sale with the *Woman weighing Gold* which was in the Kaiser Freidrich Museum in Berlin until 1945 but was later more accurately attributed to Pieter de Hooch under the influence of Vermeer); nevertheless he did list the present work in

Vermeer's *œuvre*. In this painting, to tell the truth, the objects being weighed are not absolutely clear and the money scattered on the table might make one think that it is gold which is being weighed. This painting (or, according to Thoré-Bürger, the one in Berlin) then appeared at another auction in Amsterdam in 1701 (113 florins). It may possibly have been in the collection of P. van Uchelen in the same city in 1703; it was sold, again in Amsterdam, in 1767, and 1777 (Nieuhoff sale: "Interior, where a young woman is intent on weighing gold. Her head is covered with a white hood (sic): on her shoulders a short blue cloak bordered with white fur. In front of her is a table covered with a blue cloth on which lies a box with pearls in it. On the wall a picture. Painted with extreme delicacy and density": it is here said to be on wood; it was sold to Van der Bogaert for 235 florins). In 1826 it was bought in Munich at the King of Bavaria's sale, as a Metsu, by the Marquis de Caraman, French Ambassador to Vienna, whose collection was dispersed in Paris in 1830 (2,410 francs); in 1848 the painting appeared in the Casimir-Perier sale in London (where it fetched over £141); then again in Paris, in the possession of the Comtesse Ségur-Perier (1910), whence it returned to London (the collection of F. Lippmann, Colnaghi's), and thence to the Widener family of Phila-delphia, who bequeathed it to the museum. It is generally assigned to the period 1660–5 with slight critical preference for the latest date possible, while Malraux places it definitely in 1663. The most recent iconographic study of the painting is by N. Salomon (in *Essays in Northern European Art presented to E. Haver-kamp Begemann*, ed. A.-M. Logan, Doornspijk 1983).

19 ⊞ ⊘ 55×45 *1662-63 ▤ ⋮

Woman with a Necklace looking at herself in a Mirror (The Pearl Necklace)
Berlin, Staatliche Museen
Signed on the table. This has the same blue table-cloth as the previous painting and 22. Thoré-Bürger considered the vase to be Japanese, but in fact it seems more Chinese. The woman is wearing a little jacket edged with ermine which often appears in Vermeer's work. Some zealous scholars have discovered in this painting – though it is doubtful – a personification of lust (Gerson). The painting may be identified as no. 36 of the 1696 sale "A young girl adorning herself: very beautiful"; 30 florins. It reappeared in Amsterdam in 1809 at the J. Caudri sale (55 florins); and then in the same city at the Teengs sale in 1811 (36 florins); then in another sale held by Rooz in 1856 (110 florins). From there it reached Thoré-Bürger via the H. Grévedon Collection, finally it entered the Sedelmeyer Collection from which it was acquired by B. Suermondt of Aachen. The Berlin Museum bought it from him in 1874. Because of its perfect condition this painting ranks as perhaps the finest of the group dealing with the typical Vermeer theme: a dialogue between a female figure and the light, in a silent room. Beyond the truncated "barrier" in the foreground, whose density is pierced by the gleam of light in which appears one of the table's round feet, the ecstatic woman is placed against the bare wall, which looks even lighter by contrast with the opposing darkness. Bloch believes that a map or a painting originally decorated this wall and that Vermeer himself painted it out.

20 ⊞ ⊘ 46,5×39 *1662-64 ▤ ⋮

Woman in Blue reading a Letter
Amsterdam, Rijksmuseum
It was E. V. Lucas (1922) who first put foward the idea that the woman is Vermeer's wife; Bodkin argues that no other woman would have posed in such a condition. Malraux rightly rejects this theory, but agrees with the identification of Catharina Vermeer, in his opinion at the age of thirty-three. Hanging on the wall in the background is the same map of the Netherlands as in 6. Besides books there is also a pearl necklace on the table, its presence revealed by subtle lighting. Perhaps this is the "little woman (*vrouwtje*) reading in a room by Van der Meer of Delft" which appeared in the P. van der Lip sale in Amsterdam in 1712 (110 florins). It subsequently appeared in other sales: the first in 1772, the P. Lyonet sale in 1791 (43 florins); another in 1793 (170 florins),

the H. ten Kate sale in 1801 (110 florins), then in Paris (Paillet sale, 1809, 200 francs; Lapeyrière sale, 1825, 2,060 francs; Sommariva sale, 1839, 882 francs [?]); finally it came to the London dealers J. Smith & Sons, where it was bought for £70 by A. van der Hoop, who left it to the city of Amsterdam in 1854. The painting attracted the attention of Van Gogh (see his *Journey* quoted in the *Critical Outline*). Of the famous color of the clothes Plietzsche writes: "The way in which the aquamarine jacket, painted in dabs, blooms and gleams beside the milky tones of the dark blue chair covers, like a perfumed chalice, is unique even in Vermeer's work."

21 ⊞ ⊘ 51,4×45,7 *1663-64* ▤ ⋮

Lady playing a Lute
New York, Metropolitan Museum
Signed on the table. Hanging on the back wall is a map of Europe (J. Hondius, 1613; republished by J. Blaeu in 1659). Besides this, we can see all the usual furniture of Vermeer interiors: a cover on the table with various sheets of music on it, a window, a chair, a well-lit wall, a square-tiled foor. In the woman listening tensely to a note from the instrument, there is perhaps a hint of movement. It has been noted that the execution of the lute is extremely vague, while Vermeer usually shows himself to be an impeccable connoisseur of musical instruments (Descargues). According to Blankert, the authenticity of this picture is questionable. It was included in the van der Schley and de Pré in Amsterdam in 1817, was acquired in England by C. B. Huntington of New York, who in 1897 bequeathed to the museum (it entered the museum in 1925). It is generally assigned to 1663–4 (Valentiner, De Vries, Trantscholdt, Gowing, etc.). Goldscheider dates it for certain in 1664, noting that the painting of light is inferior

to that in other paintings which, in his opinion, really do date from those two years. Bloch dates it in 1665. The work was cleaned in 1944 when the large pearl in the woman's ear, another typical element, reappeared; until then it had been hidden beneath a different jewel.

22 ⊞ ⊘ 47×36,8 *1665 ▤ ⋮

Lady (or Girl) writing a Letter
Washington, National Gallery of Art
Signed on the frame of the picture hanging on the back wall. This is a still-life of musical instruments which Bostrom (O-H 1951) attributes to Cornelis van der Meulen, while Isarlo considers it to be a work of Evaristo Baschenis. It could be the work which appeared in the inventory of Vermeer's possessions after his death as "vanity with viola da gamba and a skull" (*een bas met een dootshooft*) in the dining room. On the table are Vermeer's usual rich accessories: the jewel-box, a pearl necklace, etc. Even the woman's dress is typical; pearl ear-rings, short ermine-lined jacket (as in *The Necklace* in Berlin [19]) and so on. Most probably this painting should be identified as no. 35 of the 1696 auction: "A young girl writing; absolutely perfect" (63 florins). It can almost certainly also be identified as a picture which appeared in the J. van Buuren sale in The Hague (1808), in two sales in Rotterdam, that in the Luchtmans sale in 1816 ("Girl in a négligé and yellow cape, busy writing," 70 florins) and at the Reydon sale in 1827 ("An elegant lady, seated and writing at a table on which appear various items. Unusually fine in color and execution"). In 1857 it was in the De Robiano sale in Brussels ("Young lady with a short, yellow jacket bordered with ermine; her head raised towards the spectator," 400 francs). In 1907 it was purchased by P. Morgan in Paris and from there it went

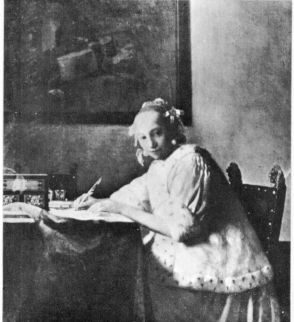

22

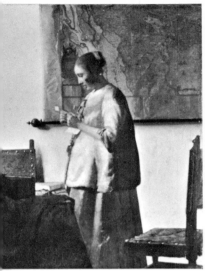

20 (Pls XXXVII–XXXVIII)

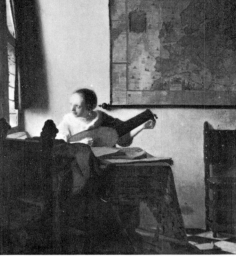

21 (Pls XLV–XLVI)

ot the firm of Knoedler in New York; from 1940 it was in the Oakes Collection in Nassau in the Bahamas, and finally it went to H. Have-meyer – apparently in 1946 – whose sons donated it to the museum in 1966 where it can now be seen. Apart from a deepening of the blues in the shadows, it is in excellent condition: the contrast of yellow with blue shines like enamel and makes one understand Thoré-Bürger's definition of Vermeer as a "potter of genius."

23 🔲 ⊘ 24,5 × 21 *1665* 📑 ⁞

The Lacemaker (The Little Lacemaker)
Paris, Louvre
Signed on the back wall, to the right. According to Descargues the clothes should lead us to conclude that she is a lady of quality; Malraux sees in her yet another portrait of Catharina Vermeer, this time aged thirty-five. The carpet is similar, if not identical, to the one in *Christ in the House of Martha and Mary* (2).The light comes, as in only a few other cases in Vermeer's known *œuvre* (25, 26 and 29), from the right. It is usually identified as no. 12 of the Amsterdam sale in 1696 "A young lady working" (28 florins), but it can be identified with greater certainty as a picture which passed through several other auctions in Amsterdam: J. Crammer (1778: 150 florins), H. Muilman (1813: in which sale *The Milkmaid* [9] was also sold) and yet again in 1815 (9 florins). Then it came to the Lapeyrière sale in Paris in 1817 and to the Van Nagell sale in The Hague (1851: 260 florins). Later, when the collection of D. Vis Blokhyzen of Rotterdam was dispersed in Paris in 1870, it was purchased for 7,270 francs by Napoleon III. After the superficial praise of Pérignon ("A painting rendered with the maximum of attention, in which the artist has perfectly expressed – and in noble style – natural perfection, the variety of items and the silkiness of the cloths, by his precise rendering of their colors and effects [catalogue of the Lapeyrière sale, 1817]",

we may recall those of Renoir, who considered *The Lacemaker* and Watteau's *Embarkation for Cythera* to be the two finest paintings in the Louvre. But one should pass over in silence the tribute paid by Dali in his "paranoiac critique" version of the picture, where the perfect contemplation of Vermeer's world explodes in the shape of a rhinoceros horn. It is generally recognized as dating from 1664–5, but because of its *pointillism* and intense color is assigned by Gerson to a date about 1658–60, the same period as *The Milkmaid*. Blankert moves the date forward to 1670–71.

24 🔲 ⊘ 130 × 110 *1665* 📑 ⁞

Painter at Work (De Schilderkonst; L'Atelier; *Ars pictoria*; Allegory of Painting: Vermeer in his Studio)
Vienna, Kunsthistorische Museum
Signed on the lower edge of the map. In view of the number of problems in the iconography of this painting it should be described in detail. The map is of the Netherlands; and apart from the twenty views of Dutch

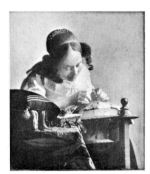

23 (Plate LVIII)

cities down the sides it also bears an inscription at the top, which is partly hidden by the chandelier: 'Nova XVII. Prov[in]ciarum [Germaniae Inf]eri[o]ris descriptio et accurata earundem. . .de no[vo]·em[en]d[ata]. . . rec[tiss]ime edit[a per] nicolaum piscatorem" Tolnay (GBA 1952) reads the words as "Nova XVII Provinciarum Germaniae Inferioris

descriptio. . ." and draws attention to the presence of the two-headed eagle, emblem of the Spanish Hapsburgs. All this refers to the political situation of the Netherlands under Spanish rule, which lasted until 1581 when the seventeen provinces pro-claimed their independence. Tolnay agrees with Hulten (KT 1949) in identifying the carto-grapher, Nicolas Piscator, as Nicolas Visscher (c. 1618–79). This hypothesis has recently been confirmed by J. Welu (AB 1975) from a copy of the same map which he identified in the Bibliothèque Nationale in Paris. The large raised curtain on the left resembles the one in the *Allegory of Faith* (35); a very similar motif appears in other works of Vermeer's maturity: the Beit *Letter* (28), the Rijksmuseum *Love Letter* (30) and the *Geographer* (32); in the *Dresden Woman Reading* (5) the curtain hangs in a completely different way. Thoré-Bürger thinks that the woman on the left is the same as the one who posed for the Brunswick picture (12); E. V. Lucas sees her as Vermeer's eldest daughter, which would necessitate a date well after 1653, the year of Vermeer's marriage; Malraux identifies her as the painter's youngest daughter, which would date the picture not earlier than 1672. Early interpreters understood the figure to be the personification of Fame, and various works, from a drawing by Frederico Zuccari in the Albertina in Vienna to a self-portrait by Pierre Mignard of about 1670, can be used to support this theory. Hultén, however, asserts that the lady is the Muse Clio, drawing a comparison with a painting by Le Sueur (Paris, Louvre), the latter dating from about 1647 (Van Gelder, 1951). The girl is rather awkwardly holding a trumpet (Tolnay) and a history book, attributes mentioned by C. Ripa in his famous *Iconology*, together with the laurel crown. In fact the *Iconology* first appeared in 1603; it was translated into French in 1636 and into Dutch in 1644. The original suggested that Clio's book was a volume of Herodotus, but translators substituted the

name Thucydides. In any case, comments Tolnay, the reference to Fame stands, even if the lady is the Muse; and thus he is convinced. On the table there are, an exercise book, in which Tolnay sees an architectural drawing but which is generally held to be a musical score, with a reference to Euterpe; a fore-shortened plaster head with hollow eyes generally interpreted as the comic mask of Thalia (but by Tolnay as an allusion to sculpture); and a book, which alludes to Polyhymnia. In short there are allusions to Clio's three sister muses, or, according to Tolnay, a kind of comparison between the three plastic arts in which painting, as symbolized by the figure on the stool, has the lion's share. Goldscheider, after commenting that the woman presumed to be Clio is not looking at the painter but at the plaster mask, wonders if the score and the huge book might rather be emblems of Erato and Calliope, if the mask might not be that of tragedy, why it has no eyes and whether it does not bear some resemblance to Michel-angelo's celebrated *David*. But he concludes that the theory of the Muses is so ingenious that it ought certainly to be adopted. At the same time he maintains the need to consider the other mythological significance indicated by the trumpet, in view of Vermeer's proven knowledge of musical instruments (as well as, one might add, the connection, frequently established and asserted by seventeenth-century critics between painting and music). Lastly, the artist: intent on painting the laurel wreath as blue as it appears on the model's head, he is also curiously using a mahlstick, although in so early a stage of the work. As well as his face the artist is also hiding his palette and other professional equipment;

it is generally agreed that he is wearing a gala costume which is extremely clean and in obvious contrast to the usual way in which his contemporaries are represented. Tolnay thinks that the style of clothing is merely old-fashioned, dating back to Dutch fashions of the years 1530–80 (Gerson agrees on this point and calls the fashion "Burgundian"). Goldscheider relates this costume to the one worn by the musician in the *Courtesan* (3), but this does not seem very apt. Numerous critics, from Thoré-Bürger to Goldscheider, have thought that this is a self-portrait, although they have seen in it increasingly important allegorical meanings; as a result, what began as an apparently realistic scene (the title for Thoré-Bürger was simply, "Vermeer in his studio") has turned into a full-blooded allegory (*Ars pictoria* etc.) in which Renown (indicated by the trumpet) and Glory (by the laurel wreath) are the most important elements. Tolnay, in view of all this comment, believes that the painting expresses regret for the period of Spanish domination which Vermeer considered ideal for artists (citizens' status and renown) and especially for lovers of painting, the highest form of art: in short, it is a kind of dream, and the heavy portière (which is not in fact unique in Vermeer's work, as he says it is) is supposed to be the feature that indicates this, by analogy to certain medieval paintings.
Tolnay's thesis has not won many followers; Gerson rejects it as utterly without foundation, mythological or historical. Moreover Swillens and other interpreters deny that it is a self-portrait, and their reasons are quite as convincing as those of the critics they are opposing. However it remains to record that no. 3 of the 1696 auction in Amsterdam was described

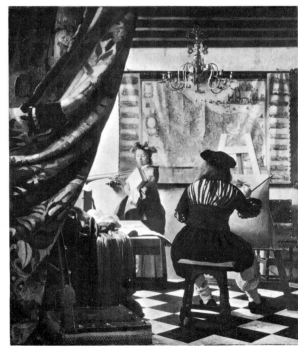

24 (Pls IL–LI)

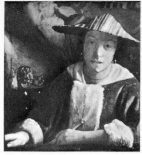

25 (Plate XLI)

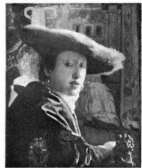

26 (Plate XL)

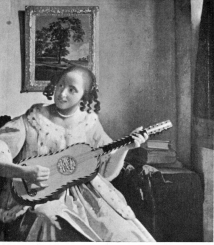

29 (Plate LII)

as follows: "Portrait of Vermeer, in a room with various accessories; unusually beautiful, painted by himself" (45 florins); and that the artist's mother-in-law, who had inherited the painting from his widow Catharina with complete liberty to dispose of it as she wished, had reason to protest when Vermeer's executor put it up for auction. But few critics identify that painting with this one in Vienna. Another explanation was offered by Sedlmayer (FHJ) who discovered in it metaphysical characteristics of a different period, but K. Badt (1951) rejects his suggestion. It was also Sedlmayer (SU 1962) who attributed to Vermeer a desire to glorify Holland through painting, a notion which seems anachronistic, if nothing worse. With regard to the complexity of its structure, H. Jantzen (ZAK 1922) pointed out that the composition's central axis does not correspond with that of the canvas, but is placed somewhat to the right, along the guiding line which runs from the chandelier through the fold in the map and the painter's figure. The diagonal made by the latter seems to derive from that of the curtain, while the perspective view-point was taken from near the objects in the foreground. The latest study of this picture and its meaning is by H. Mieden (*Proef. Kunsthistorisch Instituut van de Universiteit van Amsterdam*, 1972).

At Vermeer's death, the painting (if this is the one: but see above) stayed with his widow who gave it to her mother in 1676 as a pledge for a debt of 1,000 florins contracted by Vermeer a year before. For its identification as no. 3 of the 1696 sale, see below, and also catalogue no. 39. In the late eighteenth century it belonged to Baron von Swieten, Austrian Ambassador first to Brussels, then to Paris and Berlin; in

1813 it became part of the Czernin Collection in Vienna for 50 Austrian gulden and remained there till 1942 when it was confiscated by Hitler. In 1945 it was restored to the Kunsthistorisches Museum, to which it had been entrusted before the war. In 1860 Waagen acknowledged it as a Vermeer; but a year before, in the Galerie d'Ahrenberg, Thoré-Bürger had discovered the signature on the cross-bar of the stool to be false, as a result of which, Count Czernin had bought the picture as a Pieter de Hooch: the signature having been added at a time when De Hooch's paintings were much sought after, and it had been accepted, although Vermeer's signature had not been eliminated, and was recognized by Thoré-Bürger. In 1860 Viardot (*Musées d'Allemagne*) upheld the old attribution, which was then by general agreement superseded by the correct one, although with different datings: 1660–70 (Eisler), 1663–5 (Valentiner), 1665 (De Vries, Bloch, Goldscheider etc.), 1670 (Pleitzsch), after 1672 (Malraux [opposed by Tolnay]). Bloch has shrewdly commented that "the poetry in this painting is above all visual and however we try to interpret it we must beware of trying to read too many meanings into it". Indeed, even if we cannot overlook the presence of a certain hermetic, obsessive, even bewitched element in its adherence to reality (a reality which is perhaps itself so exact that it transports us into an hallucinatory, surreal world), the fascination of its atmospheric luminosity is certainly no less striking. This is a world into which the light abruptly breaks, sharpening the outline of the heavy curtain, which has a light of its own, one that reveals the vitality of its woven pattern, executed in rapid dots and brush strokes similar to those in many a good abstract painting (Descargues). This light then fades rapidly to the right, first stroking the yellow book, which strikes a chord against the blue dress, and the objects on the table; it makes the exercise-book "deliciously pink" (Tolnay); it plays among the black stripes of the painter's doublet; it

encrusts the handles and intricate twirls of the chandelier and caresses the folds of the map; and all the time achieves a strict adherence to the rules of the subtlest harmony. Once again that wonderful unity between man and creation, to which Dutch painting aspired by various means, had been achieved, and yet Vermeer appears to accomplish it with greater freedom than anyone before, and at the same time with greater formal strictness since "intellect remains the decisive factor" (Brion). Its condition is not perfect owing to some retouching of the highlights of her eyes, and in the corners of the picture. There have also been restorations (perhaps in the nineteenth century) which are clearly discernible, especially in the areas in shadow.

25 ▦ ◉ 20,2×18 1665*

Girl with a Flute (The Flautist)

Washington, National Gallery of Art (Widener Collection)

This is, together with 26, the only known painting by Vermeer on wood. The figure is wearing a "Chinese" hat, a strange, slender necklace and is holding a double flute (unless it is some exotic instrument [Descargues], in keeping with the hat); the woman musician is seated on one of the usual lion-head chairs. It is one of the rare paintings by Vermeer in which the figure is looking out at the spectator, and the direction of the light is rather unusual in that it comes from the right (see 23). An eye has been noticed on the tapestry corresponding to the girl's right eye (id.). This picture belonged to J. M. van Boxtelen of 's-Hertogenbosch, then to his sister M. de Grez of Brussels, where it was discovered in the J. de Grez Collection by Bredius (1906). Afterwards it stayed for some time on the antique market (Goudstikker in Amsterdam and Knoedler in New York) before being acquired by J. E. Widener in Philadelphia, who donated it to the National Gallery in Washington. Agreement on the painting's authenticity is not unanimous: Van Thienen (1949), Swillens (1950) do not accept it; Gudlangsson

Old copy of 29 (canvas: Philadelphia, J. G. Johnson Collection). Before the discovery of the Amsterdam canvas it was believed autograph.

doubts its authenticity; Bloch, who following his own theories on the relationship of this painting to the following one (see 26) considers that it seems reasonable to accept the painting as being by Vermeer. Its authenticity is accepted without reservation by De Vries, Goldscheider, Descargues, etc. Johansen thinks it may be a sketch, while Bloch believes it to be a fragment of a painting as big as 26. But De Vries rejects this view, saying that the picture has been reduced only to the left and at the bottom. Blankert says that this, like 26 below, is a seventeenth- or nineteenth-century pastiche. Wheelock, in the light of recent analysis confirming that the pigments are old, regards it as the work of a direct follower of Vermeer, and he believes 26 to be an "original".

26 ▦ ◉ 23×18 1665*

Girl (or Lady) in a Red Hat (The Red Hat)

Washington, National Gallery of Art (Mellon Collection)

Signed in the background, to the left of the hat. It offers a number of iconographic similarities to the preceding painting (of which it has sometimes been considered the pendant, despite disagreement about its authenticity): perhaps the same model, the same lions'-head chairs (particularly common in Vermeer), the same tapestry and the light coming from the same unusual direction, from the right (see 23). Malraux identifies the figure as Vermeer's eldest daughter, his third child, who was born after 1656. The first mention of the painting seems to be that of 1822, when it came up at the Lafontaine auction in Paris where it must be compared with the work described as: "A young man, slightly more than a bust, his head covered with a red straw hat of considerable size, his body wrapped in a blue cloak. A ray of sunlight illuminates part of his left cheek . . . ,"

and it is said to be on wood. Later it certainly belonged to the Atthalin Collection in Colmar, whence it passed to the dealer Knoedler in New York 1925. Mellon bought it from him and presented it to the National Gallery in 1937. Like the preceding work it was rejected by Van Thienen and Swillens, the latter being suspicious of the presence of too many typically Vermeerian elements; but their doubts hardly seem justified. Most critics agree in dating the picture about 1665 or a little later; following his own identification Malraux dates it after 1670. Bloch reports that beneath the present picture radiography has revealed a portrait of a man, which is "vaguely Rembrandtesque".

27 92×78,7 1665-70

Maid holding out a Letter to her Mistress (Mistress and Maidservant doing the Accounts)

New York, Frick Collection

It is generally agreed that there are traces of a signature; in fact it appears that in 1953, during restoration, the trace of Vermeer's signature was discovered on the shaded side of the casket on the table, but that a slight touch of solvent was enough to dissolve it; in that case the signature must have been added much later. Nor does Thoré-Bürger, who is so quick to find traces of signatures, find any other sign of one in this painting, which was well-known to him. Its subject is sometimes described as "a woman entrusting a letter to her maid". The lady is wearing the same yellow jacket bordered in ermine that appears in 19 and 22; the maid resembles the girl in 34; the casket is the same as the one in 22. In the opinion of some, the background was originally not neutral but represented a curtain (Plietzsch); the alteration must have been made before 1809, when the picture was engraved in its present form. It should be identified with no. 7 of the 1696 auction, valued at 70 florins. The subsequent history of the painting has often been confused with that of 28, thanks to some inaccurate statements by Thoré-Bürger. From these it would appear that this may be the same work that came up at the auction sale of the possessions of the burgo-master Van Slingelandt in The Hague in 1770. But the first definite reference to it occurs only in 1809, when it was at the Paris dealer Lebrun (whose catalogue included the engraving mentioned above), there is was sold for 601 francs in 1810. In 1818 at the Paillet sale, also in Paris, it made 460 francs, and in 1837 it appeared as a work of Terborch at the Duchesse de

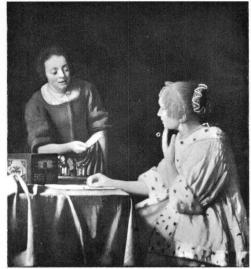

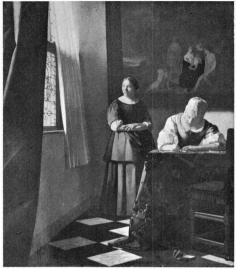

27 (Pls LV–LVII) 28 (Pls LIII–LIV) 30 (Pls XLVII–XLVIII)

Berry's sale. (The catalogue describes the subject dramatically by adding that the maidservant is trying to read the address on the message.) For a time it belonged to the Dufour Collection in Marseilles, and then was sold for 75,000 francs in the Secrétan sale in Paris in 1889. It later passed through the hands of Pavlovstoff in St Petersburg, the dealer Sulley in London (1905), Simon, the Berlin collector, who bought it for 325,000 marks, and Duveen in New York (1919). Here it was acquired by Frick in the same year. Earlier M. Chaumelin (*Trésors d'art de la Provence*, 1862) had enthusiastically written: "The beauty of its execution can be admired without reservation; so can the supreme elegance of its drawing, the power and harmony of its colors. Only a pupil of Rembrandt could have modeled, in full daylight like this, the lively face of the young girl whose vanishing profile is revealed with such strength and at the same time such unusual delicacy. . . ."

28 71,1×60,5 1667*

Lady Writing a Letter, with her Maid (The Letter)
Blessington (Ireland), Beit Collection
Signed on the table, near the lady's left arm. The figure of the maid resembles that in the previous painting. The picture in the background is sometimes attributed to Jacob van Loo, or at least its similarity to his Italianate style is recognized; it represents *The Finding of Moses*, and reappears, though on a smaller scale, in *The Astronomer* (31). Together with 29, the painting belonged after Vermeer's death to his widow, who then consigned them both to the baker H. van Buyten to pay a bill of 617 florins 6 stuyvers. It reappeared later at the sale of J. van Belle in Rotterdam (1730; 155 florins) "young woman seated writing a letter, while, behind her, the maidservant waits", a description which clearly refers to this painting and not to 27, as has sometimes been thought. It then belonged to

F. van Bleiswijk of Delft and is listed in the inventory made after his death (1734), estimated at 75 florins, then in that of his heir, H. van Slingelandt in 1761, estimated at 30 florins. It entered the collection of Miller von Aicholz of Vienna, was acquired by Sedelmeyer (1881) who sold it in the same year to Secrétan (60,000 francs). In 1889 it was sold at the Secrétan sale in Paris for 62,000 francs. It is next found in the Marinoni Collection, and again on the market – still in Paris – as the property of Kleinberger's, from whom it was bought by Sir Alfred Beit. The work consists of another wonderful dialogue of light and shade; the maid is very fine, firmly planted in her grey dress, as grave and pyramidal as a Piero della Francesca saint. She catches the sunlight which models the lady's whiteness against the rich grain of the table cloth.

29 53×46,3 1667*

Lady playing a Guitar
Kenwood House (London)
Iveagh Bequest
Signed on the lower edge of the curtain, right. (In Thoré-Bürger's time the signature was not visible). The figure is one of the few that Vermeer painted smiling; she is wearing the same jacket that appears in other paintings, although here it is wonderfully and very elaborately draped. Experts recognize great precision in the depiction of the instrument, which they note to be double-strung as was

customary in the seventeenth century, while the metallic "rose" in the center is slightly unusual. It is not known who painted the picture shown hanging in the background; Bloch relates it to the style of Wijnants. As far as one can see from the little that is visible, the chair on which the player is sitting is the usual lions'-head type. We may almost certainly identify this painting (instead of *The Lute player* in New York (21) which Vermeer's widow gave, in 1676, with *The Letter* (28) to the baker Van Buyten to cover the debt of 617 florins, 6 stuyvers. It was probably no. 4 in the 1696 Amsterdam sale ("A young lady playing the guitar: excellent," 70 florins). In 1794 the painting was acquired in The Hague by Viscount Palmerston, entered the collection of W. Cowper-Temple by 1871, and then passed to the Hon. A. E. Ashley, who sold it to Agnew's in London, from whom Lord Iveagh bought it in 1889. As a result of recent cleaning the painting, which is in excellent condition, has acquired an intense brightness, whereas Thoré-Bürger described the figure as immersed in a "gentle half-light." An old copy (a few millimeters smaller) is in the J. G. Johnson Collection in Philadelphia; before the discovery of the Iveagh painting, it was considered to be the original, notably by Thoré-Bürger who had seen it at the dealer de Gruyter's in Amsterdam.

30 44×38,5 1667*

Maid and a Lady with a Letter (The Love Letter)
Amsterdam, Rijksmuseum
Signed below the maid's hand, to the left. *The Love Letter* is the traditional title; it is obviously connected with the anecdotal element which has played so large a part in the discussion of Vermeer's work; at any rate we must recognize in such comment the wish to distinguish this work from other "epistolary" scenes (5, 20, 22, 27 and 28). The distinction is merited in the first place by the most unusual composition, with the narrative element situated like the central panel of a triptych and seen through a doorway partly covered by a curtain (perhaps the same one as in the *Allegory of Painting* and the *Allegory of Faith* (24 and 35). This curtain is drawn back into the right hand "compartment", where there is a big chair with a sheet of music on it. In the other "wing" a map is hanging on an oblique wall (perhaps the same map as in 6 and 20). In the middle – behind the slippers (which are reminiscent of those in van Eyck's *Arnolfini Marriage* in the National Gallery, London) and the broom – sits the mistress with her maid; she wears a fine ermine dress, is heavily bejewelled and holds a lute. Behind the two women, high up, are a landscape (which Bloch describes as "in the style of Wijnants", different from the one in 29, and an unidentified seascape. Below this is a panel of gilded leather which reappears in the *Allegory of*

Faith. On the right a chimney-piece of which only a part, including a cornice and a column, is visible. The floor is not, in fact, the one that can be seen in the *Allegory of Faith* (35) (as Goldscheider states), but the one that appears in the Beit painting (28) and in the *Lady standing at the Virginals* (33). Yet the setting may be the dining-room in Vermeer's house since, in the inventory of his goods made after his death, a gilded leather panel and landscape, which might well be these, are listed in this very room.

The painting was part of the J. F. van Lennep Collection in Amsterdam; then it appeared in the Messchert van Hollen-hoven auction, also in Amsterdam (1892, 41,000 florins) and was bought by the Rijksmuseum in 1893 with help from the "Vereeniging Rembrandt". It is generally dated 1665–70, with a preference – in recent criticism – for the latest possible date. The composition is unanimously considered to be one of the most complex and studied of all Vermeer's work. Indeed, it is a commonplace nowadays to define its structure as "mathematical" and to point in evidence to the formal relationship between the vertical "cylinder" of the maid's sunlit arm and the column in the chimney-piece, or between the sail in the seascape, the lady's right arm and the broom handle in the foreground (three diagonals so scaled as to measure the depth of the field of vision, as if focally aligned with the

Rembrandt, Faust *(engraving); reproduced in reverse for easier comparison 31.*

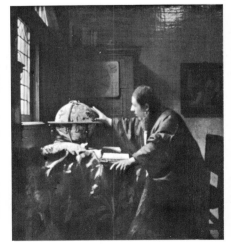

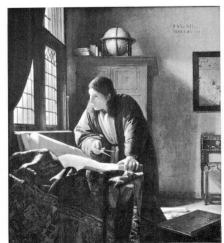

31 (Plate XLII) 32 (Pls XLIII–XLIV)

95

rapid recession of the bright lozenges of the floor towards the left). But although for some critics, among them Bloch and Descargues, these correlations and the disposition of light, create a complete, perfect unity of expression; others, such as A. Martini, see in them an "excessive meticulousness" which causes them almost entirely to disperse "the enchantment of the whole work."

31 50×45 1668?

The Astronomer (The Philosopher; The Geometer; The Geographer; The Astrologer)
Paris, Louvre
There are a signature and date on a panel of the cupboard (1668), but almost all the critics doubt the authenticity of the signature (Swillens, etc.) and also have reservations about the date, particularly because of the strange gap between the first five numbers and the last four. (This is, in fact, so strange that Mündler [in Thoré-Bürger], who examined the painting at Christie's in 1863, thought he should correct 1668 to 1673). Moreover, Goldscheider thinks that the writing may have been transferred from the original frame when the picture was put into a new one. But the engraving of the work published in the catalogue of the Lebrun Collection (1792) shows no indication of a signature. The titles in parentheses are those given during the eighteenth and nineteenth centuries, we might add that the work was probably called The Mathematician, and in the Christie catalogue already referred to is described as "A Gentleman sitting at a table . . . on which there is a globe." There have been many identifications of the sage. Tradition had it that the clean-shaven face and long hair were those of Spinoza. But there is no evidence to confirm this theory, and the philosopher's astronomical ideas offer nothing to justify the identification, even if Vermeer could have known his work. Recent interpreters are in favour of the naturalist Anthony van Leeuwenhoek of

Delft (1632–1723); but, as Malraux notes, contemporary engravings show his features to have been quite different. Malraux agrees with Huyghe in identifying the figure as possibly being Vermeer himself. Nevertheless there is hardly enough definition for us to tell who it is. Besides, the astronomer was a common subject at the time; Descargues has made a careful list of all the artists who used it: Johannes Moreelse (Utrecht, Central Museum), Cornelius de Man (Hamburg, Kunsthalle), Ferdinand Bol (London, National Gallery) etc.; and one might also add Rembrandt, since he engraved Faust (Plietzsch). The celestial sphere is identical to a globe by J. Hondius (1600) and forms a pair with the (terrestrial?) sphere in the Frankfurt Geographer (32), which is, as far as one can tell, identical with the one in the Allegory of Faith (35), and is also by Hondius (1618). This tends to confirm that originally 31 and 32 were pendants. The picture hanging on the back wall to the right, which Thoré-Bürger saw as a "a kind of Holy Family," is actually of a woman with a baby and a man dressing. Usually it is thought to be a The Finding of Moses in the style of Jacob van Loo, and it can be identified – thanks to a seventeenth-century copy of the astronomer in the Koch Collection, London – with the similar, though larger painting in the Beit Letter (28); from old auction catalogues it would seem that Vermeer painted two pairs of similar subjects (but see 67). In any case it is thought that the relationship between the two subjects has some corresponding significance, symbol-izing in one case heaven, and in the other, earth.
The first mention of the work is in the catalogue of a sale arranged in Rotterdam in 1713, during which The Astronomer and The Geographer together made 300 florins. The two paintings were quoted at only 160 florins in the H. Sorgh sale in Amsterdam (1720) and at 104 florins in the Looten sale in the same city (1729). Then The Astronomer appeared by

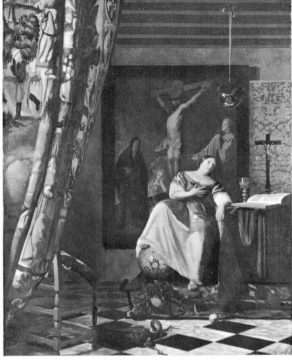

35 (Pls LXI–LXIV)

itself in the Lebrun Collection in Paris (see above), later appearing with 32 at the D. Nijman sale in Amsterdam in 1797 ("A philosopher in his study . . . very natural and skilfully executed": 270 florins); it was bought by J. Gildemeester, at whose own auction (ibid. 1800) it was quoted for 340 florins. Later it appeared at the L. Double sale (Paris, 1881); in 1907 it became part of the Rothschild Collection from which it passed to the Louvre in 1983. It has often been asserted that the size of the picture has been reduced on the right; but that view seems to be based on a study of old, barely distinguishable photographs. The Koch copy in London has both the background picture and the astronomer's chair cut off, as in this canvas. The painting was taken by the Nazis during the Second World War and was destined for the Hitler Museum in Linz. It was recovered in 1945.

32 53×46,5 1669?

The Geographer (The Mathematician; The Astrologer; The Sage)
Frankfurt, Staedelsches Kunstinstitut

On the back wall, high up on the right, are the signature and date (1669), which are generally considered to be a later addition; another signature on the cupboard is also considered doubtful. Moreover, while this second signature is reported by Thoré-Bürger (1886) in the catalogue of the Pereire (1872) sale, where the exact position of the signatures is usually described, there is no indication of the position of either of these two. As a result we must think that the signature seen by Thoré-Bürger was already almost invisible and was sub-sequently restored. Unlike the titles for the previous work, the variants Geographer and Astrologer for the Frankfurt canvas each have their justification; and in fact the second title, which has now been supplanted, has the more justification since the map spread on the table appears to be a map of the heavens and the globe on the cupboard is one of the stars (Goldscheider). It must be noted, however, that the map hanging in the background can be identified as a maritime chart of Europe published by Willem J. Blaeu, and that the few details visible on the globe on top of

the cupboard are reminiscent of the terrestrial sphere by J. Hondius shown in the Allegory of Faith (35), which tends to confirm that the title by which the painting is known is correct. Huyghe thinks the figure is one of Vermeer's sons; Malraux believes it to be Vermeer hmself: the two hypotheses are impossible to verify. As for the possibility that this painting is a counterpart of the other, this one is taller, and, in any case, canvases of the measurements of these supposed pendants were frequently used by Vermeer. Unlike 31, it was not engraved for the dealer Lebrun's Galerie, but it reappeared with 31 at the D. Nijman sale (1797, 133 florins), still in Amsterdam. It belonged also to the Amsterdam merchant C. Josi and was in the auctions of de Lange (1803, 720 florins) and Goll van Frankenstein (1833, 195 florins). Then, via the Dumont Collection in Cambrai, it came back on the market at the Pereire sale in Paris in 1872 (17,200 francs). Later, from the M. Khan Collection in Paris it went to Prince Demidoff of San Donato (Florence). In 1880 it appeared in a sale in Florence; in 1885 it was acquired for the Kunstverein of Frankfurt from the J. Bösch sale in Vienna. Together with the two Views (7 and 8) it was frequently copied, a rare occurrence in the life of Vermeer's works.

33 51,7×45,2 1670*

Lady standing at the Virginals
London, National Gallery
Signed on the musical instrument. The landscape painting hanging on the back wall to the left has been generally compared with the style of Allart van Everdingen, but there are plenty of points of similarity to that of Jan Wijnants. The larger picture, Cupid, is the same as in the Frick Duet (13) and probably as in the Sleeping Girl in New York (4). Swillens believes that it symbolizes a proposal of love (and Tolnay goes further to define the lady as engaged); it is usually thought to be by Cesar van Everdingen. Believed to be a pendant to 34. The first known reference may perhaps be found in the catalogue of the collection of the banker and jeweller Diego Duarte (Antwerp, 1682): "A small picture representing a woman playing the harpsichord, with divers accessories, by Vermeer, value 150 florins" (but this could just as well describe 15 or 34). It is identified by Thoré-Bürger with no. 37 of the 1696 sale in Amsterdam: "A young lady playing the harpsichord" (42 florins, 10 stuyvers); but the description would apply equally well to its pendant. Thoré-Bürger also believed it to have been the picture similarly described in a sale in 1714 (55 florins) and another

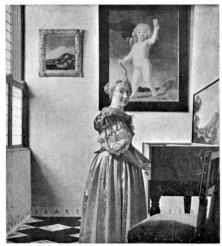

33 (Plate LX)

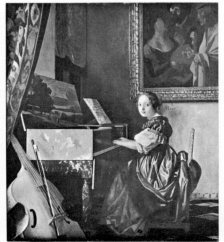

34 (Plate LIX)

D. van Baburen, The Courtesan (1622, Amsterdam, Rijksmuseum): the work appears to be reproduced in 14 and 34, its composition may also be compared with 3.

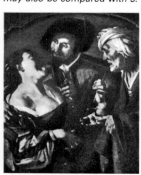

96

in 1797 (49 florins), both in Amsterdam. It then passed from the Solly Collection, London, to E. W. Lake, and thence to J. P. Thon's, then to Thoré-Bürger's own collection (1866). When this was dispersed (Paris 1892, £2,400) it was acquired for the National Gallery. It is unanimously dated about 1670–1 and is a typical example of Vermeer's cold manner, as is its counterpart; they are so planned that the light areas were all painted at the same strength and only at the end were they brought into relief with slightly stronger accents upon the face and clothes. The shadowed areas were similarly treated, and in one of these, the further arm has a completely flat surface and could have been part of the side of the harpsichord, had not this been "marbled" (Descargues). In short there are too many bright reflexions, and the woman's posture, turned towards the spectator, is not very pleasing because it is too posed. In comparison with the "abstract" figures of a few years earlier, it seems reasonable to talk of a decline.

34 51,5 × 45,5 / 1670*

Lady sitting at the Virginals
London, National Gallery
Signed on the back wall below the picture. The virginals are very similar to those in 33, but the landscape painted on the lid differs in some respects. Descargues thinks that the instrument is the work of Ruckers of Antwerp, or their circle. The position of the bow, through the strings of the 'cello, is considered usual by experts. The picture on the wall is the same *Prostitute* by Dirck van Baburen that is seen in the Boston *Concert* (14); curiously, no relation has been deduced between this painting and the lady's status. The painting was possibly at the 1696 sale in Amsterdam, but see the note to 33, which is considered to be its twin. Thoré-Bürger commented on it in 1866 when it belonged to the Schönborn family of Pomersfelden who had owned it since at least 1746 and whose property eventually came up for sale in Paris in 1867, where Thoré-Bürger himself bought it. When his collection was sold (Paris 1892: 25,000 francs) it went to the dealer T. H. Ward in London, and then to his colleague in Paris, Sedelmayer (1898). Thence it passed to the Salting Collection in London from which it was bequeathed to the National Gallery in 1910. Gerson (1966) regards this work as a "perfect essay in purely formal interest, quite indifferent to every external element": but we find it hard to share this view because of various conclusions rather similar to those in the preceding work, even if critics

have generally found more to praise in the seated lady than in the standing one, especially a greater, subtler harmony between the composition and the texture of its colors. So much so that P. Johansen's Shakespearian exclamation on looking at the two pictures – "O! what a noble mind is here o'er-thrown" – hardly seems appropriate.

35 113 × 88 / 1670*

Allegory of Faith
New York, Metropolitan Museum
A. J. Barnouw (O-H 1914) first recognized the literary source of the composition of this *Allegory of Faith*, which is to be found in C. Ripa's *Iconology* (see 24); the relevant passage, according to the Dutch translation (1644) by D. P. Pers, reads: "Faith is represented by a seated lady . . . with a chalice in her right hand, her left hand being posed on a book which rests on a firm Cornerstone – that is, Christ – and her feet resting on Earth. She is dressed in blue silk, with a carmine overdress. Under the cornerstone lie a crushed serpent and Death with his arrows broken: nearby an Apple represents Sin. Behind the woman hanging on a nail is a Crown of Thorns which needs no explanation. In the background is a representation of Abraham on the point of sacrificing his son." The New York painting does not carry out Ripa's text to the letter: the Chalice and Bible, together with a crucifix, are on the table, not on a cornerstone, though this is a solid block which is crushing the serpent near the symbolic apple. Behind her there is not a *Sacrifice of Abraham* but a *Crucifixion* next to a leather panel decorated with a gilded motif. There is also the curtain which is to be found in most of Vermeer's later works (24, 30 etc.); according to Bloch the curtain here is from the Gobelins factory, whereas Goldscheider believes it to be of Slavic origin, though he gives no reason for this), and the empty chair, found in the works of his youth (from 4 onwards): the purpose of these features is plastic and scenographic rather than symbolic. Also missing from Ripa's description is the mysterious crystal sphere seen here suspended from the ceiling by a blue ribbon. E. de Jongh (S 1975) has shown that for this feature and for the *Crucifixion*, Vermeer was apparently inspired by an allegorical representation of Faith contained in *Emblemata Sacra de Fide, Spe, Charitate* (1636) by the Jesuit W. Hesius, in which a crucifix and a sphere appear. The commentary accompanying this plate explains that man's idea of God is as limited as the reflection of the whole universe in a sphere. One

should, however, recall Paul Claudel's interpretation of Vermeer's allegory: "And as for the symbolism of the triple sphere, of that globe which the Church, seized by her high ideal, tramples under foot, of that culpable fruit, which she has rejected scarcely tasted, and of that perfect and transparent truth which her desire contemplates – what could be simpler to interpret?" ('Introduction à la peinture hollandaise', RDP 1935). E. de Jongh (S 1975) emphasizes that the gold and pearls, to be found here in the form of a necklace, a chalice and a panel of gilded leather, were symbols of faith current in religious writing of the seventeenth century. The *Crucifixion* is an exact reproduction of a painting by Jordaens, now belonging to the Terningh Foundation in Antwerp, but which once hung in Vermeer's dining-room, as we discover from the inventory drawn up after his death, which refers also, as we have seen, to a leather panel which may well be identified with the one in this picture. Hence the supposition that the setting of *Allegory* is in fact Vermeer's dining-room; but the floor, on which Goldscheider bases his identification, is different from that of 30, in which the leather panel can also be seen. Since the *Allegory* described by Ripa refers to Catholicism, to which the *Crucifixion* probably also refers (Swillens), and since Vermeer's wife came of a Catholic family, Gerson sees the painting as an illustration of the artist's religious ambience; it also proves that he had a Catholic clientèle for his work (the Jesuits of Delft? [cf. Montias, O-H 1980]). The work is rightly identified as no. 25 of the H. Van Swol auction in Amsterdam 1699: "A woman seated, with a secondary meaning, concerning the New Testament: by Vermeer. . . ." (400 florins): it also appeared at other auctions in Amsterdam: in 1718, 1735 and 1749 (70 florins). Around 1824 it was in a private Austrian collection (Plietzsch notes that it is reproduced in a double portrait painted in that year by F. G. Waldmüller; Münster, Westfälisches Landesmuseum); it then entered the collection of D. Stouchkine, Moscow; then the Wächler Gallery, Berlin, as work by Eglon van der Neer. Wächler, after M. Friedländer had identified it as by Vermeer, sold it to A. Bredius, and from 1899 till 1928 it was exhibited at the Mauritshuis in The Hague. Then it was sold by the dealer F. Kleinberger in Paris to M. Friedsman in 1928 who bequeathed it to the Metropolitan Museum in 1931. Recent critics generally agree about its authenticity and hold almost unanimously adverse opinions about its

quality; only Paul Claudel thinks very highly of the work. ("Delicious passages from one tone to another, a picture of an angelic purity and devotion [. . .] the half-drawn curtain is that of human illusions.") Veth found that the woman's expression was merely that of "a tearful actress" (*eine larmoyante Schauspielerin*), which is not much praise. Similarly, Goldscheider is somewhat luke-warm in propounding his own judgment: the model is fat, the size of her hands and feet is large, her head looks

like an Easter egg; dressed for a party she is posing almost indecently (like a *Drunken Woman* by Jan Steen) and certainly uncomfortably (even if – as Goldscheider admits – her position is not very different from that of Bernini's *Truth*). De Vries, more convincingly, sees a total lack of imagination in it; and Bloch more specifically states that this defect and the smoothness of the painting are not compensated for by the wonderful treatment of the curtain.

Other recorded paintings

Apart from the unidentified paintings among the twenty-one featured in the Amsterdam sale of 1696 (see *Chronology*; some hypotheses are, however debatable) we have listed here works mentioned by seventeenth-century sources, contemporary with the artist or after his death, and others attributed to the master later (particularly on the grounds of their being signed), which have since been lost. Bearing in mind how little was known of Vermeer in the eighteenth and nineteenth centuries, the periods to which most of the references belong, the attributions here are of very limited value; in some cases the signatures themselves were probably those of namesakes of the Delft artist.

36. The Three Marys at the Tomb
This picture appeared in the inventory of the estate of the Amsterdam art dealer Johannes de Renialme, dated 27 June 1654, with the fairly high estimate of 80 florins (Montias, O-H 1980). The religious subject matter is reminiscent of another work of Vermeer's youth, *Christ in the House of Martha and Mary* (2), and the painting was probably similar in style.

39. Self-portrait
Although this cannot be identified with the fine Vienna canvas (24), no. 3 of the 1696 sale in Amsterdam ("Portrait of Vermeer in a room, with various accessories") is still untraced (but see 72). Thoré-Bürger thought it might have been the painting that was sold as a Vermeer for 480 florins at a public auction in The Hague in 1780. In 1785 it fetched 600 florins at the Van Slingelandt sale, where, however, it was presented as being by Pieter de Hooch. Smith (no. 8 in his catalogue of De Hooch) accepts this attribution and describes the painting as follows: "An interior. A gentleman dressed in indoor clothes standing at a window appears to be busy at a desk close by. A table nearby covered with a rug

and with an open book on it. A traveling bag, a purse, and a map are hanging on the wall. An armchair and other items fill the foreground." In 1833, labeled Nicolas Coedyck, it appeared at the Goll van Frankenstein sale (450 florins); later it was acquired, in about 1860, by an Englishman in the Netherlands from whom it seems to have found its way to Thoré-Bürger, who attributed it with certainty to Vermeer. He regretted that, despite several items which also appear in the Vienna canvas, this picture could not be proved to represent the same character, because in the Austrian painting the figure, which is presumed to be Vermeer, has his back to the spectator and cannot therefore be compared with the other so-called *Self-portrait*. The work Thoré-Bürger discusses should perhaps be identified with one known only through a seventeenth-century print made by Joannes Meyssens in which, so tradition has it, a likeness to Vermeer is discernible.

40. Leyden University Procession
A painting of this subject came up at the De Romondt auction (Amsterdam 1835; 450 florins) under the name "Van der Meer of Delft."

41. Woman at her Toilet
This work (approx. 40 × 35 cm.) changed hands at the P. de Blok sale (Amsterdam

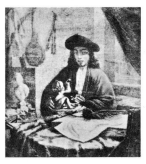

Engraving by Joannes Meyssens (1612–70) related to 39.

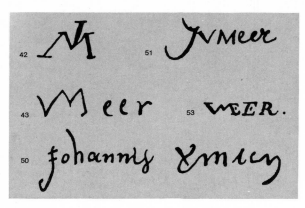

Monograms and signatures discovered by Thoré-Bürger in paintings which were attributed by him to Vermeer (numbers refer to this catalogue). In some cases the signature must be ascribed to Vermeer's contemporaries of the same name.

1744, 18 florins) described as "Small woman concentrating on her make-up," and attributed to "Van der Neer (*sic*) of Delft" which can be understood as a misprint for "Van der Meer."

42. Maid Asleep
Wood (53 × 41 cm.). Belonged to the collection of N. Hudtwalcker in Hamburg (1861) and then to Thoré-Bürger, who attributed it definitely to Vermeer because of the monogram reproduced here. It shows the interior of a kitchen with the maid seated near the fireplace. Thoré-Bürger found several elements in it which are rather strange in Vermeer's work, such as the full-length figure wearing a short red jacket, the dim light coming through a dormer window, and a lot of accessories in the style of Kalf: characteristics which lead us to believe that this is not Vermeer's work. Thoré-Bürger, however, thought he had identified it as no. 8 of the 1696 sale in Amsterdam which – as we have seen – is generally identified with the *Young Girl* in New York (4).

43. Interior of a Nunnery
Wood (36 × 29 cm.). It appeared at the Reydon sale in Amsterdam (1827) with a false signature of Pieter de Hooch. It then came to Thoré-Bürger, who discovered the monogram reproduced above and attributed it to Vermeer. It showed "a little woman with a nun's coif and wimple leaning on the lower half of the door of her house and looking on to a street along which another nun is passing." Thoré-Bürger also owned its counterpart (same measurements) which showed "a nun standing in an alley, with her back turned, in conversation with another nun leaning on a window-sill and seen full face." This he also believed to be autograph. But in neither case does the attribution seem admissible.

44. Domestic Interior
A work described as briefly as this appeared at a Rotterdam sale in 1820, as an authentic

"Jan van der Meer of Delft" (194 florins). Perhaps it is the same picture that came up, without attribution, at another sale in 1832 (190 florins) described as "Domestic Interior with Three Figures" (see also 45).

45. Domestic Interior
Wood (59 × 49 cm. [?]). It is listed in the catalogue of the Brentano sale in Amsterdam (1882) as a work of "Van der Meer of Delft." It showed a woman peeling vegetables, with on one side a baby in a cradle and on the other a man near the fireplace absorbed in reading. Bought by a certain De Vries for 701 florins. Might be identifiable with the previous work.

46. Domestic Interior
Wood (93 × 61 cm.). It appeared in the De Roos sale in Amsterdam in 1841 as a work by "Van der Meer of Delft." It showed a woman in a fur-trimmed jacket busy working at a table and a child offering her an apple.

47. Musical Quartet
Wood (126·6 × 97·2 cm.). Pointed out by Cremer to Thoré-Bürger as an autograph Vermeer because of the quality of its color and light. Represents a drawing-room with two ladies and a gentleman playing the violin and singing, while a second gentleman, in shadow, is also making music. It bore the signature "P. de Hooch," considered to be a fake. The experts at the Brussels Museum were right to reject any attribution to de Hooch, and refused it (1868) when its owner, a certain Kurt of Berlin, offered it to the museum for 30,000 Belgian francs.

48. Still-Life
Authenticated by Thoré-Bürger in the Vienna Kunsthistorisches Museum (no. 1731) as by Vermeer, but the date 1659 and the signature (B. v. der Meer identify it without doubt as by Barent Vermeer.

49. Wooded Landscape
Wood (c. 53 × 71 cm.). It came

to the Suermondt Gallery via the Weyer sale. Thoré-Bürger thinks that it is a Vermeer autograph on account of the initials "J.V.M." which can be seen on it.

50. Wooded Landscape
Canvas (c. 50 × 48 cm.). Depicting the entrance to a wood with two peasants, a dog and a flock of sheep. Thoré-Bürger attributed it to Vermeer when it was in the Czernin Collection in Vienna both because of its signature, reproduced below, and because of its likeness to the *Dunes* of Suermondt Collection. Most probably by the same artist as the next painting (see 51).

51. Landscape with Dunes
Wood (45 × 37 cm.). Brought to Paris in 1862. Among the dunes, three cottages, with sandy paths covered with little spots; on the right a clump of trees. Because of its signature, reproduced at left, Thoré-Bürger attributed it to Vermeer, but with some doubt whether it might not be the work of his namesake from Haarlem, called "The Elder." From the description it does, in fact, seem to be by the latter painter.

52. Girl with a Glass and Suitor Wood (32 × 25 cm.). Appeared in the 1816 sale in Rotterdam. Since its description – "Girl with a glass in her hand, being courted by a young man" – recalls the subject of the Berlin picture (11), Thoré-Bürger thought it might prove to be a Vermeer.

53. Alley
Wood (41 × 43 cm.). Purchased by Thoré-Bürger in Holland. The presence of the signature, reproduced here, made him consider it to be authentic. He thought it could be identified as no. 33 of the Amsterdam sale of 1696 (admitting at the same time that the identification could hold good for various other similar subjects which were attributed to him by Vermeer with equal certainty). At the retrospective exhibition in Paris in 1858, Théophile Gautier exalted it as "a marvel" (M) and C. Yriarte (F) wrote that "it is superior to anything one could imagine in the harmony of its color and intimate feeling." Almost certainly the attribution was wrong.

54. A Street in (?) Delft
Wood (c. 53 × 40 cm.). Thoré-Bürger drew attention to it in the Hudtwalcker Collection in Hamburg. The Hudtwalcker catalogue identified the town as Delft and pointed out various features. Its attribution to Vermeer was based chiefly on a signature. Another work that Thoré-Bürger considered identifiable as no. 33 of the 1696 sale (see 53).

Works attributed to Vermeer

This section contains some essential information on paintings (in alphabetical order of their location) attributed in the last few decades to Vermeer, and sometimes with excellent authority, but nonetheless rejected by the most recent critics; and on others which, although unanimously rejected, have played a certain part in the literature on Vermeer. This list does not claim to be exhaustive.

Bristol
55. Portrait of Simon Decker (?) Canvas (58·4 × 45·7 cm.). Initialled "IVM." Bought at a London sale in 1922 by E. W. Savory. The initials emerged when some ninteteenth-century overpainting had been removed. Immediately after the discovery the attribution to Vermeer was accepted, privately, by the then director of the Louvre, Guiffrey; by H. Hollmer, the dealer Duveen and various others, who noted its affinity with the Budapest *Woman* (59). Furthermore an engraving of the work was discovered (. . . *noboni, Sc.*) which not only gave the probable name of the sitter (the name written in ink was Simon Decker who had died in a gunpowder explosion in Delft in 1654) but gave the attribution to the master (*J. Van der Meer pinxit*). Many Dutch experts, however, immediately rejected the connexion with Vermeer, and stated that it was more like the work of Adriaen van de Velde, one of whose self-portraits, engraved in the Groote Scouberg by Houbraken, bears a striking resemblance to these two (Hofstede de Groot). The attribution was then rejected by Hale and has been undermined by modern criticism.

Brunswick
56. Landscape with Dunes
Wood (40·6 × 19 cm.). In the Herzog Anton Ulrich Museum, where it was rightly attributed to Vermeer the Elder of Haarlem, until Thoré-Bürger preferred to discover in it a Vermeer, because of the signature "I. V. Meer."

Brussels
57. Portrait of a man
Canvas (73 × 59·5 cm.). Musées Royaux des Beaux-Arts. It is known to have been in the collection of P. Norton, London (1836), then in the Humphry-Ward Collection, also in London (1888). In 1898 it was sold by the dealer Sedlmayer in Paris as a work by Nicolas Maes. Thence it reached the Otlet Collection in Brussels, and, still as a Maes, came again on to the Paris market where at the Cotley Dupont sale in 1900 it was acquired by the Belgian

Musées Royaux. Once it bore the signature of Rembrandt, which proved to be a forgery. In the museum catalogue it is called a Vermeer (in L. Chardon, 1922) and is described as a self-portrait (see p. 82). But soon this attribution was abandoned and that to Maes was substituted. Nevertheless, at an exhibition in Rotterdam in 1935, Isarlo, not without some immediate agreement, took up again the earlier attribution (mainly because of some similarities with the man in the Berlin canvas (11) and a certain stylistic affinity with the Budapest *Woman* [59]). But other critics have not supported this attribution. There is an old copy, formerly in the Magnin Collection, in the Dijon Museum, where it has been since 1922.

58. Girl sitting at the Virginals
Brussels, Baron Rolin Collection
In 1814 it was bought for 30 florins at the W. Reyers auction in Amsterdam. Considered authentic by Hofstede de Groot, Plietzsch, Hale and others, it was rejected, or at least doubtfully attributed, by De Vries (who in his latest catalogue [1948] thinks it was painted about the year 1800 by one of the numerous imitators of the seventeenth-century Dutch school), and the majority of recent critics. Goldscheider, while excluding it from the canon, considers its quality higher than that of most other attributed works.

59. Portrait of a Woman
Budapest, Szépmuvészeti Muzeum
The style of dress has rightly been compared by Goldscheider with that of the female figure in *Portrait of the Helm Family* (Amsterdam, Rijksmuseum) by Barent Fabritius. Until 1812 this painting, attributed to Rembrandt, was in the Viennese Collection of the Counts Esterházy; in 1865 it was bought by the Hungarian government. When Bredius suggested a direct connection with Vermeer many critics agreed with him. Isarlo thought that it had been painted after the *Man* in Brussels (57) because of the presence of important technical preoccupations. Then the scandal of the Van Meegeren forgeries (see Appendix) was a strong factor in excluding it from Vermeer's *œuvre*. Swillens in particular pointed out that the shadows and blurred edges, even the coloring and style, have nothing to do with the master. René Huyghe declared that the handling of the paint is quite contrary to Vermeer's usual technique; others, like Malraux, cannot find the painter's "malaise," his customary unease when

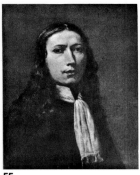

55

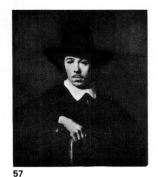

57

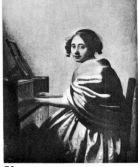

58

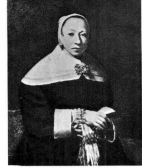

59

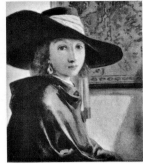

60

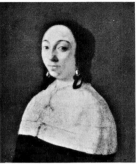

61

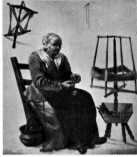

62

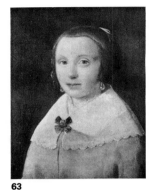

63

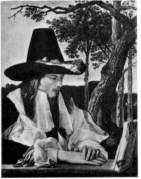

64

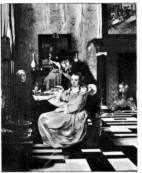

65

he is outside familiar circles. De Vries began in 1945 by accepting it as genuine, albeit with grave doubts because of the "psychological poverty" of the portraiture, but shortly after, in 1948, he rejected it, suggesting that it should be attributed to Willem Drost. But E. Gerson does not think that the problem of its origin has yet been satisfactorily solved, while Descargues has recently drawn attention to its superb quality and finds affinities – especially in the face ("The heavy, even animal-like, posture of the figure with her emphatic lips which look as if they have been rouged") – with the two *Girls* in Washington (25 and 26). Goldscheider concludes that it was painted at the same time as *The Procuress* (3), but only because of the costume, since the paint surface is substantially different. Plietzsch's attribution of the drawing of a *Head* (Berlin, Kupferstich-kabinett) would have been acceptable.

Castagnola (Switzerland)

60. Girl in a Blue Hat
Canvas (23·5 × 21·3 cm.) Belongs to Countess Margit Batthyany. In about 1895, it came up at a Fr. Muller sale in Amsterdam as a work of "the school of Rembrandt." In 1930 it was sold, as a work by Johannes Vermeer, by the dealer Cassirer in Berlin to Baron Thyssen-Bornemisza, who gave it to his wife. First Plietzsch (1939) and later De Vries (1945) considered it autograph, dating it – with considerable doubts – about 1664; but later (1948) De Vries rejected it as a fake (see Appendix). Any direct con-nexion with Vermeer has been opposed and criticized by later experts. Goldscheider, at any rate, excludes its identification as no. 38 of the Amsterdam sale

in 1696, or as nos. 39 and 40 of the same sale.

Cincinnati

61. Portrait of a Woman
Canvas (22 × 17·7 cm.). Once perhaps in a private Norwegian collection, but certainly sold by the dealer Bottenweisser of Berlin to the Edwards family from Cincinnati. The direct reference to Vermeer was first expressed (privately, 1924) by Bode, Friedländer and Hofstede de Groot. But by 1930 it was rejected, although privately, by Valentiner and then by Hale and almost all modern critics.

62. A Woman spinning
Geneva. Private Collection Sir Charles Eastlake, then Director of the National Gallery, drew Thoré-Bürger's attention to this painting as a genuine Vermeer. Phillips had brought the painting to Eastlake's notice and Waagen too was inclined to see in it the master's hand. Thoré-Bürger kept it by him for some time and thought he had discovered that the kind of skein-carrier on the wall formed Vermeer's monogram, the I superimposed over the M. Eastlake had been struck by the abstract luminosity of the background which might, had there been no objects hung upon it, have been the open sky. Thoré-Bürger put it back on the London market, where it was acquired by H. Ward. It is not known how it subsequently came to its present home. Its attribution to the master has long been disregarded; indeed the work has been shunned by almost all contemporary experts, except for De Vries who has put forward a doubtful attribution to an unknown French seventeenth-century artist. The only critic who still maintains that it is a Vermeer is Blum (1946), who considers it to be the canvas painted after *The Toilet of Diana* (1).

63. Portrait of a Girl with a Blue Bow
Glen Falls (New York), L. F. Hyde Collection It came to light in 1934 at a sale at Christie's in London of the Ch. E. Carruthers (Somerset) Collection, where it fetched £504. It was then identified as a Vermeer by Frank Davis (ILN 1935), Borenius (BM 1935), Valentiner (*Expertise*, 1935), Isarlo and Hale. De Vries, Swillens, Gowing and practically all the most recent critics, reject it. Reyre, a London antique dealer, bought it and then sold it to a Dutch colleague, Katz of Dieren, who took it to the United States. It bears obvious traces of unsuccessful recent cleaning and old photographs show it in much better condition. Kurz thinks it is a forgery.

The Hague

64. Portrait of a Man
Canvas (87·5 × 66 cm.). The painting belongs to the Nederlands Konstbezit foundation. During World War II it was acquired by the Kunsthistorisches Museum in Vienna where it was exhibited for a time and then sold. Various critics have considered it to be authentic, the most recent among them being De Vries (1945), who dated it about 1665. Shortly afterwards, in 1948, he rejected it and the attribution to Vermeer was finally abandoned. It was De Vries who found the signature "I.V. Meer 16" which proved to be a fake. But another one appeared, that of Jan Casteleyn, which also seemed to be a fake. De Vries, however, discovered a drawing connected with the present work (A. Welcker Collection, Amsterdam) which is also signed "Jan Casteleyn Fec," but this could be either a derivative or a preparatory work. Subsequently, in 1948, he suggested that it might be by Jan Baptist Weenix.

London

65. Woman refusing a Glass of Wine from a Man
London, National Gallery This came to the gallery in 1910 in the Salting Bequest. In the 1929 catalogue it was attributed to Pieter de Hooch and this attribution, together with the attribution to Samuel van Hoogstraten, was widely accepted until Altena (O-H 1960) placed it amongst the works of Vermeer's youth. The same year it was catalogued as the work of an unknown painter of the Delft school, perhaps about 1660–5; and this classification seems to meet with Gerson's approval. The painting has been ignored, however, by the most recent Vermeer scholars.

66. Minuet Dancers (The Minuet)
This canvas (60 × 45 cm.) belongs to the dealer Gimpel. It comes from the W. A. Coats Collection in Skelmorlie Castle, where *Christ in the House of Martha and Mary* originally was to be found (2). In 1927 it was exhibited by the Royal Society of British Artists in London as a Vermeer. Its style can be compared with that of Ludolph de Jongh, Jacob van Loo and Hendrick van der Burgh; Valentiner judged it to be definitely by Burgh. If this were in fact so, the theory that Vermeer was his pupil would receive considerable support. But recent critics tend to exclude the painting

from Vermeer's œuvre, except Gowing, who finds certain points in common with *Diana* (1), and therefore believes that this might be a youthful work. Although in a good state of preservation it reveals several repaintings, besides having been reframed and reduced in size all round.

New York

67. The Astronomer
Wood (48·5 × 37 cm.). It was recorded as autograph and dated 1665 by Thoré-Bürger in the gallery owned by I. Pereire in Paris. When the Pereire estate was dispersed in Paris in 1872, it was sold for 4,000 francs. Later it made 8,500 francs at the E. Kums sale in Antwerp in 1898; after that it belonged to Vicomte du Bus de Gisignies of Brussels and to one of his heirs, who sold it to René Gimpel in Paris. Finally, via the dealer Jonas in New York, it came into the possession of E. J. Magnin. It differs from the Paris *Astronomer* (31) in that the sage is shown in profile, facing right with his left hand on the glove which stands on the table, his right on a book. He is wearing an ample soft hat, and although the background is very like that of the Paris painting it is so much more in shadow that the cupboard, the map and everything else can hardly be seen (but this could be a result of the picture's poor condition). Thoré-Bürger thought that Vermeer's signature was originally

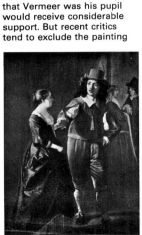

66

67

68

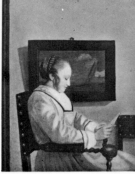

69

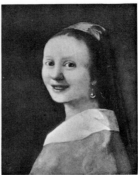

70

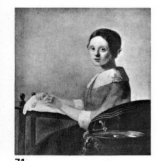

71

visible among the words – now illegible – written on the open book. In fact at least three signatures came to light, one of which was superimposed on the one which Thoré-Bürger had pointed out. This led modern critics to abandon the attribution to Vermeer. Thoré-Bürger deduced that Vermeer had painted two versions of *Philosophers* or *Mathematicians* as the Paris and Frankfurt paintings came to be called (32); he also thought that the pendant to the present work was the Neven *Geographer* in Cologne, which is most probably a replica of the Frankfurt painting already mentioned.

68. Bust of a Young Man
Canvas (59·7 × 49·5 cm.). It came from the collection of Y. Perdoux, via Sir J. Duveen, to that of J. S. Bache. It had been attributed to Sébastian Bourdon. The attribution to Vermeer was suggested by Hofstede de Groot with the agreement of several other critics, although Waldmann was already putting forward grave doubts. Then Hale definitely rejected it and most later critics have ignored it.

69. Young Woman reading
Canvas (19 × 14 cm.). It went from the Rademaker Collection in The Hague to the Wildensteins in Paris; in 1926 it was exhibited at the Reinhardt Galleries in New York and two years later was bought by J. S. Bache. Hofstede de Groot first attributed it to Vermeer and some critics followed him, but the attribution depended chiefly on the paintings's fair quality. Hale was the first to reject it; and modern critics have followed him, most of them, in fact, utterly omitting any reference to the picture.

70. Laughing Girl
Washington, National Gallery of Art (Mellon Collection)
This picture was purchased in

Berlin in 1926 from W. K. Rhode by the firm of Duveen in New York, who sold it to A. W. Mellon as a signed Vermeer, according to Bredius. Its attribution to Vermeer was welcomed by de Groot, Hale and at first, although with reservations, by De Vries, who later rejected it. He agreed instead (1948) with Swillens, Gowing, Bloch, Goldscheider, and virtually all contemporary experts. Kurz thinks that it is definitely a forgery. (See *The Times* 2 May 1968.)

71. The Lacemaker
Washington, National Gallery of Art (Mellon Collection)
It was discovered in 1926 by a dealer in Bremen. The following year it was exhibited at the Kaiser Friedrich Museum in Berlin as an authentic Vermeer, according, at least, to M. J. Friedländer and Bode, with whom Martin, Valentiner (AA 1928), Hofstede de Groot and others, all agree. Mellon bought it in 1928 at Duveen's in New York and bequeathed it to the museum. Hale, however, gave his opinion that it is a poor painting; and after him De Vries (1948), Swillens, Gowing and others excluded it from Vermeer's *œuvre*. Kurz thinks that it is a fake. (Cf. also *The Times* 2 May 1968, which reports the recent radium 226 tests by Dr Keisch [Mellon Institute] on this painting and 70, with his negative conclusions.)

Whereabouts unknown

72. Domestic Interior
The painting is divided into two parts, the left one appears to belong to a German-American collection, the right to a French one; but it is possible that they are both in the possession of a Swiss antique dealer. They may have come from the English dealer R. Reyre, but they came up together at a New York sale (1959) with an attribution to Van Brekelenkam: the second part had earlier (1956) appeared at a sale at the Hôtel Drouot, in Paris. All we know is to be found in an article by F. Neugass (W 1965). The initials I.R.V.M. were discovered on the jewel-box under the window in the left-hand section, and were immediately associated with the signature visible on *Diana* in The Hague (1). Van Thienen, dated it as possibly 1655–7, and identified the woman in the foreground as a widow. Furthermore the writing W 127 was discovered on the tub in front of the woman, which F. Lugt (1962) connected with the receptacles used in Dutch cities for putting out fires. These details and the presence of some typical accessories led to its identification – though cautiously – as an early Vermeer. The figure shown might represent the artist's mother shortly after her husband's death (1655), busy washing precious earthenware connected with the business conducted by the deceased Reynier. (Two plates and a jug, identical to those in the foreground, Chinese Wan-li porcelain [Ming dynasty], known and imitated in Holland in the first half of the seventeenth century have recently appeared in Milan at the antique dealer Eskenazy's.) Behind, to the right, is Catharina Vermeer with her elder son, who is facing his father, the hunter in the right-hand section. These theories have led the painting to be identified with no. 3 of the 1696 sale in Amsterdam. In the catalogue of the sale, however, only the figure of Vermeer is mentioned.

73. The Music Lesson
Canvas (63 × 51 cm.). Formerly belonged to Dr F. Mannheimer of Amsterdam. It was published by Bredius (BM 1932) and rejected as a fake by de Fries (illustrated on p. 102).

APPENDIX

Fake Vermeers and the Van Meegeren "affair"

If forgers were to become interested in Vermeer, his fame clearly had first to be re-established and the antique market to have created a demand. Some false Vermeers were in fact in circulation by the end of the nineteenth century, many of which were imitations made in good faith by admirers of the master such as the German Meyer; but they were soon destined to become the tool of confidence tricksters. At any rate the climax of the counterfeit business was reached in the Van Meegeren case.

The "affair" is not easy to reconstruct. There was a great number of important interests involved in it, along with stubbornness and retaliation, and journalistic distortion aiming at sensationalism (as a result it is still almost impossible to find two first-hand accounts which fundamentally agree). We shall, therefore, try to concentrate on only the most firmly authenticated factors.

First of all a biographical note on the protagonist. Hans Anthonius van Meegeren was born in 1889 at Deventer, Holland. He studied at the Technological Institute in Delft with the aim of becoming an architect, the profession his father wished him to follow; and in the course of his studies acquired a grasp of chemistry which was to prove useful to him later on. But he felt himself more drawn to painting and soon changed to follow his own preference. In 1913 he won his first recognition with a group of drawings and watercolors, among which there were some *Interiors* in seventeenth-century Dutch style. In 1914 he passed the examination of the Academy of Fine Arts in The Hague with a copy of a seventeenth-century painting, having earlier failed with a portrait. In the following years he organized several one-man exhibitions in The Hague, at which he showed biblical

subjects painted in a somewhat antique style, which found ready buyers. Reviewed today, these works can be immediately associated with the forgeries which were to make their author celebrated in years to come. During that period he visited museums in Belgium, France, Italy and Great Britain, as well as in his own country. His subsequent work did not meet with the universal praise which he thought it deserved, so, leaving Holland (1932), he moved to the French Riviera, living first in Roquebrune and later Nice. But in 1939 the outbreak of war drove him back to his homeland. His capital at that time appears to have amounted to about £15,000, made from portraits of wealthy Englishmen and Americans; a few years later his fortune was estimated at about £600,000.

Van Meegeren's ambition to steal the limelight on the artistic scene began to be realized towards the end of World War II. In May 1945 soldiers of the VIIth American army discovered amongst various paintings, hidden by the Germans in rock salt caves, a *Christ and the Woman taken in Adultery* signed by Vermeer. It came to light that the painting had been bought on the Nazi minister Goering's behalf for 1,650,000 florins in Amsterdam; and the sale was traced to Van Meegeren, who was arrested (29 May). To cut a long story short, he first failed in every attempt to elude the charges of collaboration and ended by admitting that he himself had painted *The Adulteress* and several other Vermeerian "masterpieces" between 1935 and 1943 to avenge himself on the critics and their claim that the works were by somebody else. The Dutch court put Van Meegeren to the test; under continuous surveillance the accused painted a *Jesus among the Doctors* in the style of

(From the left) Jesus among the Doctors, *an oil by Van Meegeren (1918) and* Mother and Children, *a published drawing by him (1942). The first shows an immediate similarity to the fakes; the woman's head in the second is identical to that of Christ in the fake here reproduced.*

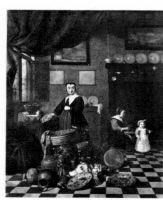

72

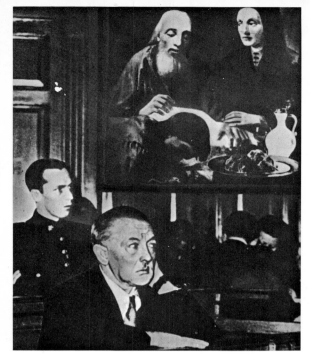

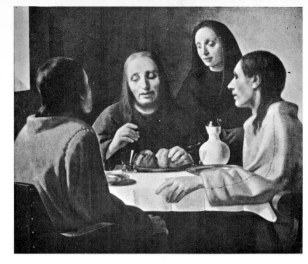

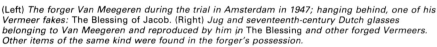

(Left) *The forger Van Meegeren during the trial in Amsterdam in 1947; hanging behind, one of his Vermeer fakes:* The Blessing of Jacob. *(Right)* Jug and seventeenth-century Dutch glasses *belonging to Van Meegeren and reproduced by him in* The Blessing *and other forged Vermeers. Other items of the same kind were found in the forger's possession.*

Vermeer (the choice of subject did not lack a certain irony in its application to Van Meegeren against the experts). The canvas was finished in September; rather, not completely finished but sufficiently so to prove that, despite its inferiority to *The Adulteress* and other works, the charge of forgery was thoroughly justified. After being condemned (not for collaboration but for forgery) to a year's imprisonment on 12 November 1947, Van Meegeren died in December at the age of 58.

The sentence was preceded by an enquiry which lasted ten months; it was conducted with the assistance of art-historians such as J. Q. van Regteren Altena and H. Schneider, and scientists (especially chemists) such as W. Froentjes and A. M. Wild, the best that Holland could provide. They were accompanied by experts from Belgium (including P. B. Coremans), England and America. The experts examined canvases sold by Van Meegeren as works by Vermeer: *Meeting at Emmaus, Head of the Redeemer, Last Supper, Jacob's Blessing,* and *The Washing of the Feet,* as well as *The Adulteress.* They also scrutinized two unfinished paintings in the forger's possession, *Woman reading Music* and *Woman playing a Mandoline.* Finally they looked at other forgeries of De Hooch and Terborch which Van Meegeren claimed were also by him. (For further information on the juridical aspects of the affair see J. W. Kallenborn [*Revue internationale de Police criminelle XXII*]).

Van Meegeren's conviction as a forger dealt a heavy blow to Vermeer scholarship. *The Meeting at Emmaus,* one of

his forgeries, had aroused acclamation all over the world at its appearance. At the time, in 1937, the painting was said to have come, via a noble Italian family who owned it and wished to remain utterly anonymous, from a distant Dutch castle in Westland, where there was a fabulous collection of El Greco, Holbein, Rembrandt, Hals, Terborch, De Hooch, Metsu and others. In fact Van Meegeren had only just completed it in 1937 and had brought it, via an intermediary, to the famous critic A. Bredius, who was passing through Monte Carlo. The critic immediately and enthusiastically identified the hand of Vermeer and reserved for himself the right to make the discovery public, which he did with great despatch in the *Burlington Magazine.* The "classical proofs" (that the colors resisted solvents, analysis of the white lead, x-rays, examination through a

microscope of the coloring substances) all confirmed his verdict. The same intermediary then took the painting to Paris, where in December 1937 it was bought for 550,000 florins by the Rembrandt Vereeniging (Rembrandt Society) for the Boymans Museum in Rotterdam. Here it was exhibited in the following year with other masterpieces from the fifteenth century, as part of the celebrations of the Jubilee Year of Queen Wilhelmina. The authoritative review *Pantheon* commented that no work of art had in so short a time achieved such universal celebrity; and for its part, the *Zeitschrift für Kungstgeschichte* exalted it with the Rembrandts, the Halses and the Grünewalds as the "spiritual nucleus" of the collection.

We may say that critics had been anticipating religious works by Vermeer, since various art-historians of the time had become convinced

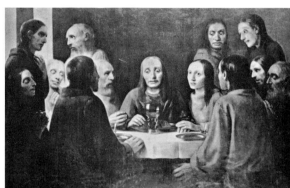

Two "Vermeers" by Van Meegeren: The Meeting at Emmaus *(canvas 1936–7; acquired by the Boymans Museum in Rotterdam in 1937) and* The Last Supper *(canvas, 1940–1; acquired by Van Beuningen in 1941); both with false signatures.*

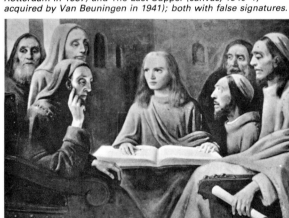

Jesus among the Doctors *(canvas; executed by Van Meegeren in Amsterdam in 1945 under the supervision of the Dutch court, bought privately in 1950); no signature.*

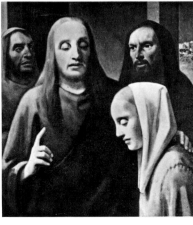

Other fake Vermeers by Van Meegeren. (From the left). Christ and the Adulteress *(canvas 1940–1; bought by Goering in 1942);* The Washing of the Feet *(canvas, 1942–3, bought by the* Rijksmuseum, Amsterdam in 1943); The Blessing of Jacob *(canvas 1941–2: bought in 1942 by W. van der Vorm for 1,275,000 florins); all with forged signatures.*

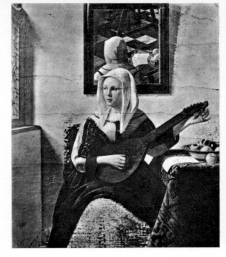

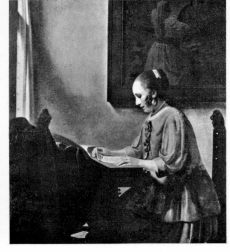
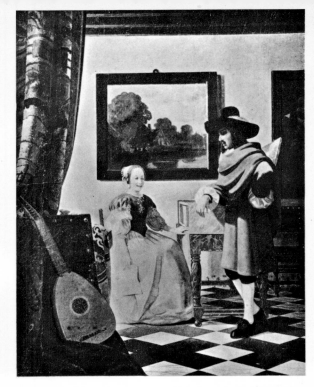

Two incomplete forged "Vermeers" found in Van Meegeren's studio in Nice. (From the left) Lady playing a Lute (canvas 1935–6 [?]); Woman reading a Sheet of Music (canvas, id.).

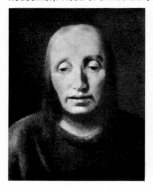

(Above, left) Hunting Scene, attributable to A. Hondius, bought in 1940 by Van Meegeren who painted The Last Supper bought by Van Beuningen as a Vermeer on it. (Right, from above) Detail of a dog in the preceding picture; the dog revealed by X-rays under the Van Beuningen Last Supper. (Below, from the left) Bust of the Redeemer (canvas, fake Vermeer by Van Meegeren, 1940: sold to Van Beuningen [1941] for 400,000 florins, as the sketch for an unknown work). Detail of the above-mentioned Last Supper (bought by Van Beuningen as the work which followed the Head of the Redeemer). Head of a Musician, drawing by Van Meegeren.

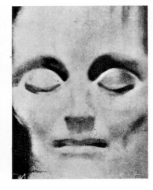

(Top) Lady at the Spinet and Gentleman, a fake Vermeer, perhaps executed at the end of the nineteenth century without fraudulent intention. (Above) Landscape. Exhibited in 1930 at the Munich Gemäldegalerie together with the Thyssen Collection; the painting exalted as the "major surprise" of the exhibition, was really of eighteenth-century origin; above the cottages, which are original, the Bell Tower of the New Church in Delft was recently added. Thus, as a View of Delft it passed as a Vermeer until Bredius (BM 1932) disclosed the forgery.

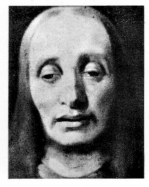

that Vermeer had worked for Catholic groups in seventeenth-century Holland; so when the *Emmaus* appeared, several critics were able to boast of their own penetrating foresight. The direct attribution of the work to Vermeer was settled by Bredius (O-H 1938) and critics who agreed with him included Hannema, Feulner, Plietzsch, Gerson, MacGreevy, Hammacher, Veth, Van Breek, De Graaf, Van Guldener, Hefting and others; in fact, all the critics who made a special study of Vermeer until the bomb-shell. Thanks especially to Van Rijckevorsel (*Historia*, 1938), Vermeer's connexion with Caravaggesque painting in about 1662 was fully analyzed; and attention was drawn to his dependence on two paintings of the same subject by Caravaggio, in the National Gallery, London and the Brera in Milan. Apparently the historian and philosopher Huizinga advanced some perplexity but nobody supported him. In his monograph on Vermeer in 1945, De Vries reserved for the *Emmaus*, with only two other paintings, the honor of being his supreme works in color, and revealed its "peculiar atmosphere of inaction" while he declared it "a miracle in painting."

To tell the truth, some vague doubts had been aired even before that time. In 1939 connoisseurs and amateurs had discovered four new, unpublished Vermeers (*Jacob's Blessing, Head of the Redeemer, The Last Supper,* and *The Adulteress*), and during the German occupation of Holland a fifth had come to light, *Washing the Feet*, which the Rijksmuseum had bought in 1943, on the advice of Hannema and the Fine Arts Commission, for 1,250,000 florins.

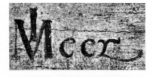

(From the top) A signature by Vermeer (34) and one forged by Van Meegeren (Blessing of Jacob).

A few people began to think that too many Vermeers were being discovered. But because of the war, and fear that the paintings would be confiscated by occupying forces, the Dutch government were reluctant to initiate inquiries.

When the time of his confession arrived, it was learned that the execution of the *Emmaus* had been preceded by patient research into Vermeer's materials and procedure. Only in 1934 did Van Meegeren think himself ready; buying a cheap *Raising of Lazarus* by an unknown seventeenth-century Dutch artist in Amsterdam, he had used this canvas to paint the Vermeerian "masterpiece." His work was completed in 1935 after six or seven months; this was quite quick, if one takes into account the detailed care taken by the forger to make his counterfeit seem as good as the real thing. He kept the original hand-beaten nails and strips of leather from *The Raising of Lazarus* and reapplied them in the *Emmaus*. To confound the connoisseurs, he made the whites of the old painting coincide with those of his own "Vermeer." He always kept bunches of lilac in his studio to hide the smell of the lilac oil he used in his forgery. But neither Van Meegeren's confessions, nor the results of the scientific tests, were able to allay doubts. In 1948 the director of the Mauritshuis in The Hague, De Vries, who had completely changed his opinions about the *Emmaus* and all the other paintings from the same source, maintained at a conference in the Louvre that there was no possibility of error in the verdict of the false Vermeers. A. Lothe at once objected that the *Emmaus* and *Last Supper* were authentic Vermeers; a view which J. Decoën of Brussels endorsed the following year when he had cleaned the two paintings. In 1949 Coremans published a

Sketch by Van Meegeren for the Boymans Emmaus; *we can see the attempt to make some parts of the fake coincide with* The Raising of Lazarus *painted on the seventeenth-century canvas used by Van Meegeren.*

detailed note on the researches which had led to the conviction of the forger; among other factors the critic noted that Van Meegeren's colors had been mixed with a synthetic resin based on formaldehyde which had only recently been discovered (for later clarifications see an article also by Coremans [MBK 1950]). Professor Ch. Meurice from the chemistry faculty of Brussels University objected (*L'Ingénieur chimiste*, 1951) that the substances used by Coremans to discover the synthetic resins produced exactly the same reaction with the ancient varnishes. Other chemists offered similar objections. The following year, in an interview in Paris, Van Meegeren's son maintained that besides two recognized fakes (*Boy with a Pipe* in the Museum voor Stad en Lande in Groningen and *The Laughing Cavalier*, authenticated and made known by the famous critic Hofstede de Groot) his father was responsible for two other paintings which until that time had been accepted as Vermeers: *Girl in a Blue Hat*, at the time belonging to Thyssen (60), and a second *Girl* which was never exactly defined. As for the Thyssen canvas, critics immediately upheld the doubts that had already been aired, although Van Meegeren junior's revelations contained certain contradictory elements. This sequel to the "affair," far from putting the remaining illusions to rest, seemed to excite them all over again. But the one that seemed to take firmest root was that fostered by the great Dutch collector Daniel George van Beuningen who brought an action against Coremans maintaining that Van Meegeren's assertions were merely idle boasts, at least in the cases of the *Emmaus* and *Last Supper*. Of these two paintings, the former was bought by the Boymans Museum with the munificent help of the accuser; the other Van Beuningen had bought in

1941 for 1,600,000 florins. Then Decoën joined the attack on Coremans by publishing a "*Retour à la vérité*" (Rotterdam 1951) in which the authenticity of the *Emmaus* and *Last Supper* was established; and it was maintained that Van Meegeren had been inspired precisely by these two paintings to execute his own Vermeer forgeries. In the first trial (1955) Coremans was given the verdict, but only because the tribunal in Brussels accepted the validity of the reasons which the Amsterdam court had deemed sufficient to find Van Meegeren guilty. In a later trial (cf. "*Cahier des arts*," Brussels), Coremans brought decisive evidence: the photograph of a *Hunting Scene* attributed to A. Hondius, the same one that X-rays showed had existed under the presumed *Last Supper* by Vermeer, and documentary proof that Van Meegeren had bought this *Hunting Scene* in 1940. At this point we need a note on the methods adopted by the experts to decide about Van Meegeren's "idle boasts." He declared that he had executed his forgeries on seventeenth-century canvases, after removing the original paintings from them, but leaving some part of the ancient material with its genuine "cracks." In fact X-rays revealed a woman's head under the *Emmaus*, horses and horsemen under *The Adulteress* and *Washing*, a dog smelling a dead bird under *The Last Supper* (as is noted above); and they showed that the cracks on the two layers of paint are quite different. Comparing these with radiographs of authentic Vermeers, one discovers the double layer of cracks only in the fakes. Moreover, one can see that the cracks in the fakes were marked with Chinese ink in such a way as to make them appear blackened with the dirt of centuries.
In the case of the *Emmaus*, pieces of the original frame

were found in Van Meegeren's studio in Nice which corresponded to the forger's own indications; and it was possible to reconstruct the whole of the wooden structure by using the part kept in the Boymans Museum. Still, microchemical examination of the counterfeits showed the use of colors with a high degree of stability, enough to resist not only organic solvents (alcohol, benzol etc.) but even acids and alkalis. Now it is well known that these last spoil oil paints, even antique ones; and as a result we must think that Van Meegeren had resource to synthetic resins. In fact, colors and resins confiscated from him showed exactly the same chemical reactions as those obtained with particles taken from *Emmaus* and other double paintings. In short it was quite satisfactorily proven that the supposed Vermeers were modern.
If the evidence of the *Emmaus* canvas, the results of the various analyses, the comparison of the materials owned by Van Meegeren, the plates, glasses and maps which figure in his pictures and were found in his studio were not enough; if even a close study of the incomplete fakes in his studio and stylistic considerations did not provide the answer, a look at the arrangement of the heads in *The Last Supper* – which are unrelated to each other, without any connecting element at all, neither a formal one, nor even any external coherence – is not enough to differentiate this work even minutely from mere illustration. Yet Kurz comments that the *Emmaus* forms the apex of Van Meegeren's career; beside it, the other forgeries seem mere parodies of Vermeer. As a final proof, some of Van Meegeren's own "genuine" paintings, some of them dating back to 1918, show decisive evidence. For instance, precisely the same intimate travail expressed on Christ's face in the *Emmaus* concealed beneath apparent "non eloquence," (which encouraged a critic [*Art News*, 1938] to talk of "Classical restraint in the style of Piero della Francesca"), is to be found in several allegories that Van Meegeren exhibited in his own name. Indeed, by examining all his works their chronological sequence can be established. In conclusion, it should be remembered that the auction of Van Meegeren's works arranged by his heirs raised not the millions they had hoped for, but 226,599 florins. The sale included a *Last Supper* executed in 1939, which served as a model for the one that cost Van Beuningen 1,600,000 florins, and the *Jesus among the Doctors* made only 3,000 florins.

Indexes

Subject Index

The identification of some of the figures, as given in this index, is uncertain (see the relevant notes in the catalogue). References to pages indicate subjects relating to the paintings, considered in the appendix devoted to the fakes. All other references are to catalogue numbers.

Title Index

An asterisk indicates the existence of replicas or copies of the same subject, which are discussed in the commentary to which the number refers. Reference to pages indicate the pictures considered in the appendix devoted to the forgeries. Other references are to catalogue numbers.

Topographical Index

An asterisk indicates a replica or copy cited in the commentary to which the number refers. Page numbers indicate the pictures considered in the appendix devoted to the fakes. Other references are to catalogue numbers.